Lincoln Public Library

December 1990

THE LIBRARY OF AMERICAN ART

WINSLOW HOMER

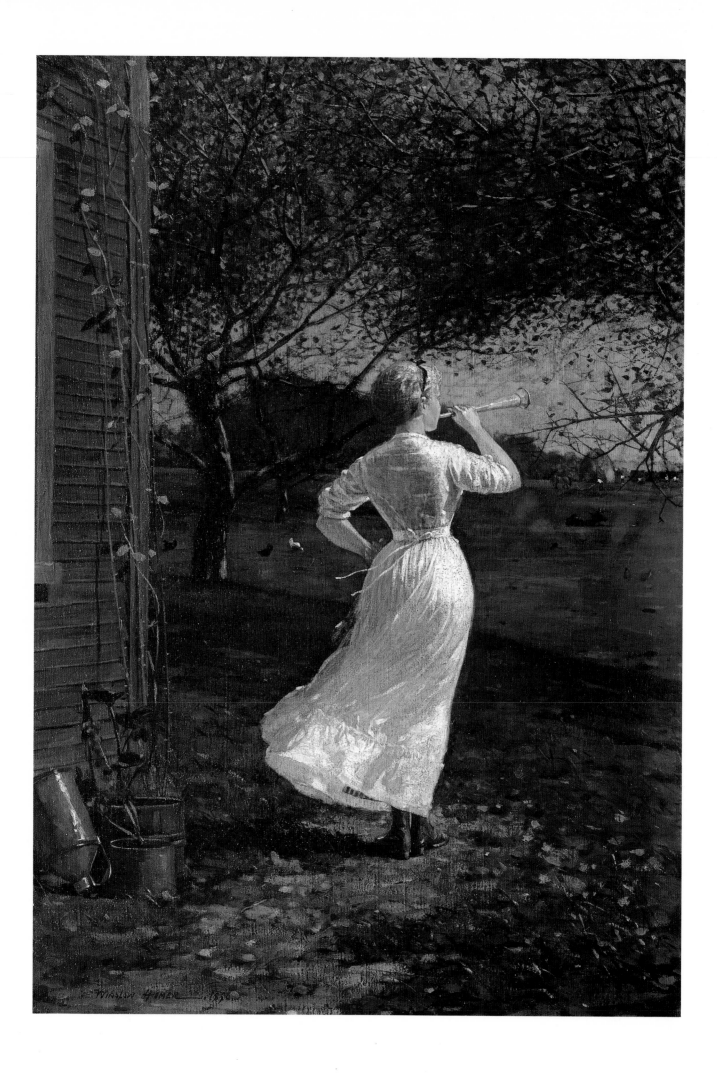

Winslow Homer

NICOLAI CIKOVSKY, JR.

Harry N. Abrams, Inc., Publishers, New York
IN ASSOCIATION WITH
The National Museum of American Art, Smithsonian Institution

Series Director: Margaret L. Kaplan
Editor: Eric Himmel
Designer: Ellen Nygaard Ford
Photo Research: Jennifer Bright and Judith Posner

Library of Congress Cataloging-in-Publication Data

Cikovsky, Nicolai.
 Winslow Homer / Nicolai Cikovsky, Jr.
 p. cm. — (Library of American art)
 "In association with the National Museum of American Art,
 Smithsonian Institution."
 Includes bibliographical references.
 ISBN 0-8109-1193-0
 1. Homer, Winslow, 1836-1910. 2. Painters—United States—
Biography. I. National Museum of American Art (U.S.) II. Title.
III. Series: Library of American art (Harry N. Abrams, Inc.)
ND237.H7C54 1990
759.13—dc20
[B] 89-17839
 CIP

Frontispiece: *The Dinner Horn.*
 1870. Oil on canvas, 19⅛ x 13⅝".
 Mr. and Mrs. Paul Mellon, Upperville, Virginia.
 See page 50 for commentary.

Text copyright © 1990 Nicolai Cikovsky, Jr.
Illustrations copyright © 1990 Harry N. Abrams, Inc.

A Times Mirror Company

Printed and bound in Japan

Contents

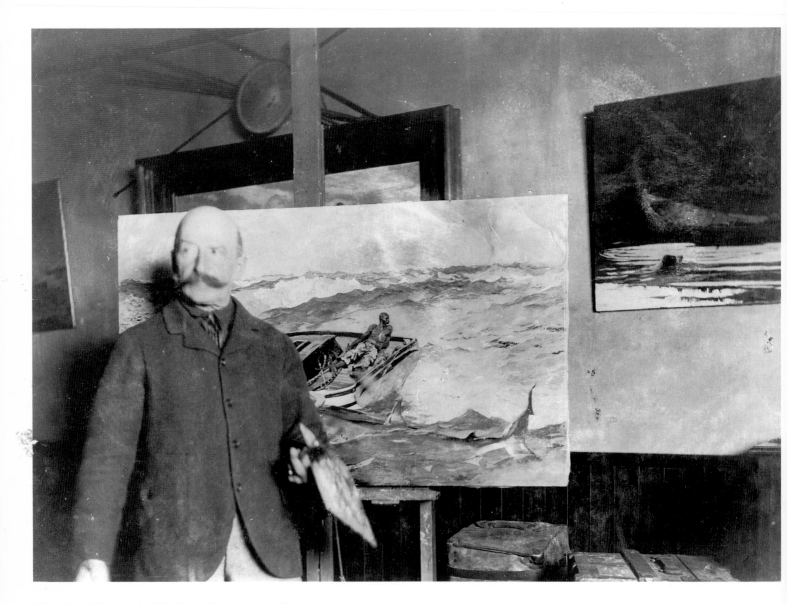

Winslow Homer in his Prout's Neck studio, 1899

Preface

WHAT FOLLOWS IS AN EXTENDED ESSAY, unburdened by the explanatory notes and references that, in the conventions of scholarly writing, justify an author's claims, support his arguments, and acknowledge his sources. For the general reader that scholarly apparatus is mostly a nuisance and usually remains unused. That is why it is absent here. But in case one might think that there are no claims or arguments (as there always are, of course); or in the event that this text comes to the attention of more specialized readers who will easily notice what in it may be new to the discussion of Winslow Homer and what has been borrowed for or omitted from it, some prefatory commentary—some explanation and acknowledgment in the place of the usual formalities of scholarly notation—might be helpful. But this, too, can be passed over.

If this differs in any significant way from earlier books on Homer (apart from its comparative brevity) it is mostly in the larger place it assigns to what one might call his consciousness and conscience—what is known or can be inferred of his thought, his belief, and his participation in the cultural, social, and even political life of his time—in the determination of both the meaning and the form of his art.

A concern for Homer's conscious and unconscious mentality—his intelligence and artistic, intellectual, moral, and political awareness on one hand, his psychology (including his sexuality) on the other—is a generational phenomenon, not a singularity of mine. It is largely in this respect that the current understanding of Homer differs from earlier ones, which were on the whole descriptive (biographical) or classificatory (stylistic). As a result, Homer has become a much more complex artistic being.

That complexity, in *its* time, was also generational, not merely personal. For Homer's undertaking has not been seen, as I think it should be, in the larger context of modernism. In applying it to Homer I do not mean that he was either ahead of his time or anticipated ours but, on the contrary, that he was very much part of his own in ways and degrees that we have not adequately recognized. I take modernism to be a description of attitude and purpose, not just of style. Homer belonged to the great modernist generation; he was the contemporary of the French artists Edouard Manet, Edgar Degas, and Claude Monet, and the American expatriate James Whistler. There is no sufficient reason to believe that he was influenced by any of them directly, but in essential ways he shared their enterprise. His depiction of contemporary life, his stress upon the act of

Winslow Homer in his Prout's Neck studio, 1899

Photograph
Bowdoin College Museum of Art,
Brunswick, Maine

This is the only known photograph of Homer at work. The painting on the easel is The Gulf Stream, *now in the Metropolitan Museum of Art, New York (pages 120-121). Hound and Hunter, now in the National Gallery of Art, Washington, is hanging on the wall to the right (page 108).*

7

seeing and the facts of sight, his obliqueness of vision and meaning, his problematic relation to artistic tradition, his deliberate originality of style, his detachment, his irony, his anxiety (he was described as "nervous," with "a countenance full of the expression of apprehension"), his impersonality and social aloofness, are properties of Homer's modernism that he shared in varying and differing degrees with the artistic generation to which he belonged.

The recognition of Homer's modernism helps us to understand, or puts into a different light, some of the distinctive aspects of his art and his artistic personality. It explains his Americanness, for to the extent that, in America, contemporary life and national life were inextricable (as they were not to the same degree elsewhere), nationality was an inescapable condition of modernity. And it was disillusionment with modernism in the late 1870s—with an art that conformed to the description of contemporary society—that drove Homer to the social and artistic privacy, the inwardness, of his later years (a phenomenon he shared also with Degas and Monet).

Homer's modernism was not a result of influence. Influence has been usually understood to mean the effect of art upon art, and in American art-historical practice has often been used almost exclusively, and often mindlessly, to explain the process of artistic formation. Homer's art was formed not only by what he saw of other art—of which he could easily have seen a great deal in America and Europe—but as much, if not more, by what he thought and believed. That formation, in other words, was determined not only by knowledge of other art, which no artist can escape, but by issues outside of and larger than the hermetic and mechanical operations of influence, by what might be called ideologically directed policy (one tenet of which was, as Homer put it, that an artist "should never look at pictures"). Hence, for example, I am not as taken as others have been with the possibility that Homer necessarily saw and was influenced by French Impressionism. Its influence is far from proven or even provable and not in any event required to explain the character of Homer's artistic development. Hence, too, my attentiveness to one of Homer's friends in the 1860s, the minor artist but important critic Eugene Benson, and the possibility that in Homer's formative years Benson represented in his presence what we have not customarily believed Homer to possess: an artistic program and some significant measure of artistic and literary culture.

Because I cannot by the format of this book acknowledge my specific debts to them (though in most cases they are cited in the bibliography), I must mention those scholars, friends, and colleagues upon whose discoveries, arguments, and ideas I have depended, and who form a noble tradition of Homer scholarship to which this is a small but I hope not unworthy addition: Henry Adams, Philip Beam, Helen Cooper, David Curry, Albert Ten Eyck Gardner, William Gerdts, Lucretia Giese, Gordon Hendricks, Barbara Novak, Jules Prown, Michael Quick, Natalie Spassky, Roger Stein, David Tatham, John Wilmerding, Christopher Wilson, Peter Wood, and, above all, the late Lloyd Goodrich. And while I

cannot possibly thank all those who have been helpful I must mention Elaine Dee and her staff at the Cooper-Hewitt Museum, Garnett McCoy and the staff of the Archives of American Art, Philip Beam and John Coffey at Bowdoin College, and Lois Homer Graham. Elizabeth Chen was indispensably helpful in the preparation of the Chronology. I must also thank Charles Eldredge, former Director of the National Museum of American Art, Elizabeth Broun, its Director, and my editors at Harry N. Abrams, Inc., Margaret Kaplan and Eric Himmel, for their kind and helpful words, gentle criticism, and unflagging patience. For the opportunity to think about Homer over the years I am deeply indebted to the Guggenheim Foundation and the National Gallery's Center for Advanced Study in the Visual Arts.

In this as in everything I owe the most to Sarah Greenough.

NICOLAI CIKOVSKY, JR.
Washington

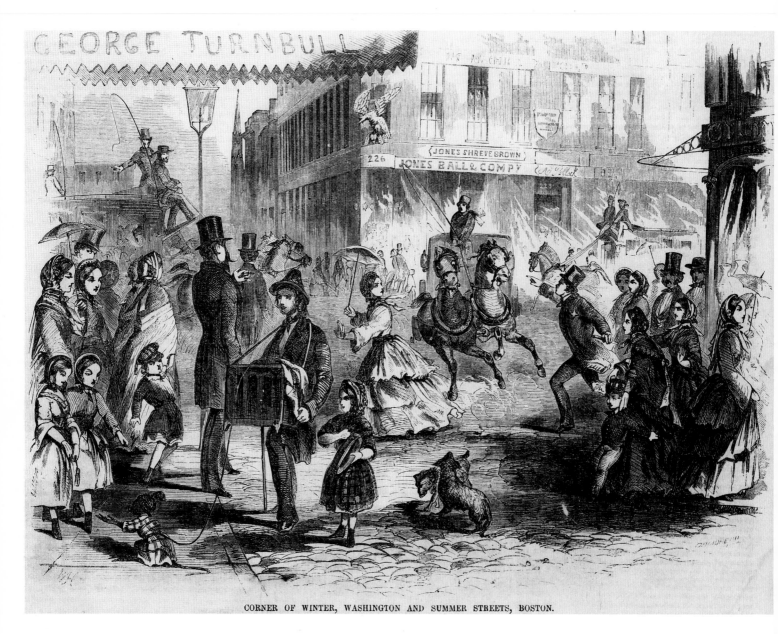

CORNER OF WINTER, WASHINGTON AND SUMMER STREETS, BOSTON.

Corner of Winter, Washington and Summer Streets, Boston

I. Treadmill Existence

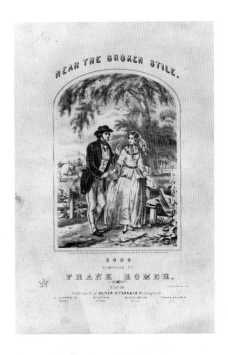

WINSLOW HOMER WAS SECRETIVELY PRIVATE. For an artist who, from the beginning of his professional life, commanded public attention, he managed also to keep carefully, at times even reclusively, out of the public eye. He had few close friends and no students to tell tales about him, rarely allowed visitors to his studio, never explained his artistic purpose, and provided only enough information about himself for a very skeletal biography. His family, to whom of all people he was the closest, respected his privacy during his life and after his death. It is clear that Homer, as a matter of public policy, wished to be known for the quality of his art, not for the character of his life. He wished it so intensely that when his first biographer asked for information, Homer said it would "kill" him to have his private life known.

If Homer had been a lesser artist it might be possible to respect his wishes. But his art is so compelling, so challenging, and in a number of ways so enigmatic and problematic, that we are irresistibly driven to search in the relatively little of what we can recover of the context of his life for clues to his art and his artistic undertaking.

What we would like to know most about, but what we know the least, are those circumstances of his early life that might tell how and why Homer became the artist he did. Not what accounted for his greatness (for that is never knowable) but the experiences and occurrences, acquaintances and associations that might tell how and why his art took the form it did and why he painted the subjects he did in the way that he painted them. But about such things we know almost nothing.

Winslow Homer was born in Boston on February 24, 1836, the second of three children, all sons, of Charles Savage and Henrietta Benson Homer. On both sides, the family descended from long lines of New Englanders. It has been to his mother, a cultivated and accomplished woman and an amateur watercolorist of more than ordinary skill, that Homer's artistic lineage has usually been traced. Winslow was particularly close to his mother throughout her life (in an 1861 letter to his father he signed himself "Truly Mothers Son"). But it was not his mother alone who formed him artistically and professionally. Homer's father, a businessman, has been seen as something of a ne'er-do-well, and there is no question that he was chronically unsuccessful in business or that in later life (he lived to the age of eighty-nine, attentively minded—"overlooked," as Winslow put it, without any Freudian slippage—by his sons) he behaved with consid-

Near the Broken Stile

1857. Lithograph, 13½ x 10½″
Sterling and Francine Clark Art Institute,
Williamstown, Massachusetts

At the age of nineteen Homer became an apprentice of the prominent Boston lithographer John H. Bufford, whose shop provided the closest thing to an intensive artistic training that Homer would experience. This is an example of the commercial work Homer produced at Bufford's.

Corner of Winter, Washington and Summer Streets, Boston

Ballou's Pictorial, 13 June 1857.
Wood engraving, 7¼ x 9½″
National Gallery of Art, Washington

Homer's apprenticeship at Bufford's, he said later, was a "treadmill existence," and when his apprenticeship ended in 1857 he began a career as an independent, free-lance graphic artist that would last for almost twenty years. This ambitiously complex illustration, published a few months after his apprenticeship ended, is Homer's first independent work and the first manifestation of his artistic individuality.

erable eccentricity. There is no doubt, either, that Winslow's relationship to him was, while close, distinctly ambivalent. But, in contrast to what practical American fathers with artistically inclined children were conventionally said to do, Homer's father, perhaps because of his own impracticality, did not stand in the way of his son's professional choice but, as Winslow said later, actively encouraged it. On a business trip to London he acquired artistic equipment for his son, "a complete set of lithographs by Julian—representations of heads, ears, noses, eyes, faces, trees, houses, everything that a young draftsman might fancy trying his hand at—and also lithographs of animals by Victor Adam which the son hastened to make profitable use of." Homer's father "was always interested to some extent in drawing and the like," and it was he who arranged for his artistic apprenticeship, which was the only extensive artistic training that Homer had. Even more, there was it seems some standard of excellence determined by family influence, to which both parents must have contributed, one that powered the achievement of both Winslow and his elder brother, Charles Savage Jr. (though less so the youngest son Arthur Patch). Charles Jr. went to Harvard and become a successful chemist and prosperous businessman. Winslow was supposed to go to Harvard too, but his interest in art, which Harvard was not equipped to nourish, prevented it; he became instead the greatest American painter of the nineteenth century.

About 1855, when he was nineteen years old, Winslow, who "wanted to draw" rather than follow his older brother to college, was apprenticed to the Boston lithographer John H. Bufford. He spent two years at Bufford's, drawing on the lithographic stone sheet music covers and similar commercial work. He thoroughly detested it; looking back at his apprenticeship, he said it was a "treadmill existence," "bondage," and "slavery."

It is difficult to see in Homer's work at Bufford's any particular individuality or exceptional skill, or to deduce from it exactly what Homer might have learned. But his apprenticeship was the most intensive, disciplined artistic training that Homer, whether by chance or on purpose, would ever have. When, a few years later, critics noted strength of drawing as one of the qualities of Homer's first paintings in oil that distinguished them from the work of his contemporaries; and when, in Homer's independent engravings, there is a consistent sense of graphic design, those properties of his mature art must owe something essential to his experiences at Bufford's. Only there could he have been "bred into that religion of the pencil," as a critic put it many years later, "which is the very life of all high and really successful art."

Perhaps what made Homer's apprenticeship particularly distasteful and unendurable was his knowledge that there was something better—something larger, higher, and finer—than commercial illustration. His ambition required a medium of expression larger and more original, more deliberately novel and individual, than anything that it was possible for him to acquire at Bufford's or within the conventions of commercial illustration. Looking at a picture by Edouard Frère (a painter of saccharine genre scenes much admired by Ameri-

cans) on a visit to a Boston picture gallery with some of his fellow apprentice lithographers, Homer announced, "I am going to paint." And when asked what he was going to paint, he said, pointing to the Frère, "Something like that, only a damned sight better." Homer kept his nose to the lithographic stone at Bufford's, as he put it later, but even then it was the smell of paint that he loved.

At about this time, too, Homer said to one of his friends at Bufford's, "If a man wants to be an artist, he should never look at pictures." This suggests, at the very beginning of his artistic life, an assertive independence and originality. But it may mean something else as well. For the belief that an artist—an *American artist*—should preserve a purity of vision by studying nature and carefully avoiding the study of art was not a singular and private belief of Homer's; it was, on the contrary, an article of a national artistic creed that resounded in American theory and criticism at the middle of the century, precisely when Homer was undergoing, or enduring, his apprenticeship. Homer's simple utterance, in other words, parrotted, and in doing so endorsed, the central artistic conviction of his time. And to that extent it suggests that in the artistic course he was setting for himself in his early years Homer was guided by a theory of art.

Homer left the "bondage" of Bufford's in 1857, when he was twenty-one years old, and "from the time I took my nose off that lithographic stone," he said later, "[I] had no master." He took a studio of his own in Boston and began a career of nearly twenty years as a free-lance illustrator. He began it at an auspicious time, for he had a field for his enterprise that earlier American illustrators did not have: the newly established, lavishly illustrated weeklies like *Ballou's Pictorial* in Boston, and *Frank Leslie's Illustrated Newspaper* and, above all, *Harper's Weekly* in New York, that created an unprecedented demand for visual material, and that by their large format gave it very literally a new dimension. Nor did Homer begin timidly. His first illustration for *Ballou's* in June 1857, *Corner of Winter, Washington and Summer Streets, Boston*, was filled with the figures, incidents, and texture of contemporary life. It was, in its observational and pictorial complexity, wholly unlike anything he did for Bufford, and provided a foretaste of the kind of art he would make for the next twenty years.

Homer rapidly became America's most important illustrator, the most incisive observer and the best chronicler of his time, in war and peace, city and country; the one with the greatest command of graphic expression and the finest aesthetic sensibility. Homer's illustrations were published as wood engravings, designs cut into wooden blocks that could be printed along with type. Homer did not himself engrave his designs on the blocks—that was done by professional wood engravers. That his illustrations were successful was due not to his own special skill as an engraver but to his ability to conceive them in graphic terms that registered with the greatest impact and could survive the corruption of often unskilled engravers. There is a great range of quality in the more than two hundred wood-engravings that Homer designed, but the finest of them have an individuality of style, a terse simplicity of visual form and narrative statement, that distinguishes them instantly from the work of others.

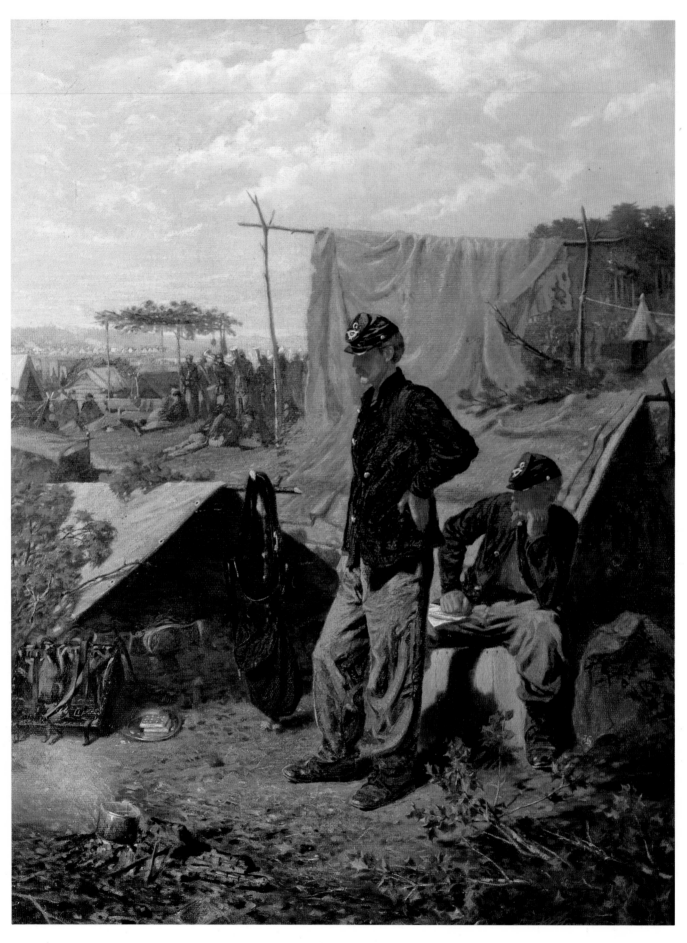

Home, Sweet Home

II. Painstaking Labor Directed By Thought

I<small>N 1859, H<small>OMER LEFT HIS NATIVE</small> B<small>OSTON FOR</small> N<small>EW</small> Y<small>ORK</small>,</small> where he would live for more than twenty years. He moved to be closer to the illustrated magazines that were his primary livelihood—and chiefly the greatest of them, *Harper's Weekly*, for which he had begun to do most of his work. But surely he also moved because New York had become by the middle of the century America's artistic center, with more art, more artists, more artistic institutions, a more dynamic artistic life, more stimulating artistic culture, and more artistic commerce by far than any other city in the country. Only in New York could an artist of serious ambition, like Homer, find the resources to nourish and to challenge that ambition.

Homer's maturity as an artist dates exactly to his emergence as a *painter* in New York in the early 1860s. Homer became a painter, and attained that maturity, not gradually and after long and diligent study, but almost overnight, and, so far as we know, with hardly any special training to speak of. In 1861 he had a few lessons from an artist of modest ability named Frederic Rondel who "taught him how to handle his brush, set his palette, &c." For all intents and purposes, however, Homer was self-taught as a painter—or, which amounts to the same thing, he followed the cardinal precept of American art theory by learning from nature, not by looking at pictures or from other artists. In the summer of 1862, we are told, "he bought a tin box containing brushes, colours, oils, and various equipments and started out into the country to paint from Nature."

The beginning of Homer's professional life as an artist coincided almost exactly with the beginning of something else: the Civil War. Not only did Homer first appear as a distinct and consequential artistic personality in his Civil War paintings; the Civil War also affected Homer's art in two crucially important ways. At the very beginning of the war he was eager to go to Europe, presumably to complete his training: "Win must go to Europe," his father wrote in January 1862, expressing the force of his son's desire. By preventing study abroad—a formal artistic education that he never received before the war and no longer had an interest in receiving after it—the war was instrumental in determining the kind of artist Homer became. It determined that in a different way by calling upon Homer's powers of innovation and interpretation to a degree that a more normal subject would not have done. An event less

Home, Sweet Home

1863. Oil on canvas, 21½ x 16½"
Private collection

In its painterly confidence and competence, and in the complexity of its meaning, this is Homer's first mature and fully successful painting. It was received enthusiastically. "It is a work of real feeling; soldiers in camp listening to the evening band, and thinking of the wives and darlings far away," a writer in Harper's Weekly said. *"There is no strained effect in it, no sentimentality, but a hearty, homely actuality, broadly, freely, and simply worked out."*

unprecedented—less intensely modern—could not have made the same urgent demands upon his inventiveness and his artistic intelligence; one less historically momentous and nationally traumatic would not as fully have aroused his convictions and deepened his understanding.

However he learned to make them, Homer's earliest oil paintings are remarkable things. Although "his very first picture in oils," *The Sharpshooter* of 1862 (it was engraved that year for *Harper's Weekly* "after a painting," although the painting itself is dated 1863), is in certain ways quite tentative—very small in size (about 12 by 16 inches, only three inches larger than the engraving) and thinly painted—it was conceived with extraordinary sophistication and perception. In its reductive concentration and ellipticality—the action is implicit rather than explicit—the work is wholly different from the traditional panoramic, populous, action-filled battle picture. Its design, judged by the formal conventions of the battle picture (or by any standard, for that matter), is a remarkably refined and sensitive pictorial invention. And the image Homer chose to represent the Civil War, in his earliest painting and in the war's earliest stages, suggests a penetrating understanding of the impersonal, distant, mechanical warfare that made its first historical appearance in the American Civil War, and that made it seem "butchery," as Homer said later, by traditional standards of gallantry.

Homer quickly, almost immediately, became by far the most intelligent artistic interpreter of the war. He knew it directly: He was in Washington in 1861; with McClellan's army on the Peninsular Campaign of 1862 (which he illustrated for *Harper's Weekly*); and, it seems, at the siege of Petersburg, Virginia in 1864.

In 1863, Homer sent two paintings, *The Last Goose at Yorktown* and *Home, Sweet Home,* to the major exhibition of the year, the annual exhibition of the National Academy of Design. This was his professional debut as a painter and it was a stunning success. He not only sold both paintings, but received lavish critical attention for them as well. "Winslow Homer is one of those few young artists who make a decided impression of their power with their very first contributions to the Academy," one critic wrote. "He at this moment wields a better pencil, models better, colors better, than many whom, were it not improper, we could mention as regular contributors to the Academy." Their greatest praise was for *Home, Sweet Home.* "There is no clap-trap about it. Whatever of force is in the picture is not the result of trickery, and is not merely surface work...but painstaking labor directed by thought." "The delicacy and strength of emotion which reign throughout this little picture are not surpassed in the whole exhibition."

In *Home, Sweet Home,* two Union soldiers (infantrymen, as we can tell from the precisely recorded insignia on their caps) listen, "in a bitter moment of home-sickness and love-longing," as the regimental band plays "Home, Sweet Home." Homer had been to the front in 1862 as a correspondent for *Harper's* and he probably found the subject then. It was a common occurrence in the early part of the war, as the Union and Confederate armies feinted, trained, and

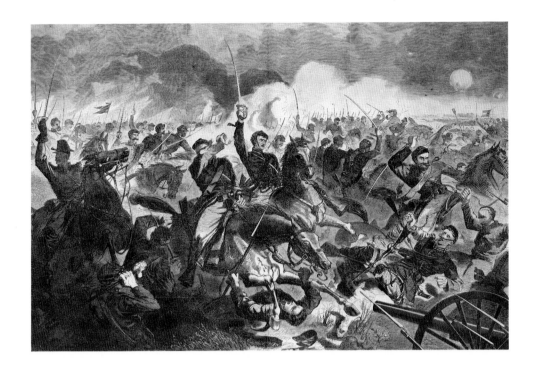

The War for the Union, 1862—
A Cavalry Charge

Harper's Weekly, 5 July 1862.
Wood engraving, 13½ x 20⅝″
National Gallery of Art, Washington

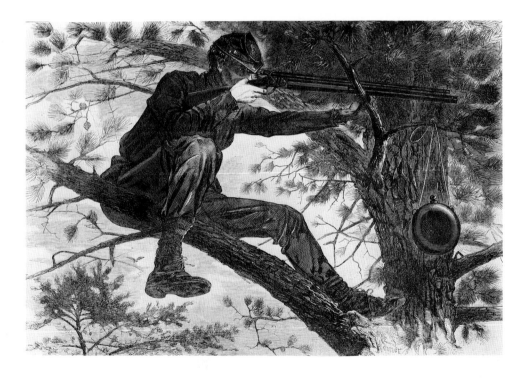

The Army of the Potomac—A
Sharpshooter on Picket Duty

Harper's Weekly, 15 November 1862.
Wood engraving, 9⅛ x 13¾″
National Gallery of Art, Washington

The contrast between these two engraved images, made a few months apart, reflects Homer's alertness to the profound changes in warfare that occurred in the Civil War. Direct, face-to-face assault, like the cavalry charge, that characterized military tactics before the war, was driven from the field by the rifled musket. War became more distant and more anonymous as attackers and defenders took cover from the greater range and accuracy of new, more deadly rifles.

battled mostly with music. General Nelson Miles (said to have posed for the figure of the Union officer in Homer's *Prisoners from the Front*) described what happened when the two armies were within hailing distance: "Late in the afternoon our bands were accustomed to play the most spirited martial and national airs, as 'Columbia,' 'America,' 'E Pluribus Unum,' 'The Star-spangled Banner,' etc., to be answered along the Confederate lines by the bands playing, with equal

enthusiasm, 'The Bonny Blue Flag,' 'Southern Rights,' and 'Dixie.' These demonstrations frequently aroused the hostile sentiment of the two armies, yet the animosity disappeared when at the close some band would strike up that melody which comes nearest the hearts of all true men, 'Home, Sweet Home,' and every band within hearing would join in that sacred anthem with unbroken accord and enthusiasm."

What is most remarkable about *Home, Sweet Home* is not only that it is executed with an assurance that one would not expect from a young painter with virtually no training or experience, but how, at the beginning of his career, Homer appears as a whole and substantial artistic being, an artist of developed maturity of feeling and understanding. The painting's title, *Home, Sweet Home*, at once names and evokes the song the soldiers listen to. But it also refers to the very different and far from sweet reality of their "home" of small tents and meals of hardtack and food cooked over small, smoky fires. The title's punning suggestion that things may be more or different than they appear reveals, by a device he would use repeatedly, an alertness to ironic complexities of meaning that would be a central element in Homer's later art to its end.

The Napoleonic wars of the early nineteenth century left a large legacy of military art, scenes of battle and heroic display, of "long lines advancing and manoeuvering, led on by generals in cocked hats and by bands of music," as a contemporary of Homer's characterized them. Some of Homer's early engravings for *Harper's* reflect that type, such as *The War for the Union, 1862—A Cavalry Charge* and *The War for the Union—A Bayonet Charge*. On the whole, however, in paintings like *Sharpshooter* and *Home, Sweet Home*, Homer depicted the Civil War so differently that it must represent on his part a deliberate revision, at the very beginning of his career as a painter, of the inherited modes of military art. Instead of battles and parades—war's formal, public aspect—Homer depicted its private, domestic side in incidents of camp life, like soldiers listening to "Home, Sweet Home" or carving brierwood pipes. Instead of generals and heroes, Homer depicted private soldiers, sometimes in conditions very far from the heroic. They can be found malingering in *Playing Old Soldier* (Museum of Fine Arts, Boston) or enduring punishment in *In Front of the Guard-House* (also called *Punishment for Intoxication*). By distilling the totality of war to small, closely observed episodes and ordinary events, and particularly by concentrating on individuals, Homer penetratingly expressed the most essential condition of the American Civil War—that it was a democratic war, one fought not by professional soldiers but citizens "engaged in the sacred warfare of peace"; a war in which, as Walt Whitman said, "the brunt of its labor of death was, to all essential purposes, volunteered."

Homer's Civil War paintings had a compelling truthfulness, a "genuineness," as one critic described it. The truthfulness of his paintings came from a scrupulous attention to detail (like the insignia in *Home, Sweet Home*), and from Homer's sense of the telling and affecting incident. But it came, too, from the visual authenticity of his paintings, their "sense of out-door life," as a critic said, their "merit," as another put it, "of looking like the thing they aim to represent."

Inviting a Shot before Petersburg, Virginia

1864. Oil on panel, 12 x 18"
© 1987 The Detroit Institute of Arts.
Gift of Dexter M. Ferry, Jr.

"Your typical 'great white plain,' with long lines advancing and manoeuvring, led on by generals in cocked hats and by bands of music, exist not for us," Colonel Theodore Lyman wrote in the same year Homer painted this picture of the siege of Petersburg. Warfare had been driven underground, into trenches and behind earthworks, and made largely defensive by technologically advanced rifles of great range and accuracy—which a Confederate soldier challenges with foolish daring.

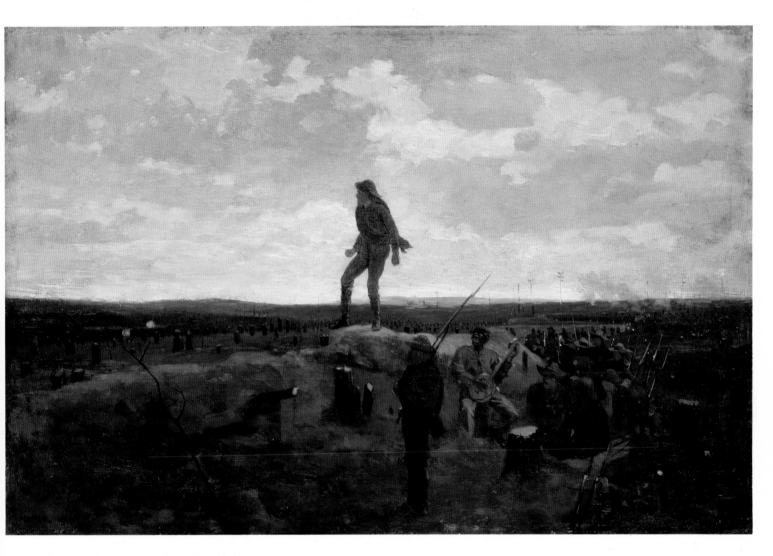

Inviting a Shot before Petersburg, Virginia

In Front of the Guard-House

1863. Oil on canvas, 17 x 13"
Canajoharie Library and Art Gallery,
Canajoharie, New York

Having to carry a piece of wood and to stand on a barrel were common forms of punishment for infractions of military discipline and hence a common aspect of camp life.

That came primarily from convincingly true effects of natural light. And that, in turn, came from Homer's practice of painting figures directly from nature. "Mr. Homer studies his figures from realities in the sunshine," a critic reported in his review of the 1864 Academy exhibition, which included *In Front of the Guard-House* and *The Brierwood Pipe*, adding, "If you wish to see him work you must go out upon the roof and find him painting what he sees." (Homer's New York studio in the 1860s was in one of the Gothic towers of the New York University Building on Washington Square, with access to the roof where he posed his models).

Paradoxically, however, the truthfulness of Homer's Civil War paintings

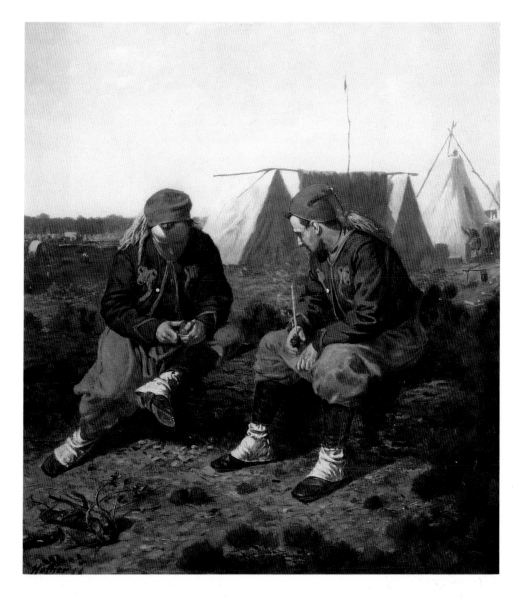

The Brierwood Pipe

1864. Oil on canvas, 16⅞ x 14¾"
The Cleveland Museum of Art.
Mr. and Mrs. William H. Marlatt Fund

Early in the war a number of units adopted the colorful costume of the Zouaves, Berbers of Algeria who had fought valiantly with the French in the Crimean War. Two of the most famous Zouave regiments, Duryee's and Hawkins's, were from New York, and it was to a New York audience that The Brierwood Pipe *was first shown in the National Academy of Design exhibition in 1864. Zouave uniforms were difficult to maintain and their bright colors made excellent targets. "They did very well to lie around camp in, and in a degree marked their owner as a somewhat conspicuous man among his fellows, but they were not tolerated on line; few of them ever survived the first three months' campaigning."*

resulted also from the essential artificiality of his artistic method. Homer knew his subject. He made several visits to the front and recorded his first-hand experiences of the war in numerous sketches that served as the material for his paintings. His paintings are not the transcription nor even the reconstruction of those experiences but their reconstitution in the more organized and concentrated structures of art. They were concocted from the "drawings, and sketches in oil, of incidents and episodes of war" that "crowded" the walls of his studio, from "a soldier's over-coat" and "a rusty regulation musket" that he kept there, and from models or lay figures painted on the roof of his studio. And that is precisely what gives them their singular force, for by their contrivance, their artifices of selection and distillation, their processes of refinement and reflection, they become much more than randomly reported incidents and achieve instead a universality and complexity of meaning, and, above all, are given arresting artistic form.

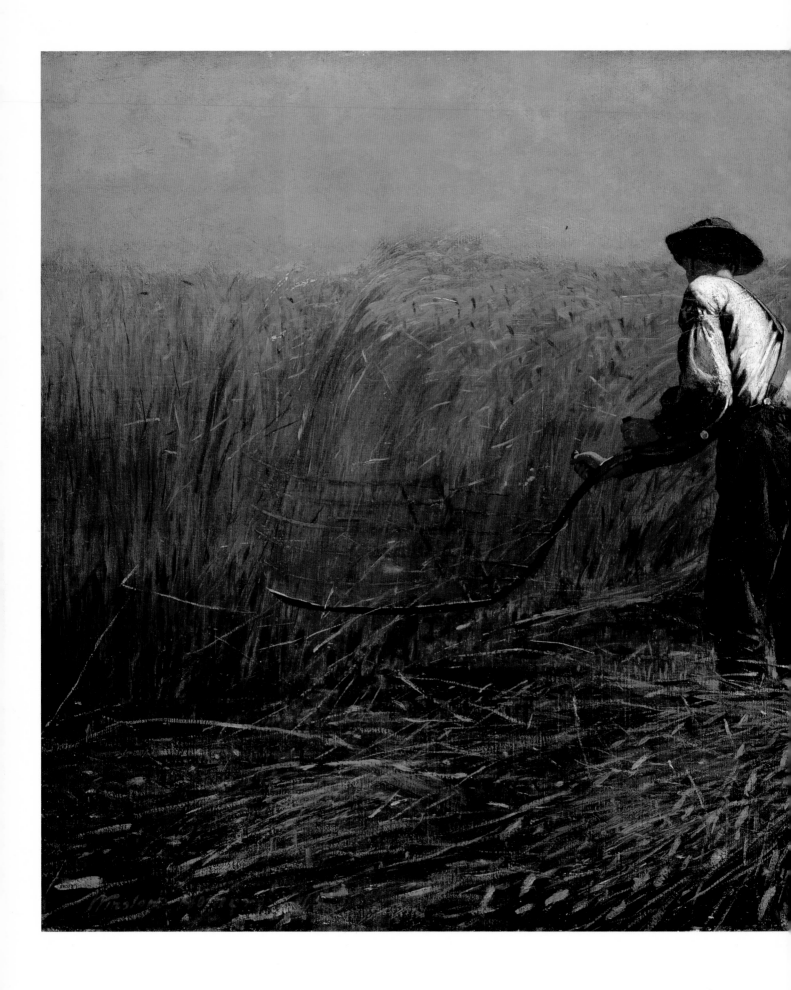

Veteran in a New Field

1865. Oil on canvas, 24⅛ x 38⅛"
The Metropolitan Museum of Art, New York.
Bequest of Miss Adelaide Milton de Groot 1967

In The Galaxy *in 1866 John Burroughs wrote of his friend Walt Whitman's poetry in terms that suggest the meaning of this, Homer's most political painting: "Vast armies rise up in a night and disappear in a day—half a million of men, inured to battle and to blood, go back to the avocations of peace without a moment's confusion or delay. . . . [I]n obedience to the true democratic spirit, which is the spirit of the times, the attention of the poet is not drawn to the army as a unit . . . but to the private soldier, the man in the ranks, from the farm, the shop, the mill, the mine, still a citizen engaged in the sacred warfare of peace. Always and always the individual, this is the modern doctrine, as opposed to slavery and caste and the results of the feudal world."*

The year after Homer launched his career so successfully with *Home, Sweet Home* he painted *Inviting a Shot before Petersburg, Virginia*. It depicts an incident in the siege of Petersburg, Virginia, during Grant's campaign against Richmond in the final action of the war, when Union and Confederate armies faced each other from trenches carved into a denuded, war-blighted landscape. As a number of his paintings and drawings indicate, Homer was at the front in 1864 and probably witnessed the incident he depicted. In the tension and tedium of the ten-month siege, a young soldier has jumped from his trench into full view of the enemy, inviting the shots—seen as puffs of rifle smoke—that come from the distant trenches. Compared to *Home, Sweet Home,* filled with details by which one reads its meaning, *Inviting a Shot* is utterly simple, reduced to earth, sky, and the single figure silhouetted against it. But by that reductiveness, and by properties of pictorial form rather than by an accumulation of detail—by the lonely, perilous visibility of the figure, seen by the beholder almost as he would be seen in the sights of a gun from opposing trenches—it achieved a dramatic force that other comparatively more story-telling paintings did not have. Some of the dramatic impact of *Inviting a Shot* is inherent in its subject, for it is one of Homer's few Civil War paintings to depict a scene of combat.

Inviting a Shot is unusual in another way. Homer was a Northerner by birth, supported the Union cause, and visited the Union army. But *Inviting a Shot* depicts Confederate soldiers, not Union ones. Confederate subjects appear once or twice in Homer's wood engravings, but in only one other painting. Perhaps he intended this subject to stand for the desperation, ignorant recklessness, and foolhardy bravado of the South (the young soldier on the breastwork closely resembles the one Homer included in *Prisoners from the Front* two years later whom contemporary critics described as "stupid" and "stolid" and a "corncracker"). Or perhaps it is an instance of Homer's ironic obliqueness, his fondness for avoiding the obvious and the direct and—in this case very literally—looking at the other side.

That obliqueness can be seen in another painting of 1864, *The Initials.* It shows the other side of the war. In it, a fashionably dressed young woman carves initials into the trunk of a tree. We do not see what it is she is carving; that takes place on the far side of the trunk, hidden from us. But by the incised crossed swords of the cavalry that Homer does allow us to see he suggests what she is carving—and why.

Two of Homer's greatest Civil War paintings, two of his greatest paintings of any subject or period, were made after the war. *Veteran in a New Field* was painted in the late summer of 1865. Although minimally simple, it is one of Homer's very richest and most moving paintings, an image, made in the most succinctly effective way, of war's end and the transition from war to peace. It depicts a recently disbanded soldier (his uniform jacket and canteen are in the lower right corner) engaged in a self-evidently symbolic event of peace, the harvest. Homer invokes a favorite republican emblem: The legendary Cincinnatus, who left his farm to assume the dictatorship of Rome and defend it against its enemies and, that done, relinquished power and office to return to

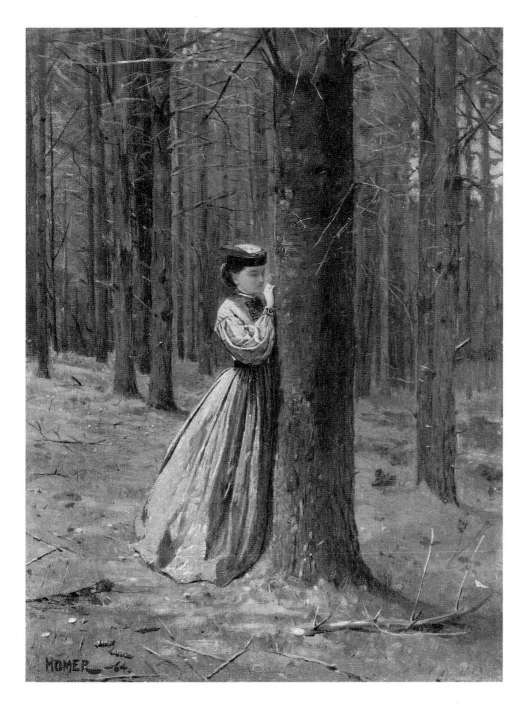

The Initials

1864. Oil on canvas, 16 x 12⅛"
Kennedy Galleries, New York

*This is, in effect, another of Homer's Civil
War subjects; a woman carves the initials
of a loved one on a tree already bearing
similarly inscribed marks of remembrance
and affection. To one of Homer's contem-
poraries it was overly conventional; in the
New York Leader in 1864 George Ar-
nold (who usually spoke favorably of his
work) said, "Mr. Homer has laid aside his
native force and simplicity, and made an
effort such as all young artists make once,
at least, and which some have made over
and over again until I, for one, am weary
of it. It is the girl in the pork-pie hat who
meditates alone in the bosom of nature."*

the occupations of peace. But, summoning up the image of death as the reaper,
Homer reminds us as well that the veteran now harvesting grain was not very
long before, in a common metaphor of war, a harvester of men—an image
made all the more forceful by its formality, its cast of seriousness and gravity that
causes the veteran to seem engaged in some solemn, ominous ritual rather than
an ordinary activity of life.

 Veteran in a New Field also addresses the widespread fear at the war's end
that the huge conscripted army, corrupted by war, would not disband peaceful-
ly. That it did was, as Walt Whitman put it, an "immortal proof of democracy."

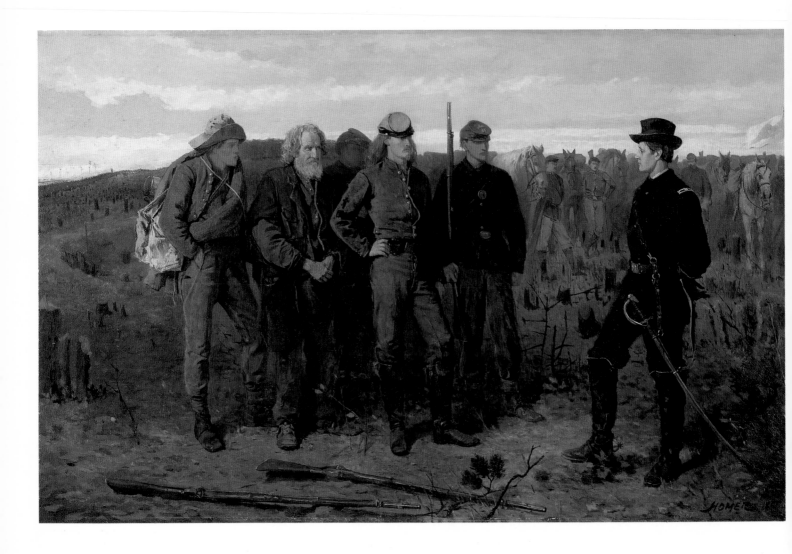

Prisoners from the Front

1866. Oil on canvas, 24 x 38"
The Metropolitan Museum of Art
Gift of Mrs. Frank B. Porter, 1922

The painting that truly launched Homer's career and signalled the full dimension of his artistic stature, it is a comprehensive summation, as the writer in the New York Evening Post *put it, of "the most vital facts" of the Civil War. "It is not easy to say how the two sides in our late war could have been better epitomized than in this group of three Southern prisoners brought up before a Northern officer," the critic of the* New York Tribune *wrote. The Na-tion's critic said the Northern and South-ern officers represented "very accurately the widely differing classes to which they belong," and* The Round Table's *that the painting expressed, "in a graphic and vi-tal manner, the conditions of character North and South during the war." It is not an impartial, non-partisan summa-tion; as a writer for* Harper's Magazine *said, "final victory is read in the aspect of the blue-coated soldier."*

In this way, therefore, the painting has a political meaning: its subject, as Homer surely knew, was in its time a "proof" of democratic government.

But the chief and most deeply felt element of the painting's meaning, and the strongest impulse to its making, is its response to the great tragic event of the year it was painted, the assassination of Abraham Lincoln. The painting's subject brings to mind such biblical texts as Isaiah's "flesh is grass" and Job's "man . . . cometh forth like a flower, and is cut down," invoking funerary associations (the same ones invoked by the sheaves of wheat that were often used as emblems on nineteenth-century American funerary monuments) and making of *Veteran in a New Field* a kind of mourning picture, a pictorial elegy on the death of Lincoln, cut down like the wheat.

In 1866, the year after *Veteran in a New Field*, Homer painted what was, in the estimation of his contemporaries, his greatest painting, *Prisoners from the Front.* It was the one that established Homer's artistic reputation and became for many years the benchmark of his achievement, mentioned so often that Homer finally said he was tired of hearing of it. *Veteran in a New Field* is as deeply felt a painting as Homer would ever make; *Prisoners from the Front* is by contrast an analytical assessment, almost an explanation, of the war. It depicts a Union officer receiving a group of three Confederate soldiers. The Union officer is General Francis Channing Barlow, a distant cousin of Homer's with whom he spent time at the front early in the war, and very likely later as well. One of Barlow's most celebrated feats was the capture, by the 1st Division of the 2nd Corps of the Army of the Potomac under his command, of a division of Confederate soldiers and two generals at the battle of Spotsylvania. It was described as "perhaps the most brilliant single feat of the war," and made of Barlow himself "one of the most conspicuous soldiers of the war—one of its most heroic and romantic figures." It is that event, perhaps, to which *Prisoners from the Front* refers. But that is not what the painting is about. Homer's historical vision is larger. "A truly Homeric reminiscence of the war," as one writer said, it embraced not events but their ultimate causes. As the critic of the *New York Evening Post* put it (he was Homer's friend, Eugene Benson, who possibly got what he wrote from Homer himself), the figures are "representative and at the same time local types of men," and he went on to describe what they stood for: "On one side the hard, firm-faced New England man, without bluster, and with the dignity of a life animated by principle, confronting the audacious, reckless, impudent young Virginian . . . ; next to him the poor, bewildered old man, . . . scarcely able to realize the new order of things about to sweep away the associations of his life; back of him the 'poor white,' stupid, stolid, helpless, yielding to the magnetism of superior natures and incapable of resisting authority." The meaning of the painting lies in these contrasts: between dignity and audacity, principle and impudence, and, finally, between warring systems of caste and culture.

Trooper Meditating Beside a Grave

c. 1865. Oil on canvas, 16⅛ x 8″
Joslyn Art Museum, Omaha, Nebraska.
Gift of Dr. Harold Gifford and
Sister Ann Gifford

This small sketch of a soldier contemplating a grave marked by a wooden cross is one of Homer's most moving Civil War paintings, closely related in its setting and elegaic mood to The Initials *(in which the crossed-saber insignia of the cavalry on the soldier's cap are carved into the tree trunk), and to* Veteran in a New Field *and* Prisoners from the Front *that are, like it, summary, reflective considerations of the war. Like all of Homer's Civil War paintings, this depicts a private and individual act, not a formal, public ceremonial event. The two crosses—one identifying the soldier, the other marking the grave—form a close, poignant, and unsentimental compact between the living and the dead.*

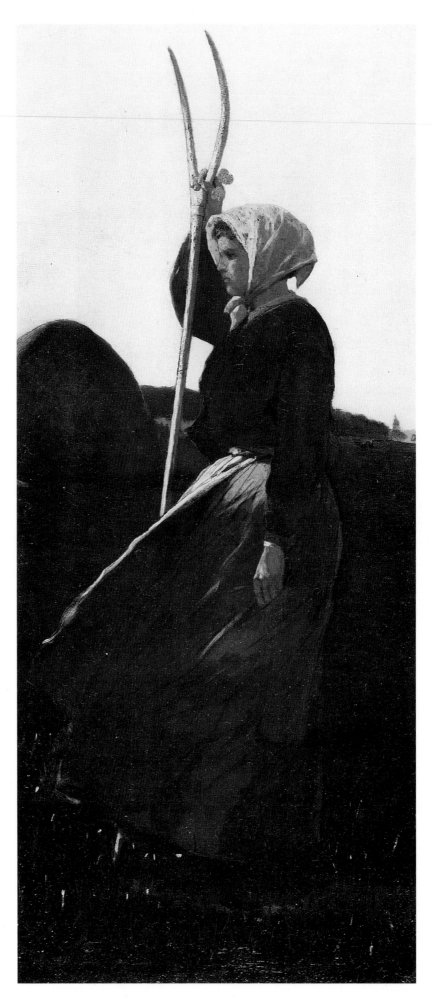

Girl with a Pitchfork

III. France

I N THE FALL OF 1866, *Prisoners from the Front* was one of the paintings chosen to represent the United States at the Exposition Universelle in Paris, and Homer evidently made that event the opportunity for his first trip to Europe. He spent ten months abroad, in Paris, and in the country at Cernay-la-Ville, an artists' colony where other French and American artists worked.

Little of what Homer did in France is known. Five years earlier his mother tried to raise money to enable him to go abroad "as he so desires to go for improvement." But when he was finally able to go he did not improve himself by study. He did not even paint very much; only somewhat more than a dozen French paintings are known, and they are mostly small ones. The illustrations of *Art Students and Copyists in the Louvre Gallery*, of *A Parisian Ball—Dancing at the Mabille*, and of *A Parisian Ball—Dancing at the Casino* that appeared in *Harper's* shortly after his return may suggest a little of what he did, and, if the ratio of their subjects are any guide, that he was more attracted by night life than art life. However, a contemporary guidebook to Paris, James McCabe's *Paris by Sunlight and Gaslight (1869)*, illustrated precisely the same subjects, and in much the same way that Homer illustrated them: *The Louvre Gallery* (with copyists), *Ball at Mabille*, and a scene of dancing at the Casino. This suggests, of course, that Homer's illustrations are of standard tourist attractions and not necessarily reliable guides to his own tastes and experiences.

It has been said that what Homer saw of French art was decisive for his artistic development—that while he was in France he encountered the advanced art of Courbet and Manet (both of whom held exhibitions of their work at the time of the Exposition), the French Impressionists, and Japanese art. Attractive as it is to suppose that a young American artist would see the merit of and align himself with the most advanced developments in French art, there is no convincing evidence that he did so. The style and subject matter of the paintings he made in France suggests, on the contrary, that Homer seems to have been more interested in the older art of Millet and the Barbizon school than in more recent developments; a painting like *Girl with Pitchfork* of 1867 is conceived wholly in terms of Millet's heroic vision of rural life. This was, moreover, just when other American artists like George Inness and William Morris Hunt, who had been decisively influenced by the Barbizon school, began to spread its influence in America; and when, too, American collectors were beginning actively to acquire Barbizon paintings. Homer, therefore, was far from alone in

Girl with a Pitchfork

1867. Oil on canvas, 24 x 10½"
The Phillips Collection, Washington

Homer painted only about a dozen small paintings in France during the ten months he spent there in 1866–1867. Nearly all of his French paintings depict rural life, painted when he lived in the country in the village of Cernay-la-Ville. But rural life was also the chief subject of the French Barbizon school, and the influence of one of its most famous members, Jean-François Millet, is unmistakable in the theme and style—the heroic scale and eternal fortitude—of Homer's figure.

29

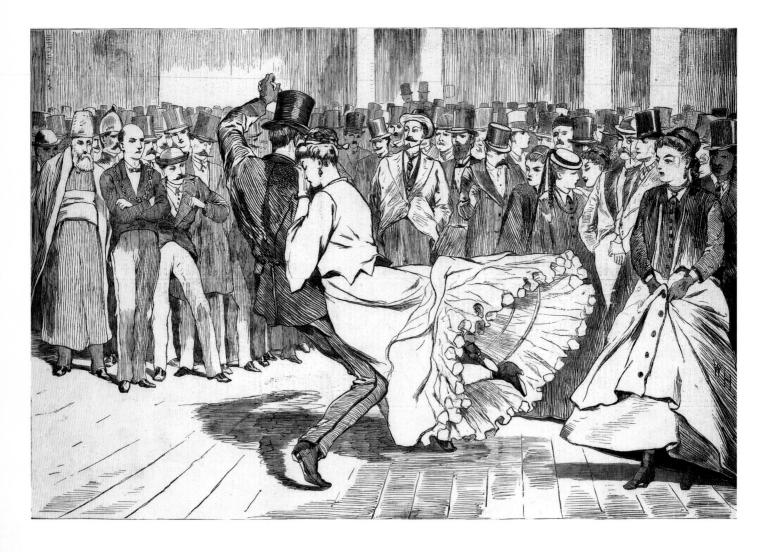

Above:

A Parisian Ball—Dancing at the Casino

Harper's Weekly, 23 November 1867.
Wood engraving, 9⅛ x 13¾″
National Gallery of Art, Washington

Right:

Unknown. *Scene at the Casino*

From James D. McCabe, Jr.,
Paris by Sunlight and Gaslight (Philadelphia, 1870)

The similarity of Homer's illustrations to those in a contemporary guide book to Paris suggest not only that his subjects were standard ones for foreign tourists, but that it was chiefly as a tourist that Homer himself went to Europe on his first visit.

Above:

Art Students and Copyists in the Louvre Gallery, Paris

Harper's Weekly, 11 January 1868.
Wood engraving, 9 x 13¾"
National Gallery of Art, Washington

Left:

Unknown. *The Louvre Gallery*

From James D. McCabe, Jr.,
Paris by Sunlight and Gaslight (Philadelphia, 1870)

his interest in Barbizon art and, what is more, may have formed that interest even before going to France (although it was visible only in his French paintings), at a time when, for American artists, Barbizon art was the most advanced language of style available.

The belief that Homer was influenced by the most modern French art is based chiefly on the assumption that no alert and ambitious young artist could have neglected it, particularly when, in the late 1860s, its claims, in the form of the exhibitions by Courbet and Manet, were so assertive. But serious American artists were not as a rule irresistibly drawn to advanced French art. Thomas Eakins, Homer's younger contemporary, was a student in Paris just the time Homer was there; from Eakins's letters to his family we know a great deal about what interested him in Paris, but he said nothing at all about newer French art.

Homer's style after his return from France suggests, particularly in the rendering of the effects of directly observed light, that he was influenced by the methods and appearance of early Impressionism. Yet it had been Homer's practice to paint out of doors well before he went to France, so it cannot have been Impressionism—even in the improbable event that he knew of it—that introduced Homer to the practice of open-air painting. It had been a central part of his artistic method virtually from his beginnings as a painter.

A description of Homer in France and a very early—and very rare—description of his artistic character may have been given by his friend, the artist and critic Eugene Benson. (Homer and Benson both had studios in the New York University Building, and they held a joint exhibition of their work in New York before both of them went to France in 1866.) It is found in a story entitled "Substance and Shadow," published in *Putnam's Magazine* in 1869, and which, although Benson subtitled it "A Fantasy," is too strongly flavored with reality to be purely imaginary. In it, Benson described an American artist friend called Lawrence, who, like Homer, was visiting France. The author visited Lawrence in the country, at a place that could be Cernay-la-Ville (where Homer worked), and he told how the artist was "hopeful about painting a certain peasant-girl he had noticed raking hay," which is a subject that Homer painted more than once. If Benson's Lawrence was based on Homer (and like Homer, too, Lawrence was a man of few words) then Benson's description of him is interesting: "He used his eyes, his feet, and his hands.... The present was to him the good or bad moment to do his work.... I respected him as I respected the Multiplication-Table, in which is no shadow of uncertainty or any possibility of caprice."

Return of the Gleaner

1867. Oil on canvas, 24⅛ x 18⅛"
The Strong Museum, Rochester, New York

In his story "Substance and Shadow," published in Putnam's Magazine *in 1869, Eugene Benson described a visit to an American artist in France who was drawn to such subjects as a peasant girl raking hay. The artist in Benson's story may well have been modeled after Homer.*

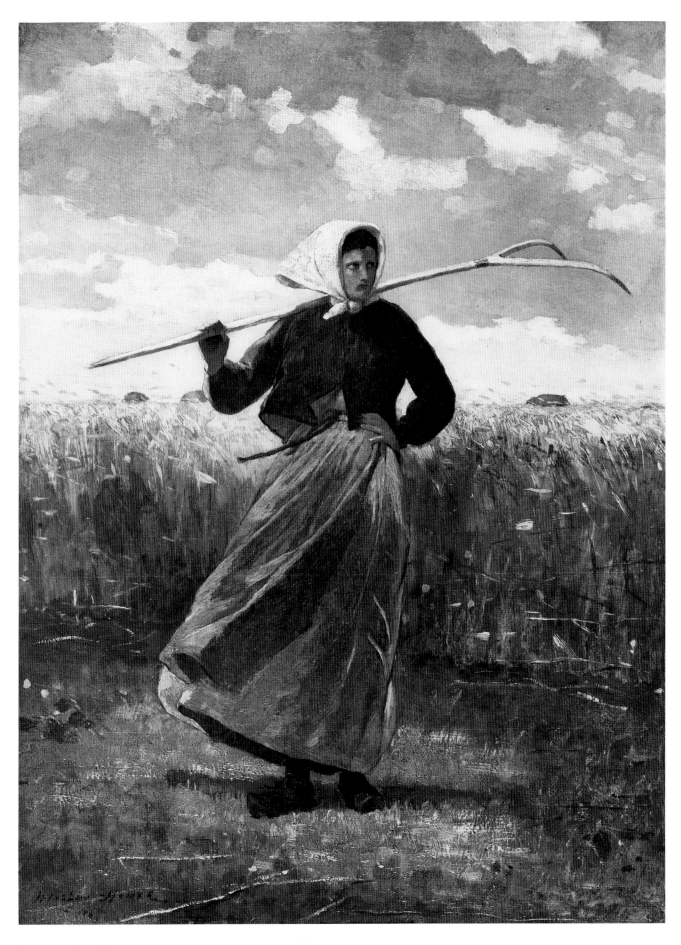

Return of the Gleaner

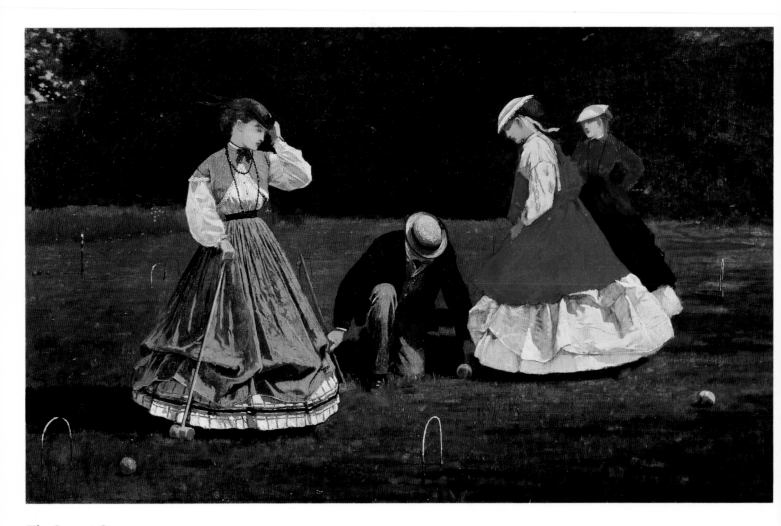

The Croquet Game

IV. An Original Form of Art Speech

I F HOMER'S EXPERIENCES IN FRANCE WERE LIMITED and without the influence that has been claimed for them, that may not be because he lacked curiosity, but because, as Benson's description suggests (if it is a description of Homer), he had by the time he got to France an already formed and certain sense of artistic purpose.

Homer could not have been artistically innocent when he went abroad. In the 1860s there was an unprecedented abundance of foreign art in New York. As a newspaper writer said in 1865, "Every picture-store is crowded, and every window, adorned or disfigured with paintings, is surrounded with a constantly changing procession of eager worshippers at the shrine," and "Every palatial residence has its gems..." At picture dealers, auction sales, exhibitions, in numerous private collections, and widely and frequently discussed in the press, was the work—often the very recent work—of every important European artist of the time (at least as the time itself reckoned their importance): Bonheur, Bouguereau, Breton, Corot, Couture, Daubigny, Decamps, Delaroche, Detaille, Dupré, Frère, Gérôme, Meissonier, Millet, Rousseau, Troyon, and many, many others. As Eugene Benson said at the end of the decade, "we have nourished, if we have not satiated ourselves with, . . . the unstinted importation of our best picture dealers . . . and, without crossing the ocean, have been able to see the elegant and correct and spirited work of men who are masters of the best methods of painting."

Yet no matter what Homer saw, either in America or later in France, nothing about his early style irresistibly, unambiguously, or consistently suggests the work of any other artist. His paintings simply do not resemble the paintings of any other artist so clearly and compellingly that the appearance of their style can be, or need be, explained by the influence of other art. On the contrary, what is ultimately most striking about Homer's early paintings is the absence from them of features of style that can be traced to the causative operations of influence.

Absence of discernible influence is so pronounced, so rigorous, and so complete that it suggests deliberate exclusion. Homer did, in fact, disavow any and all influence. While still an apprentice at Bufford's he said, "If a man wants to be an artist, he must never look at pictures," and his references to other artists disclaim rather than declare relationships; he intended, he said, to paint a damn sight better than Frère. And in the closest thing we have to an authorized biographical statement from Homer, he endorsed the view that, "He works...in

The Croquet Game

1866. Oil on canvas, 15⅞ x 26¹⁄₁₆"
The Art Institute of Chicago.
Gift of Friends of American Art

Four distinctive aspects of Homer's early, postwar art are represented in this painting: modern subjects (such as current fads and fashions of contemporary life, in this case the popular game of croquet newly introduced to America); women who are, despite their fashionable clothes, independent, self-reliant, and often athletic; figures, studied out-of-doors, depicted in bright, natural light; and the depiction of the same subject in a sequence of images, and in various mediums (the subject of croquet appears in five paintings, two engravings, and two drawings).

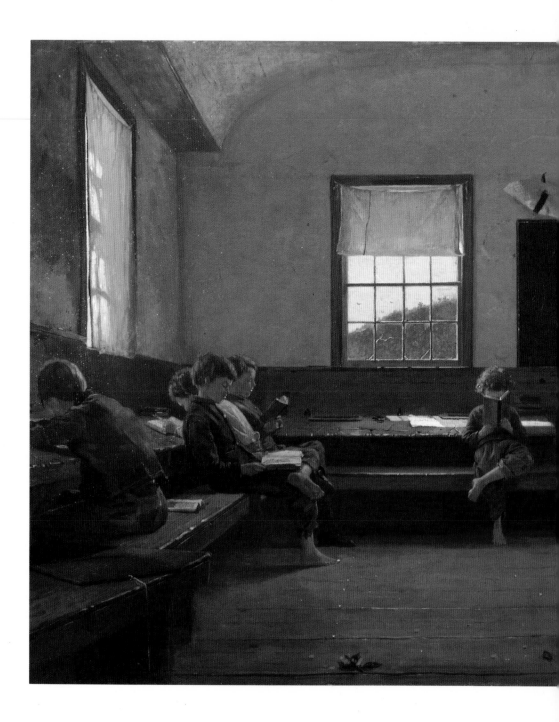

utter independence of schools and masters. His method is entirely his own." That cannot be literally so, of course; no artist can be wholly independent and exempt from influence. But what Homer may have been describing was not so much his actual artistic practice as his artistic principles, that is to say, not so much what he actually did as what he believed, not so much his behavior as his ideals and theoretical posture.

Homer never expressed himself theoretically, and there is not the slightest indication that he aspired to be a disciplined thinker. But Homer's arrival in New York coincided with a newly articulate artistic consciousness there. New York in the 1860s was not only filled with art; it was charged with heated artistic debate. Never before (and seldom since) had issues of art been as widely and as

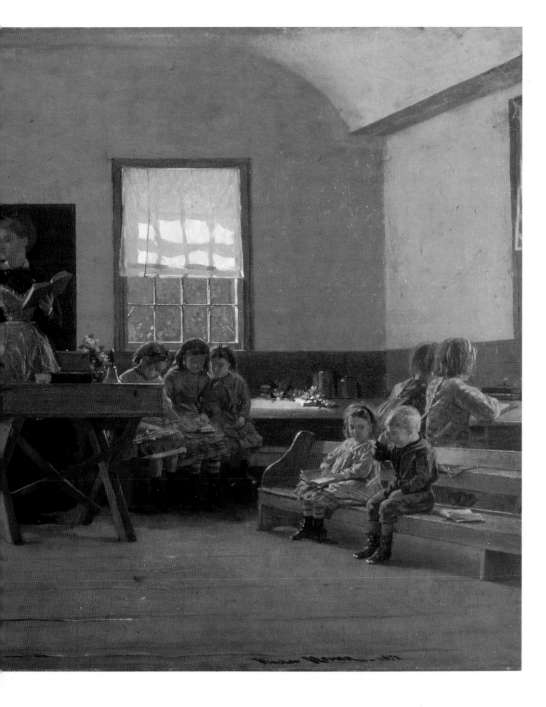

The Country School

1871. Oil on canvas, 21⅜ x 38⅜"
The Saint Louis Art Museum

*This is one of a series of school subjects
(Snap the Whip was another) that Homer
made in the early 1870s. Critics and pub-
lic alike found it irresistible—"altogether
admirable," the New York Tribune
thought; "altogether charming," said the
Express, "with a simplicity and directness
that are very delightful." "It is interesting
to observe the visitors at the Academy and
the delight with which they, one and all,
cultured and uncultured, take in the
'Country School,'" the Telegraph's critic
said of the painting's democratic appeal.
A "picture thoroughly national," said the
Express. "Mr. Homer has shown us
here…a thorough acquaintance with
our life as a people."*

intelligently discussed, never had artistic positions been as clearly drawn, as
fiercely partisan, or as openly and acrimoniously disputed. New York was seeth-
ing with artistic reform and zealous innovation. Older American artists—the
landscape painters soon to be derided as the Hudson River School—were criti-
cized as tiresomely conventional, "inert and moribund," while the adherents of
newer art who strove to replace them, the artistic and critical followers respec-
tively of the English Pre-Raphaelites and the French Barbizon school, occupied
diametrically different artistic positions, from which they attacked each other
with undisguised antipathy. Contemporaries used words like "strife," "stress,"
and "struggle" to describe this climate of artistic agitation, reform, and debate. It
was so intense, so highly charged, that it touched even those who did not actively

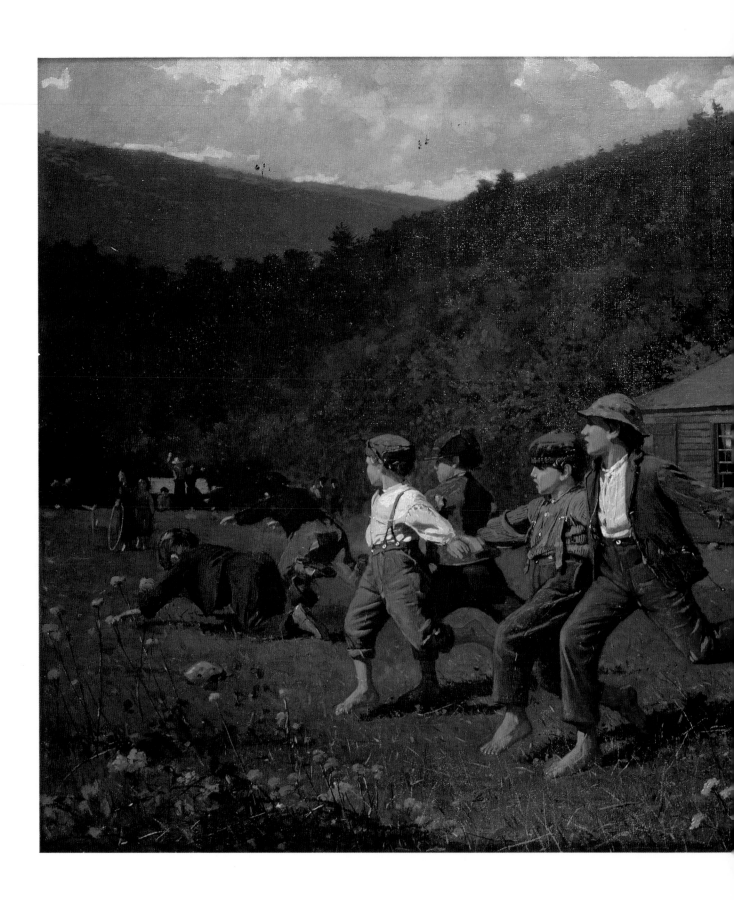

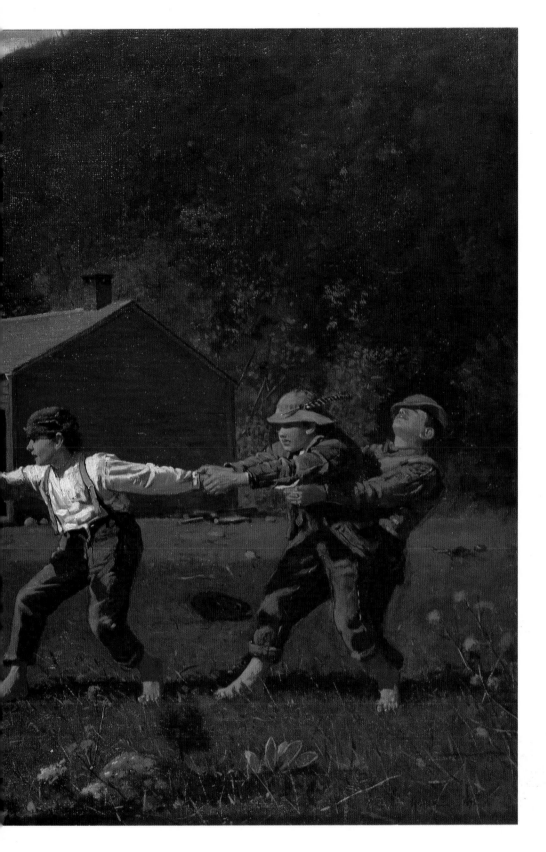

Snap the Whip

1872. Oil on canvas, 22¼ x 36½″
The Butler Institute of American Art,
Youngstown, Ohio

A group of boys, freed from the confinement of school (the same one, seen here from the outside, depicted in The Country School*), play an energetic game of snap the whip. Its nine figures in a friezelike arrangement of widely differing states of arrested instantaneous action make this one of Homer's most ambitiously conceived early paintings. Although it is a convincing image of rural life and landscape, a reporter for the* New York Evening Telegram *who visited Homer's New York studio in the summer of 1872 when he was beginning work on it said his "models for the childish games he intends to play in oil" in* Snap the Whip *were city children, "the idle gamins of the street."*

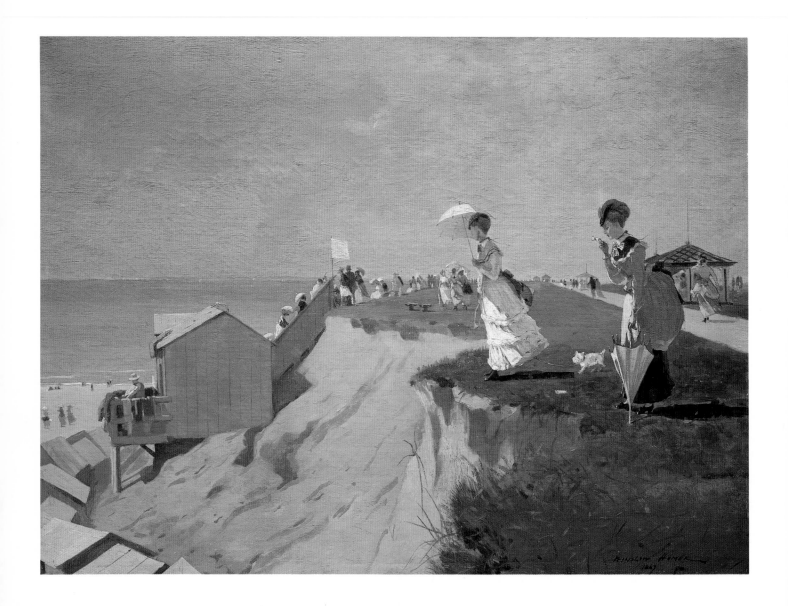

Long Branch, New Jersey

1869. Oil on canvas, 16 x 21¾″
Museum of Fine Arts, Boston.
The Hayden Collection

Contemporary observers found in the newly popular summer resort at Long Branch a specimen of the character and composition of American society. An article in Appleton's Journal *in 1869, accompanying Homer's engraving "The Beach at Long Branch," said it was "an epitome of the entire country" and "the representative 'sea-shore' of the nation." Some admired the informality and demo-cratic pluralism of Long Branch: "You dress as you please, talk with whom you please, and select your own society.... Representatives of all classes are to be met, ... and all are on an easy level of tempo-rary equality," a writer in the* New York Evening Post *said in 1868. For others, however, like a writer in* Every Saturday, *it was "sensuous, crass, and earthy," vul-gar, dissipated, and immoral.*

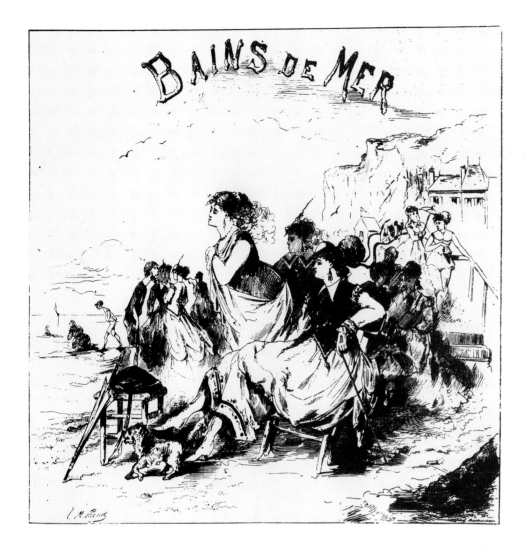

Valerie Morland, *Bains de Mer*

L'Image, 18 August 1867.
Wood engraving

The similarity of the women behaving with blatant wantonness in this contemporary French illustration to those in Long Branch, New Jersey—*particularly the one at the right dressed in the extravagant costume of the demimonde—is an indication of their common social role, and a comment on the sensuousness and earthiness of Long Branch and one aspect of its social mixture.*

participate in it; as one observer wrote in 1866, "it is almost impossible to maintain a position of lofty neutrality." Homer's early development, in other words, took place in a climate thick with theoretical discussion and vigorously expressed ideas. That Homer was touched by the excited temper and elevated temperature of his time is suggested by the observation, made by one of his most perceptive interpreters, that "impatience, irritability [and] striving after the unknown is written upon all of his works."

Homer's early years in New York were his worldliest, when he most closely associated with other artists. He worked in the centers of New York's artistic life, the University Building and the Tenth Street Studio, and had enough friends almost to constitute a "circle." Those we know of in the 1860s and 1870s were John La Farge, Homer Martin, Eastman Johnson, Roswell Shurtleff, Enoch Wood Perry, William Page, and Eugene Benson. In certain ways Benson was the most interesting of Homer's friends because of all of them he was at the time of their friendship the most articulate. Benson was a painter of modest ability whose style and subject matter had a certain congruence with Homer's. But he was much more important as a critic. He wrote for the *New York Evening Post* (using the nom-de-plume "Sordello") and was one of the important contribu-

tors to the artistic debate of the 1860s, very much on the side of French art. A prolific essayist on a wide range of topics, he was thoughtful, literate, diversely learned, and up-to-date. The presence of someone as alert and articulate in Homer's circle in the 1860s is interesting because it suggests Homer's access to a resource of ideas and of literary and artistic culture that we have not supposed to be a part of his experience. For among Benson's ideas were ones that can perhaps shed light upon what is otherwise the unclear and inadequately explained nature of Homer's artistic undertaking.

Benson was a journalist, not a theorist. He expressed his artistic ideas haphazardly and sometimes contradictorily, as opportunity allowed. But it is possible nevertheless to deduce something like an artistic program from Benson's writing.

What Benson talked about (when he talked about art) were things like modernity, democracy, and nationality. Modernity was the essential principle of Benson's program for an American art. "Modern art as it must be developed in America...is free from tradition,...based wholly on the common life of the democratic man, who develops his own being on a free soil, and in the midst of a vast country." Modernity was inseparable from nationality. Benson wrote approvingly (with Homer, significantly, as one of his chief examples) of "the idea of producing purely American pictures from home subjects alone," and, addressing the issue of national style (with Homer again as an example), of "painters who would rather stutter in a language of their own...than impose upon themselves the fetters of what is acquired and foreign." Benson developed his artistic program even more fully in his literary criticism, to the extent that in 1868, at a time when the possibility of an American national literature was under serious public discussion, he was linked with the most conspicuous (and for many people notorious) representative of literary nationality, the poet Walt Whitman, as one of the "persons who declare that they crave a literature that shall be truly American...."

To find Homer in the presence of ideas such as these, and particularly to find issues of modernity, nationality, and democracy occupying a significant place in Homer's circle in the 1860s provides a new understanding of his early development. It makes that development not a matter simply of intuited decision, but a more purposive formulation of stylistic language and determined choice of subject matter; and a development influenced not so much by what Homer may have seen of other art as by what he thought and believed (for one of the things he believed was that artists "should never look at pictures," but ought instead, as Benson put it, "stutter in a language of their own.")

If Homer's purpose resembled Benson's program, that purpose consisted of the making of a modern, national, and democratic art, derived from native materials and formed in a native language of style. The operation of such a program is particularly clear in Homer's choice of subjects: He depicted ordinary people in commonplace acts and places—the "actual life of men and women in the nineteenth century." But certain of his subjects seem to demonstrate those properties with an almost ideological edge.

The Morning Bell

c. 1872. Oil on canvas, 24 x 38¼"
Yale University Art Gallery,
New Haven, Connecticut.
Gift of Stephen Carlton Clark

The woman teacher in The Country School *and certain other of Homer's school paintings marked an important sociological event. The "capture of the common school" by women teachers was, a writer said in 1872, "one of the most vital social changes wrought by our great civil war" as "our schoolmasters went off to the war and never came home."* The Morning Bell, *painted at about the same time, depicts a similarly profound social transformation. In a splash of early morning sunlight a young woman, between the group of women behind her dressed in rustic clothing and the factory building to which she walks summoned by the pealing bell on its roof, is poised—somewhat uncertainly on a makeshift wooden ramp—between the pastoral past and the industrial present. A writer in the* New York Evening Post *in 1872 believed that the style of* The Morning Bell *was influenced by "the hard lines and mosaic effect of a Japanese design."*

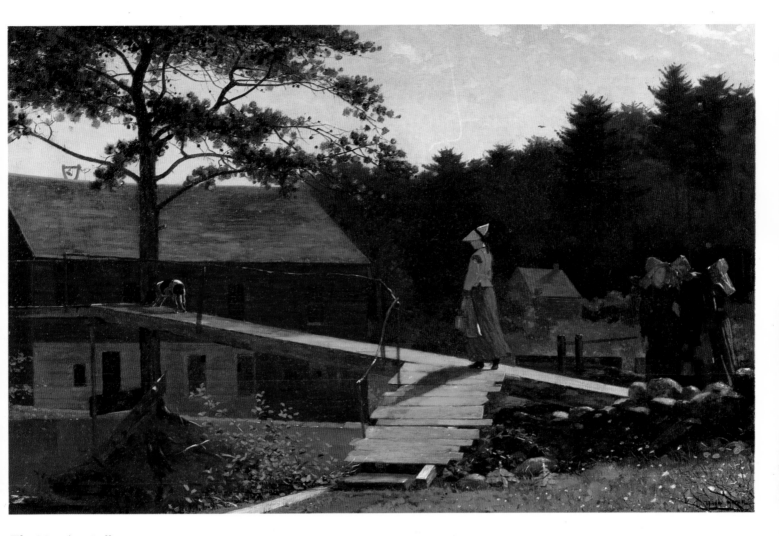

The Morning Bell

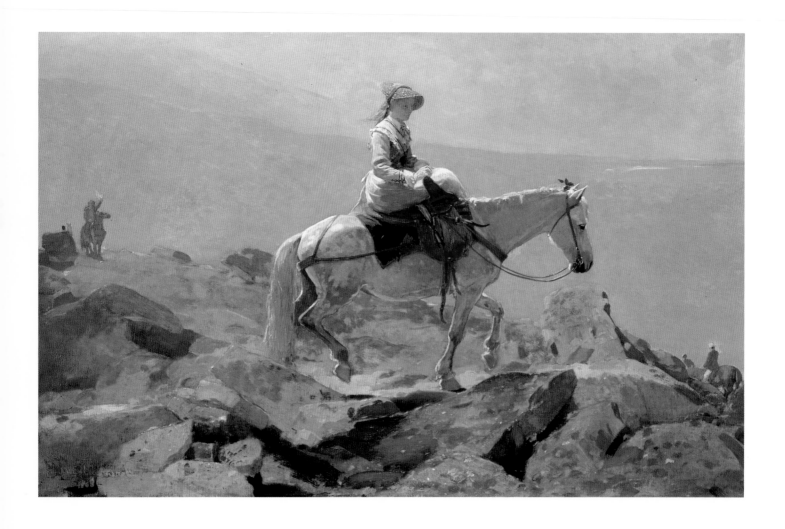

The Bridle Path, White Mountains

1868. Oil on canvas, 24⅛ x 38″
Sterling and Francine Clark Art Institute,
Williamstown, Massachusetts

This was one of the first American subjects that Homer exhibited after his return from Europe in 1867. In 1868, a writer in the New York World *(who mistook it for a European subject) thought it "a rather eccentric picture." But the writer for* Putnam's Magazine *who saw it two years later admired its Americanness: "Here is no faded, trite, flavorless figure, as if from English illustrated magazines; but an American girl out-of-doors, by an American artist with American characteristics—a picture by a man who goes direct to his subject, sees its large and obvious relations, and works to express them, untroubled by the past and without thinking too curiously of the present. Mr. Homer is a positive, a real, a natural painter."*

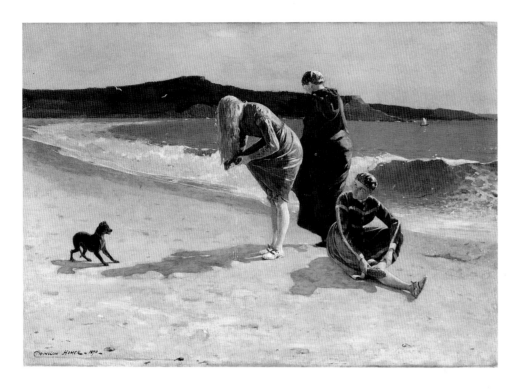

Eagle's Head, Manchester, Massachusetts

1870. Oil on canvas, 26 x 38"
The Metropolitan Museum of Art, New York.
Gift of Mrs. William F. Milton, 1923

Homer's paintings were frequently criticized for their lack of finish. In the works he showed in the 1870 exhibition of the National Academy of Design (eleven altogether including this painting, often wrongly entitled High Tide, *and* The Bridle Path, White Mountains), *his critics seemed to sense that Homer's style was a deliberately chosen, assertively individual, and innovative language of expression, not a result of youthful inexperience or lack of training. The* New York World's *critic spoke of their "perverse originality," the* Tribune's *of "earnestness, a defiance of convention, a disregard of fashionable precedent," adding, "He is a reformer, and a brave one." In 1877, the critic of the* World *wrote, "Looking back at his crudest days we are half inclined to think that even then what we mistook for crudity was partly—not altogether certainly—a youthful disregard of conventionality, rather unduly emphasized, a rather forcible as well as frank assertion of individuality."*

For example, Homer's Civil War paintings do not depict heroic moments or the formalities of warfare but almost without exception ordinary events in the lives of individual soldiers. The principal figure in *Prisoners from the Front,* General Barlow, was not a professional soldier but enlisted as a private and through ability and bravery rapidly rose to general rank. For this reason, as well as for his well-known uprightness and heroism, he was the representative type of an officer in the army of a democratic republic. That is exactly the role in which Homer cast Barlow, made explicit by the contrast—the painting's ruling contrast—with the aristocratic Confederate officer.

Homer's post-Civil War paintings were tinctured with modernity and democracy. His croquet paintings of 1866 and after reflect the popularity of a sport newly introduced into America. It was popular because it provided healthful recreation and opportunities for romantic dalliance. But its special feature was sexual equality. It was a game that, competing with men, women could win; and in Homer's paintings women are the larger, dominant figures.

Walt Whitman, who spoke of women in democracy as the "robust equals" of men, described the traits of their equality almost as they appear in Homer's art, such as *Eagle's Head, Manchester, Massachusetts* (1870) and *The Bridle Path, White Mountains* (1868). As Whitman wrote in *Leaves of Grass*:

> *They know how to swim, row, ride, wrestle, shoot, run...*
> *They are ultimate in their own right—they are calm,*
> *clear, well possess'd of themselves.*

Homer depicted Long Branch, New Jersey, several times beginning in 1869. Long Branch was a newly fashionable summer resort. Homer depicted it

not only because it was popular, however, but because it was, in a way that some found vulgar, America's most democratic resort: "Long Branch...is perhaps better in accord with the spirit of American institutions than any other of our watering-places. It is more republican...because within its bounds the extremes of our life meet more freely."

Public schools, which Homer began depicting almost serially in the early 1870s in paintings such as *The Country School* (1871) and *Snap the Whip* (1872), were the cornerstones of American democratic civilization, "as vital to our political system," a writer said in 1870, "as air to the human frame."

The series of paintings of blacks which resulted from a trip (or trips) to Petersburg, Virginia in the mid-1870s—*The Cotton Pickers* (1876) and *Dressing for the Carnival* (1877), for example, or *A Visit from the Old Mistress* (1876) and *Sunday Morning in Virginia* (1877; Cincinnati Art Museum)—are perhaps Homer's most explicitly democratic subjects. He acknowledged their significance as specifically American works by choosing two of them (*A Visit from the Old Mistress* and *Sunday Morning in Virginia*), with two of his school subjects, to represent his country in the Paris Exposition of 1878. And in the dignity, unpatronizing sympathy, and sensitive understanding by which he represented black life and culture and the new social order of emancipation there is an unmistakable element of belief on Homer's part, on the plane of political conviction and social policy, in the rightness of what was ultimately the most profound and most principled achievement of the Civil War: the destruction of slavery. Made precisely when the gains of blacks under Reconstruction were being reversed and when (in 1876) Reconstruction itself was effectively ended, their meaning was all the more pointed and principled. These would be the last of this type of painting that Homer made.

Nothing bothered Homer's critics, even his many friendly critics, quite as much as his painting style. They found it incomplete and incoherent, unacceptably broad and too freely suggestive ("slapdash," "coarse," and "careless" were words they used to describe it). Year after year they pleaded with Homer to make more conventionally finished pictures, but despite the advice of his critics he always kept his style unpolished and unresolved. Taste, temperament, and training naturally affected Homer's style, as they do the style of every artist, in ways that he was perhaps not aware of and could not control. But his style, like his subject matter, may have been purposefully shaped by considerations of modernity, nationality, and democracy into, as one of his most discerning critics described it, an "original form of art speech." A similarly deliberate incompleteness of form was also a purposeful part of Walt Whitman's democratic literary style—a style not "correct, regular, familiar with precedents, made for matters of outside propriety, fine words, thoughts definitely told out," as Whitman wrote in *Democratic Vistas* (1871), but a style rather that "tallies life and character, and seldomer tells a thing than suggests...it." It is not likely that Whitman actually influenced Homer, although what one might call Whitmanism was represented in Homer's circle by Eugene Benson, and although later critics would see in both Homer

The Cotton Pickers

1876. Oil on canvas, 24¹/₁₆ x 38¹/₈″
Los Angeles County Museum of Art

In 1878, George W. Sheldon wrote in the Art Journal *that Homer's "negro studies, recently brought from Virginia, are in several respects—in their total freedom from conventionalism and mannerism, in their strong look of life, and in their sensitive feeling for character—the most successful things of the kind that this country has yet produced." In 1880, the critic of* The Art Amateur *said Homer's paintings of blacks show a "depth of observation and philosophy, making his canvases so many authentic documents.... The reason is, that he observed [their] manners with the enthusiasm of a historian and man of imagination."*

AN ORIGINAL FORM OF ART SPEECH

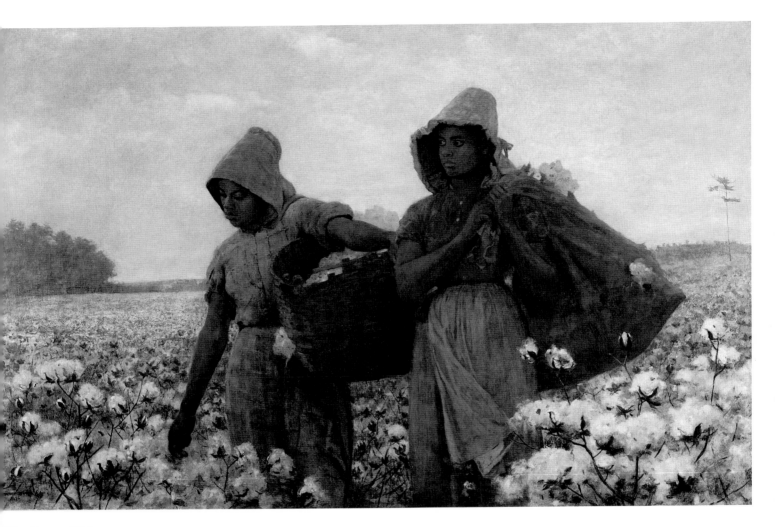

The Cotton Pickers

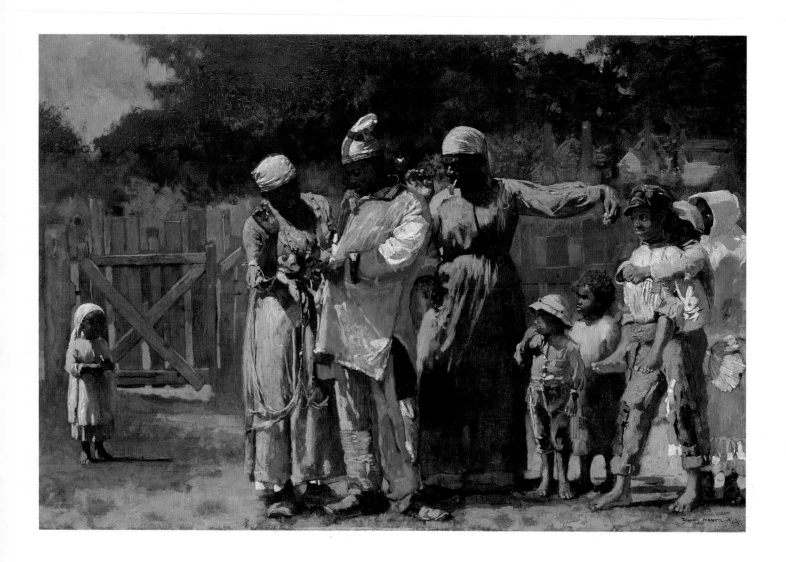

Dressing for the Carnival

1877. Oil on canvas, 20 x 30"
The Metrpolitan Museum of Art, New York.
Amelia B. Lazarus Fund, 1922

Rather than depicting "the color and gaiety" of black life, as a recent commentator has put it, Homer expresses its confused identity and essential tragedy. These figures dressed for a carnival—the older man as Harlequin in the European commedia dell'arte tradition, but, like the taller boy, with torn strips of cloth that derive from the African ceremonial dress (and which survives today in the costume of Caribbean Jonkonnu dancers)—and the two boys who hold American flags, all describe the complexity of its uprooted culture. The figure as Harlequin—the clown, the social outcast—is the symbol of its marginality and alienation.

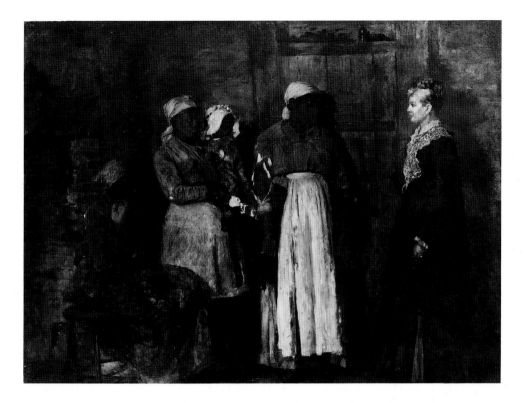

A Visit from the Old Mistress

1876. Oil on canvas, 18 x 24⅛"
National Museum of American Art,
Smithsonian Institution, Washington.
Gift of William T. Evans

A summary, analytical description of the sociological and psychological legacy of slavery and the uncertainties of freedom, painted ironically in the year Reconstruction and the efforts made during it to improve the political and social conditions of blacks was effectively abandoned. It is an historical subject, and perhaps for that reason Homer borrowed the format of his most important historical painting, Prisoners from the Front, *one that commemorated the beginning of the historical episode of which this work marks the end.*

and Whitman, as one of them said in 1883, "the same rude virility and independence, with the same disregard for conventional forms." But like Whitman, Homer rejected conventional artistic precedent with its propriety, correctness, and fineness. Instead of things—objects and their compositional arrangements—being "definitely told out" in his art, Homer developed a style of openness and suggestiveness of form in order to "tally" the unprecedentedly new forms and always shifting, unresolved and perhaps never wholly resolvable formations of American democratic life. It was a style that was in its rudeness and coarseness, as one critic put it, "wholly in sympathy with the rude and uncouth conditions of American life." It was a style, too, that in its lack of refinement and polished resolution, its roughness and terse simplicity, corresponded exactly to the qualities that Eugene Benson thought of as particularly American.

In its lack of finish and incompleteness, in other words, Homer's was a national style, one deliberately adapted by him to the description of American democratic life—at a moment, we should perhaps remember, when American democracy seemed to many, like Whitman, to have been specially confirmed and consolidated by the successful conduct and outcome of the Civil War. But for Eugene Benson, nationality and modernity were inseparable conditions, and they seem similarly joined together in the function and appearance of Homer's style—just as many of his national subjects, like croquet, or Long Branch, or the newly independent woman who figures so prominently in Homer's imagery were at the same time explicitly modern ones. In a famous essay, *The Painter of Modern Life*, written about 1860, the French poet and critic Charles Baudelaire (of whom Benson knew and about whom he wrote) described modernity as "the ephemeral, the fugitive, the contingent, . . . [the] tran-

sitory." Those were the qualities, too, that Homer's French contemporaries Degas, Manet, and the Impressionists were, at about the same time, concerned to capture and convey in their respective languages of style. It may also have been the concern of Homer's style to capture or to signify in its appearance the contigency and transitoriness of modern experience.

Homer's style took the form it did, therefore, to convey certain properties of meaning: to be national, and to be modern. But his style took the form it did for still another reason: to capture the brilliance and movement—that is, the fugitive and transitory effects—of natural light, as in *The Dinner Horn* of 1870. Painting out of doors was a well known part of Homer's artistic method. As early as 1864, at the very outset of his career as a painter, a critic who had access to Homer and watched him paint reported that if one wanted to see him work one had to go out on the roof of his studio and "find him painting what he sees," and many years later Homer said, "I prefer every time a picture composed and painted out-doors." Now Homer was on the whole extremely private. He seldom allowed people to watch him work, and spoke very little about his way of working. But one thing that he did talk about, one thing he did allow to be known, was his practice of painting out of doors. At the middle of the nineteenth century, painting out of doors was not at all the self-evident and even mandatory thing to do that Impressionism made it seem later on. Homer painted out of doors not because it was a firmly established method, but precisely because it was not. He realized that painting out of doors meant something. He was so open about it, wanting it known that it was his method (when in fact it was never a method he followed rigorously or consistently, even in the execution of particular paintings), because he understood it not as a private inclination but as a public issue—understood that it was a modern method, one with currency among modern painters (Mallarmé, writing about Manet in 1876, said "the open air…influences all modern artistic thought.") But also, and perhaps more importantly, painting outdoors and relying on visual experience, on direct sensation, was a strategy of originality, a way of making art new by evading both the traditions of the past and the influences of the present, a way of avoiding custom and fashion by turning to essentials. As a critic wrote of Homer's watercolors in 1879 (with an interesting echo of Whitman's diction), "they bear unmistakable marks of having been made outdoors in the summer and the sunlight. Their style is large and bold, free and strong, the style of a lusty and independent American who goes out to nature…unaided by precedent.…" When in 1875, in the most perceptive early criticism of Homer's art, Henry James called his style "barbarously simple," perhaps he was not merely using an empty phrase or a figure of speech but was on the contrary very precisely describing Homer's strategy of renovation and its visible stylistic consequences as a kind of primitivist return—of which there were so many episodes in the history of modern art— to experience unmediated either by the precedents of tradition or the precepts of convention. The modernity of this artistic strategy is suggested by Baudelaire's observation that "childlike barbarousness" was a condition of modern style.

The Dinner Horn

1870. Oil on canvas, 19⅛ x 13⅝″
Mr. and Mrs. Paul Mellon, Upperville, Virginia

"Judging from his pictures," a correspondent of the Boston Transcript *wrote in 1873, thinking of paintings like this one (which is reproduced in color as the frontispiece), "one might fancy Mr. Winslow Homer to be the most happy of men, full of sentiment, loving the sunshine and the flowers. He often paints women, plump and rustic, standing amid wild flowers.… He indulges in broad patches of light and shade, and seems to seek for all the quiet, cool, restful spots there are to be found in apple orchards, on side hills, or by the sea shore." But Homer's temperament was apparently not as sunny as his paintings. "He is a nervous, thin-looking man, with restless black eyes, and a countenance full of the expression of apprehension.… How ever he can paint such poetical pictures is past our finding out."*

AN ORIGINAL FORM OF ART SPEECH

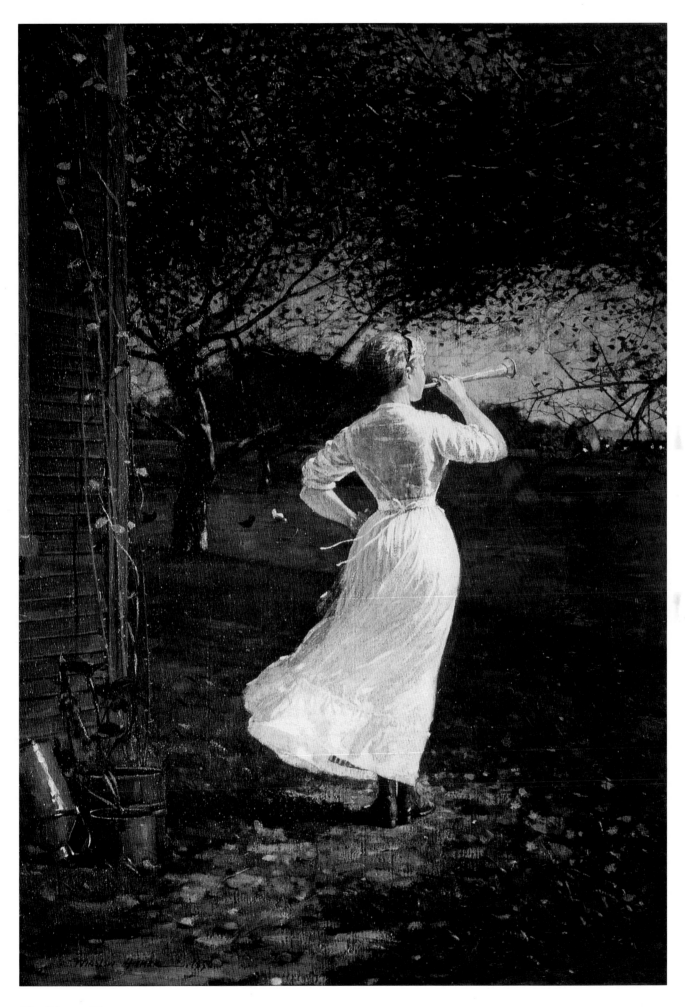

The Dinner Horn

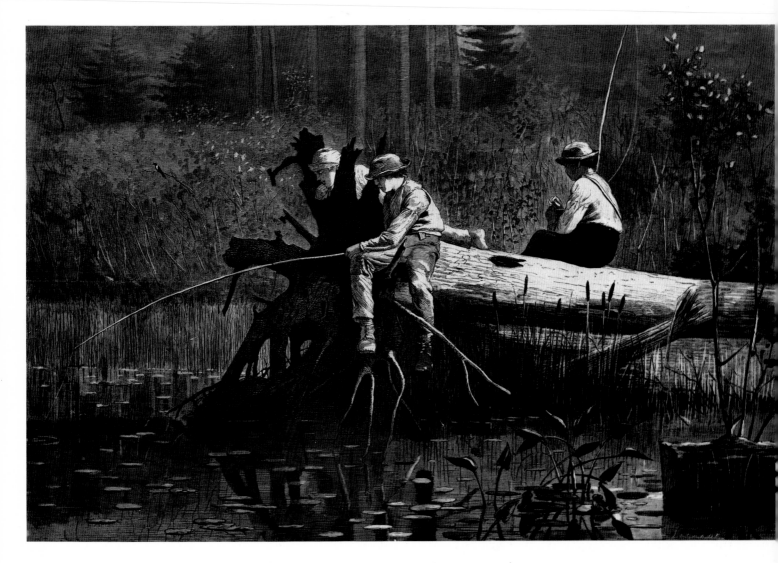

Waiting for a Bite

V. Crisis

THE APPEARANCE OF HOMER'S EARLY STYLE, so far as his critics were concerned, remained essentially unchanged from the early 1860s until about 1880, when, as we shall see, it underwent a wholesale revision; they continued to complain about its lack of proper finish (its "indistinct crudeness," as one critic put it in 1879). But in the 1870s Homer's art changed in practice and shifted in its premises in several important ways.

One was a change of medium. In the summer of 1873, at Gloucester, Massachusetts, he began seriously to paint in watercolors, adding to his artistic means a medium he had used only occasionally and hesitantly earlier but which he would use with unrivalled understanding and brilliance for the rest of his life, to the degree that he became its greatest master in the history of American art. Homer's early watercolors do not have the extraordinary fluency and utter confidence of his later ones—the ones that defined with a kind of absolute authority the possibilities of the watercolor medium—but they were never, at the same time, merely tentative. Homer had the same immediate, untutored, seemingly instinctive command of watercolor that, ten years earlier, he had when he began to paint in oils. It is often said that watercolor requires in its making and displays in its results an irrevocable rapidity and directness. It is true that Homer took advantage of that property of the medium; some of his late watercolors, particularly, are definitive in that respect. But he was not a technical purist. His early watercolors range from ones that are little more than colored drawings, through others more freely brushed that use the fluidity and transparency of pigment, to ones that have the density and opacity of oil paint. What is more, Homer did not hesitate to alter his watercolors after they were first painted in the same way that he often changed his oil paintings, removing details and sometimes whole passages, and editing formats.

In 1875, two years after he made his first watercolors, Homer ended his career as a commercial illustrator. He began his independent professional life as an illustrator and had relied upon his illustrations, as he could not on his oil paintings, for his livelihood. Homer was far and away the best illustrator of his time, the most acute observer of life and the best inventor and designer of images of the many artists who supplied the illustrated magazines. But the life of an illustrator never satisfied him. The painter John F. Weir, who knew Homer in the early 1870s when they were both tenants of the Tenth Street Studio Building in New York, remembered that "he was then drawing for *Harper's Weekly*, and struggling to get out of it to take up more important work." Perhaps

Waiting for a Bite

Harper's Weekly, 22 August 1874.
Wood engraving, 9⅛ x 13¾"
National Gallery of Art, Washington

With its clarity and subtlety of design this is an exceptionally fine example of Homer's graphic sensibility. Related as it is to two watercolors and an oil, none exactly similar, it exemplifies also Homer's practice in the 1870s of exploring subjects in different mediums.

The Berry Pickers

1873. Watercolor and gouache
over graphite, 9⅜ x 13⅝″
Mr. and Mrs. Paul Mellon, Upperville, Virginia

Except for some scattered attempts earlier, Homer made his first watercolors in the summer of 1873 at Gloucester, Massachusetts. Exhibited the following year, they were immensely popular. "Superb in strength, brilliancy, vigor, and suggestiveness," the critic of the New York Evening Mail wrote. The New York Daily Graphic, describing the immediacy of their effects of light and air, said they were "realistic to the utmost verge of realism" and presented "the most vibrant contrasts of light and shadow."

Homer never forgot the "slavery" of his apprenticeship at Bufford's. Perhaps, despite the considerable and carefully guarded freedom he had as a free-lance illustrator, particularly for *Harper's Weekly* which allowed him on the whole to choose his own subjects, there was in the very collaborative nature of illustration—the relationship between the artist and publishers, editors, authors, and engravers—an inevitable and disagreeable constraint. Or perhaps Homer had a hierarchical understanding of artistic mediums. If he had a hateful memory of Bufford's, he also had a pleasant recollection of a picture gallery, not for what he saw in it (he did not mention that), but for the unforgettable smell of paint. He not only felt the contrast between the lowly drudgery of the illustrator and the more romantic life of the painter, but seems also to have been aware of painting as a higher form of artistic undertaking than illustration—greater in its range and almost sensually richer and more compelling in both its means of expression and in the nature of their appeal, and more profound in its meanings. In virtually every case where there is a painting and an engraving of the same subject, the painting preceded the print; it was, in other words, within the more inventive medium of painting, not in the imitative form of the print, that his imagery was formed. As soon as he could support himself by painting alone, as the favorable reception of his watercolors gave him the prospect of doing, Homer abandoned commercial illustration forever.

At one time largely the medium for amateur painters (like Winslow Homer's mother, for instance), watercolor began to attract the serious and widespread interest of professional American artists, their critics, and their patrons in the 1870s. In February, 1873, an exhibition of nearly six hundred European and American watercolors and drawings, sponsored by the American Society of Painters in Water Colors, was held at the National Academy of Design in New York. Homer may have been inspired by that event, for only a few months later, during the summer at Gloucester, he began making watercolors in earnest. He had a natural affinity for the medium and would do some of his greatest work in it. But he also surely perceived that watercolors, which could be made more quickly and in greater abundance than oil paintings, and sold more cheaply, could be a more reliable source of income. He was surely encouraged in that perception by the apparently immediate popularity of his watercolors, for the ones he showed in 1874 "were snatched up at once, and the public cried for more."

Homer "made a sudden and desperate plunge into water color painting," a critic, playing on words, said in 1875, in some years flooding the annual exhibitions of the Water Color Society with his work. He continued to be criticized for the suggestive breadth of his watercolor style, as he had been for his oils. But it was more excusable and more palatable in a medium, like watercolor, that was perceived to be inherently informal and spontaneous; a critic said of his work in 1874, the first year he showed the watercolors he made at Gloucester the previous summer, that while they were "mere memorandum blots and exclamation points," they were nevertheless "so pleasant to look at, we are almost content not to ask Mr. Homer for a finished piece."

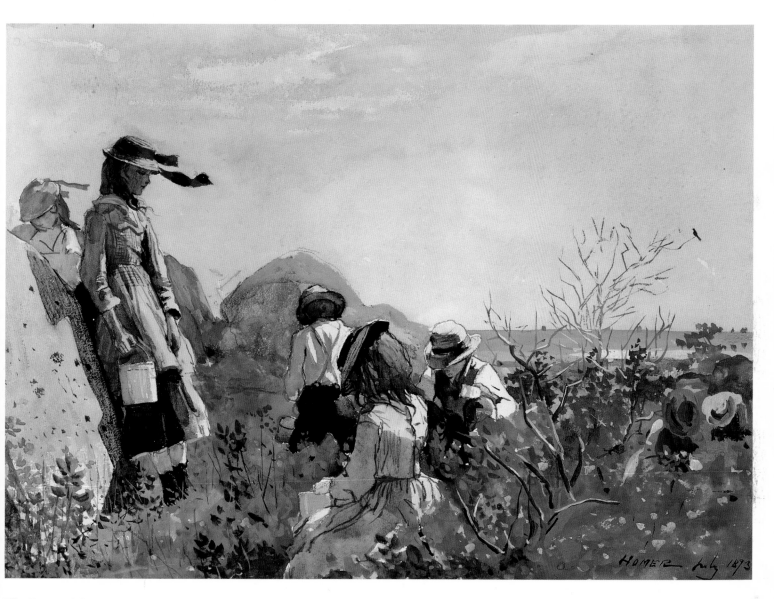

The Berry Pickers

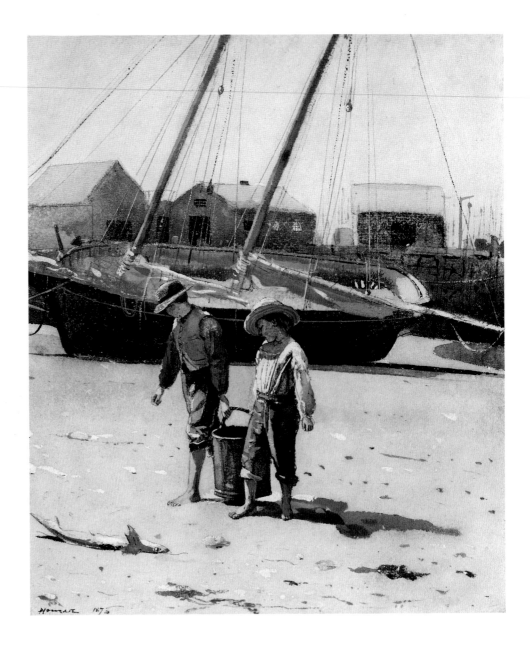

A Basket of Clams

1873. Watercolor, 11½ x 9¾"
Collection of Mr. and Mrs. Arthur G. Altschul

*With expressions of mingled revulsion
and revelation two boys come across a
dead shark on the beach, a disturbing re-
minder of mortal destiny in the summer
sunshine and innocent childhood pas-
times of Homer's Gloucester watercolors.*

Homer tended to make his watercolors on painting campaigns, like the one
in the summer at Gloucester in 1873. They were tied more or less directly to
particular times and places, unlike his oils which derived more synthetically,
distantly, and indirectly from experience. In fact, in the 1870s especially, sub-
jects first explored as watercolors were reused in oil paintings: *Breezing Up* of
1876, for example, was derived with only slight changes from a watercolor
made three years earlier. That was not, however, a consistent practice; most
watercolors did not result in oil paintings, and there are oil paintings that have
no counterpart in watercolor. Watercolor was not a preparatory medium, like
drawing, but one with its own self-sufficiency and integrity. As Homer devel-
oped, that self-sufficiency increased and the difference between oils and water-
colors became more and more pronounced. As his oils became larger in size,

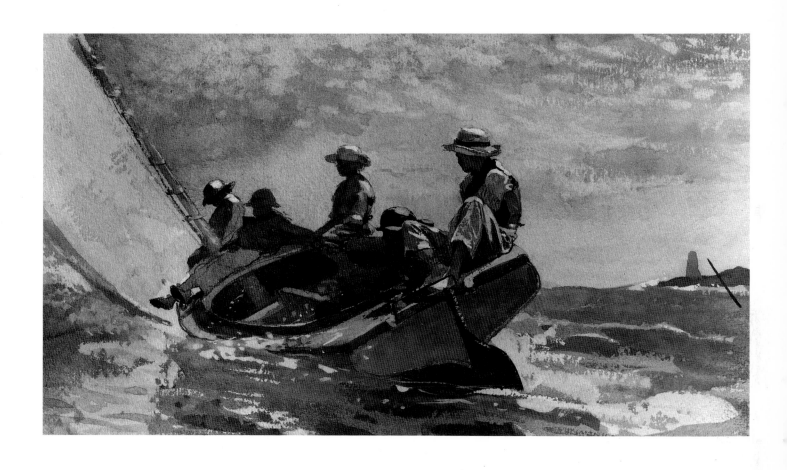

Sailing the Catboat

1873. Watercolor and gouache
over graphite, 7½ x 13¾"
Private collection

*Homer's watercolors were never merely
studies for oil paintings, although, as in
this case, oils were occasionally made after
them. The critic of the* New York Evening
Mail *who wrote that Homer "grabs nature
and dabs her on his paper, and as you look
at his work you feel the blow of the salt sea
breezes and shade your eyes from the daz-
zling sun glare," described the freshness
and brilliance of his watercolors that his
oils, however fine, never equalled.*

Dad's Coming

1873. Oil on panel, 9 x 13¾″
Collection of Mr. and Mrs. Paul Mellon,
Upperville, Virginia

This painting was engraved for Harper's
Weekly *in November 1873, accompanied
by a sentimental poem which described in
Victorian cadences the emotions of a
mother and her children as they searched
the horizon for a sign of her husband's re-
turn and ended with the refrain:*

But sing, little Johnny! Dad's coming!
 Dad's coming!
The husband and father is safe at your
 side.

A critic's description of the painting in the
New York Evening Post—"*a boy perched
on the bow of a row boat, reporting to his
mother, who is standing by, the approach
of his father on the water beyond*"—*better
suits the painting's terseness of form and
expression.*

Breezing Up

1876. Oil on canvas, 24⅛ x 38⅛″
National Gallery of Art, Washington

Titled A Fair Wind *when Homer exhibit-
ed it in 1876, this painting was lavishly
praised.* "*There is no picture in this exhibi-
tion, nor can we remember when there has
been a picture in any exhibition, that can
be named along side this,*" *wrote the critic
of the* New York Tribune. *One reason for
its popularity was that, as the* Tribune
said, Homer "*has at last painted a picture
…that will at once surprise and delight
those who have feared we were never to
have anything from his hand but sketch-
es.*" *Another was that the painting's youth-
ful freshness and spirited optimism suited
the mood of the Centennial. And still an-
other, that its* "*sincerity and uncontamin-
ated cleanliness of idea*" *(as* The Nation
*put it) served as an exemplary antidote to
the venality and corruption of post-Civil
War American political life.*

graver in meaning, more universal in content, and more conceptual than de-
scriptive, watercolor became in the same degree Homer's most immediately
responsive access to visual experience, at once more spontaneous and experi-
mental—assuming in purer and more concentrated form those acts of observa-
tion and impulse that the timelessness and formality of his oils could not
accommodate.

The addition of watercolor to Homer's artistic resources, and the dropping
from them of illustration, were not the only important changes that occurred in
his art in the decade of the 1870s. His artistic purpose changed profoundly. For
by the later 1870s it seems to have become clear to Homer, with the force and
effect almost of a crisis of faith, that the ideas and ideals that inspired and guid-
ed his early art—the possibility of making an original, national art suited to the
"conditions of American life" and the "common life of democratic man"—were
now hopelessly out of place. What seemed so clear and durable during and
immediately after the Civil War began to lose force and meaning amid the ve-
nality and immorality of Gilded Age America—all of which came to a head in
the rampant corruption of Grant's administration and in the crisis of the demo-
cratic process that the contested election of 1876 represented, and which coin-
cided closely with the crisis of Homer's art. The conditions and expectations
upon which Homer's artistic purpose had been founded became so changed, so
deformed and degraded, as to have no bearing upon him and be no longer
binding. And artistic changes, too, made his enterprise, the "home painting"
that represented a populous mainstream of American artistic endeavor in the
years following the Civil War, suddenly a lonely one. "What we used compla-
cently to call the American school," a critic wrote in 1877, "assumes a wall-flower
place" among the work of the "bold, youthful, confident" American artists
trained abroad, in Munich and Paris, that began to fill Academy exhibitions with
paintings in styles imported directly from Europe, often of European subjects.
Only "a few of our artists," Homer being one of them, "bravely persist in paint-
ing pictures illustrative of American subjects," another wrote in the same year.

So Homer retreated and sought refuge from these changes. He took ref-
uge in art, concerning himself more deeply with its mechanics, its form, and its
conventions than he had ever done before, and expressing his meaning by a
new kind and on a new plane of content, and by a new language of style. He also
retreated physically and emotionally, withdrawing increasingly from society.
This withdrawal was climaxed by his settlement at Prout's Neck, Maine in 1883,
but it was prefigured in the later 1870s by acts and signs of social disengage-
ment—of which one of the earliest may have been his rejection of illustration in
1875, removing from his artistic arsenal that part of it most committed by medi-
um and subject to public address.

By the mid-1870s a greater and more explicit aesthetic sensibility began to
operate in Homer's style, as subtleties of design, of pictorial arrangement, as-
sumed a new, indeed an unprecedented importance for him. Earlier, his paint-
ings were constructed in the simplest possible way. In *Veteran in a New Field* and
Prisoners from the Front, or in paintings of the 1870s like *Crossing the Pasture* (1872;

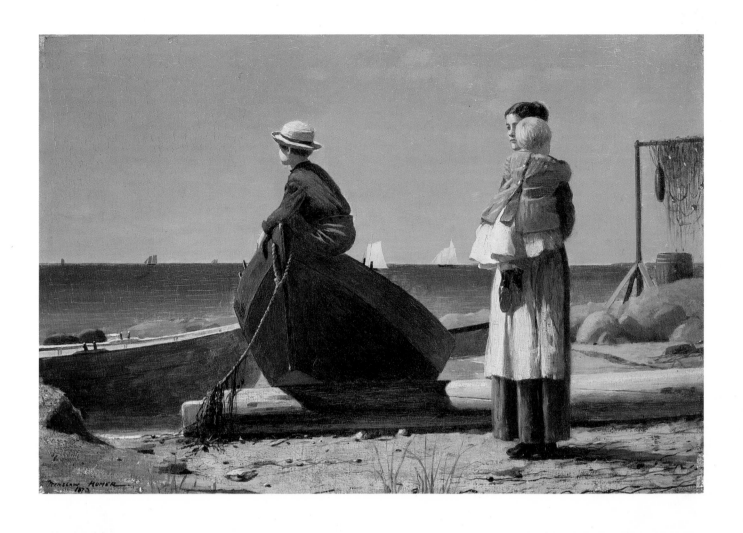

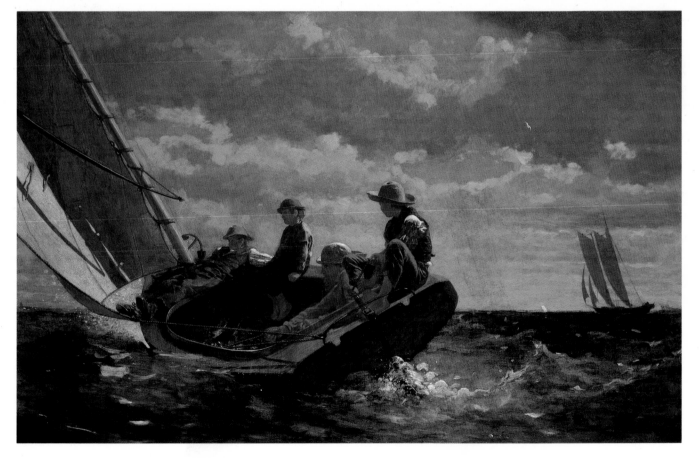

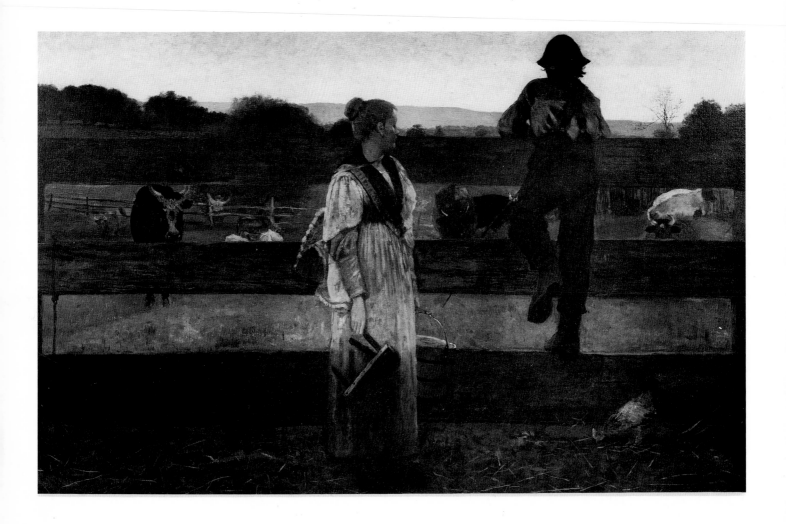

Milking Time

1875. Oil on canvas, 24 x 38¼″
Delaware Art Museum, Wilmington

The critic of the New York World *said the composition of this painting had "the 'tender grace of a gridiron.'" The Nation's, however, found it daringly inventive: "Another artist...would hardly think of making a motive out of the horizontal stripes of a fence, relieved against a ground of very slightly differing value, so as to make the group at the fence appear like a decoration wrought upon a barred ribbon."*

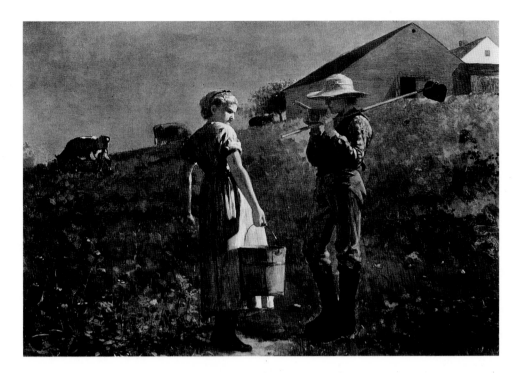

Amon Carter Museum, Fort Worth), *Boys in a Pasture* (1874; Museum of Fine
Arts, Boston), or *A Temperance Meeting* (1874), the main figure groups are
placed simply and straightforwardly in the center of the painting (as a critic
noted of works such as these, "In composition they were not remarkable—few
of Mr. Homer's productions are noteworthy in that respect; he does not seem to
care greatly for it. . . .") But in *Milking Time* of 1875 pictorial construction has
become considerably more complex and sophisticated, more overtly decorative,
and more self-assertively part of the picture's effect: "The horizontal stripes of a
fence, relieved against a ground of very slightly differing value," one writer said,
"make the group at the fence appear like a decoration wrought upon a barred
ribbon." In *Breezing Up* of 1876 the changes that Homer made in the picture—
some of which, like the deleted sails at right center, have with time become
visible once more—were primarily refinements in design.

At this time, too, Homer began to embrace stylistic, as opposed to ideologi-
cal, influences more openly than he had ever done before. The influence of
Japanese art, for instance, is clearly at work in the compositional subtleties of
Breezing Up. The main form of the boat placed far to the left and close to the
picture suface, balanced by empty space and a small, distant form at the right, is
a mode of compositional construction that is almost a commonplace in Japanese
art. One of the figures in *Promenade on the Beach* (1880) holds, almost displays, a
Japanese fan, and the painting as a whole—one of the most beautiful of
Homer's decorative paintings—also observes the compositional order of Japa-
nese art. Japanese influence is even more openly stated in the watercolor *Back-
gammon* of 1877. The floating of the figure group as a shape against a flat

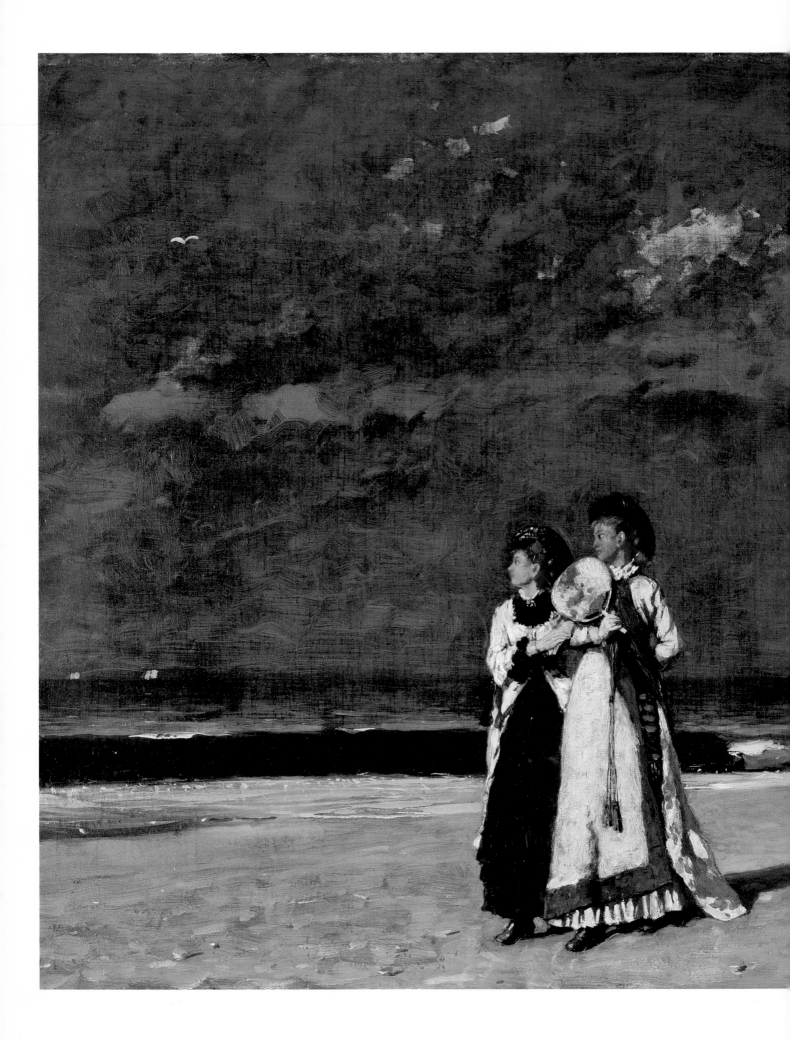

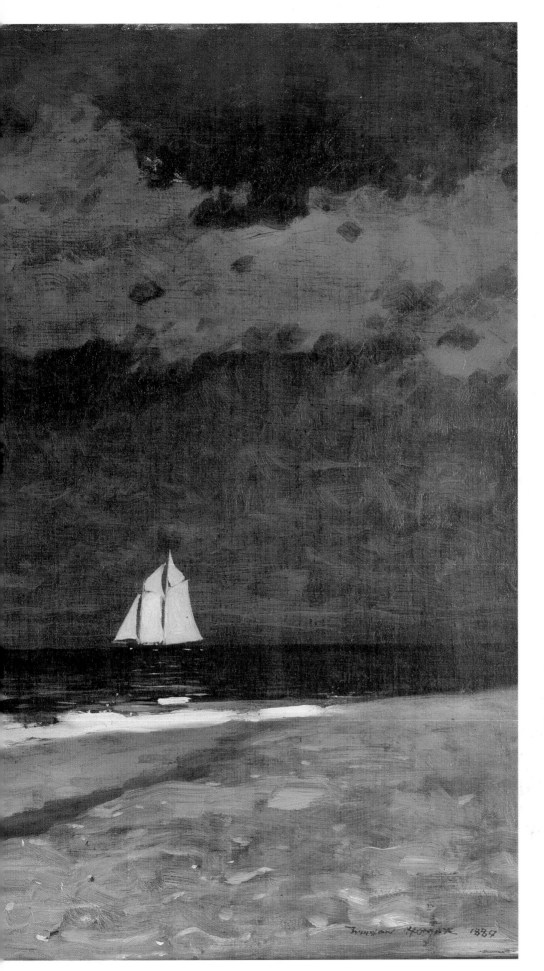

Promenade on the Beach

1880. Oil on canvas, 20¼ x 30⅛"
Museum of Fine Arts, Springfield, Massachusetts

Despite its exceptional beauty of color and composition, this oil shares the disquietude—the queerness and intensity—of Homer's 1880 Gloucester watercolors. There is something disturbing, even threatening, in the lurid lighting and darkening sky and particularly in the two handsome, richly dressed women walking closely together along the beach with self-contained assurance but otherwise ambiguous purpose. It is a projection, perhaps, of his relationship to and view of women that, partly at least, produced at this time the severe alienation of Homer's behavior and extreme emotional intensity of his art.

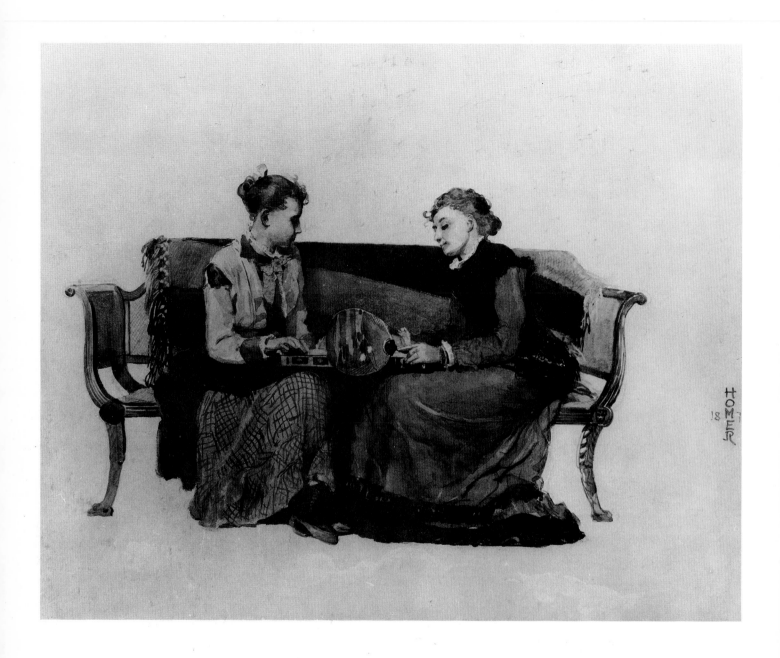

Backgammon

1877. Watercolor, 17 x 21¼"
Private Collection

This is the most explicit example of Homer's interest in the late 1870s in Japanese art, from which the overall design, the detail of the fan, and even the form and placement of the signature of this large watercolor have been derived.

Fireplace tiles designed by
Winslow Homer

1878. Ceramic, each tile 8 x 8″
Collection of Mr. and Mrs. Arthur G. Altschul,
New York

background, the fan, and even the form and placement of the signature in a witty imitation of Japanese usage, all refer very openly to Japanese art. Homer's *japonisme* did not go unnoticed. In 1876, a critic said that a painting in that year's Academy exhibition (*Over the Hills*, perhaps the one now in the Newark Museum called *Beaver Mountain, Adirondacks*, which he believed was "highly characteristic of a large class of Mr. Homer's work") suggested that if he could represent it "on a Japanese box in two lacquers . . . his secret ideal would be satisfied." Another said Homer's watercolors of the following year were "eulogiums of Japanese fan-painting."

In the later 1870s Homer became interested more literally in design. In 1878 he made two ambitious sets of decorative tiles for fireplaces, and was an active member of the Tile Club in New York, at the meetings of which he did single or sets of decorative tiles. This was the time America felt the full force of the Aesthetic Movement. It was "a decorative age," an artist said, adding, "we should do something decorative, if we would not be behind the times." Homer was far from alone in being touched by it: Albert Pinkham Ryder, like Homer an artist not usually thought of in terms of decoration, began his artistic career at this time by doing such decorative work as painted screens and mirrors. And the Tile Club was organizationally dedicated to decoration.

Decorativeness touched Homer's art more widely. In 1879, a critic described Homer's painting *Upland Cotton* (Collection Weil Brothers Cotton, Inc.) as a superb piece of decoration, and other critics at this time began to comment

Dutch tiles decorated with
shepherds and shepherdesses

1660–1725. Ceramic tiles
Philadelphia Museum of Art.
Gift of Mrs. Francis P. Garvan

Homer shared the decorative spirit of the late 1870s. It is visible in his paintings and watercolors, but especially in his decorated tiles, for which he borrowed subjects (used in his paintings as well) from earlier traditions of tile decoration.

Fresh Air

1878. Watercolor over charcoal, 20¹/₁₆ x 14 ¹/₁₆"
The Brooklyn Museum. Dick S. Ramsay Fund

Writing about the exhibition of the Water Color Society in 1879 that included Fresh Air, *the critic for the* New York Sun *was surprised by Homer's "Little Bopeeps" and commented on their resemblance to porcelain figurines and the shepherdesses of the eighteenth-century French artist Watteau. The following year, when Homer showed a group of watercolors and drawings containing shepherdesses, a writer in the* New York Evening Post *found them particularly American: "Here are the American shepherdesses which only Mr. Homer paints—self-possessed, serious, independent; not French peasants who till the soil; not Swiss slaves who watch cows . . . ; not German* frauen, *who are drawers of water and shapeless, but free-born American women on free-soil farms . . ."*

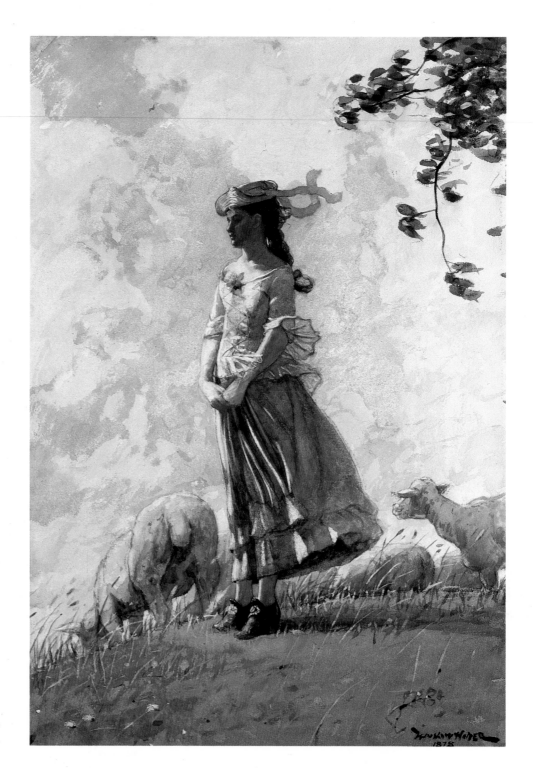

Spring

1878. Watercolor and graphite, 11¹/₈ x 8⅝"
Collection of Daniel and Rita Fraad

In the summer of 1878 at Houghton Farm, near Mountainville, New York, Homer painted a group of watercolors that were broader, fresher, and purer in technique than any he had made earlier. For some they posed troublesome questions of finish and raised the specter of "Impressionism." The Nation *said they were "art stenography." The* Century's *critic, however, thought Homer's "force lies in quick, light sketches" and many others admired their breadth and suggestive brevity.*

on the artificiality of Homer's art, and its tendency to decorative flatness (a critic remarked on the flatness of all of Homer's paintings in the 1876 Academy exhibition, describing their style as "bald as patchwork" and comparing them to stage flats). A decorative sensibility not only inflected Homer's style but also touched his subject matter. For in the shepherdesses that he began painting in the later 1870s he depicted a subject more purely and conventionally pretty than any he had ever done.

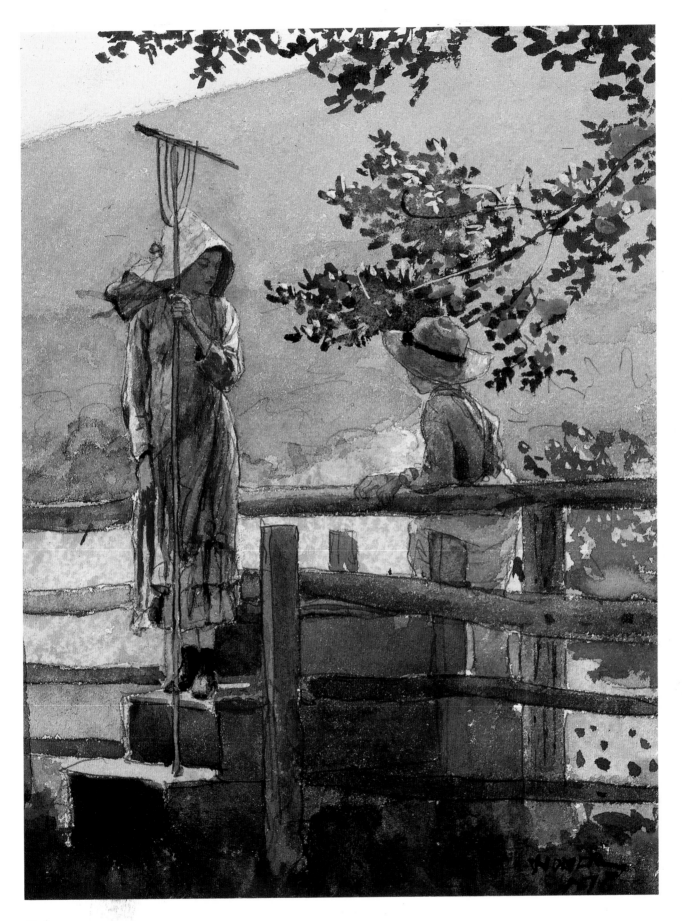

Spring

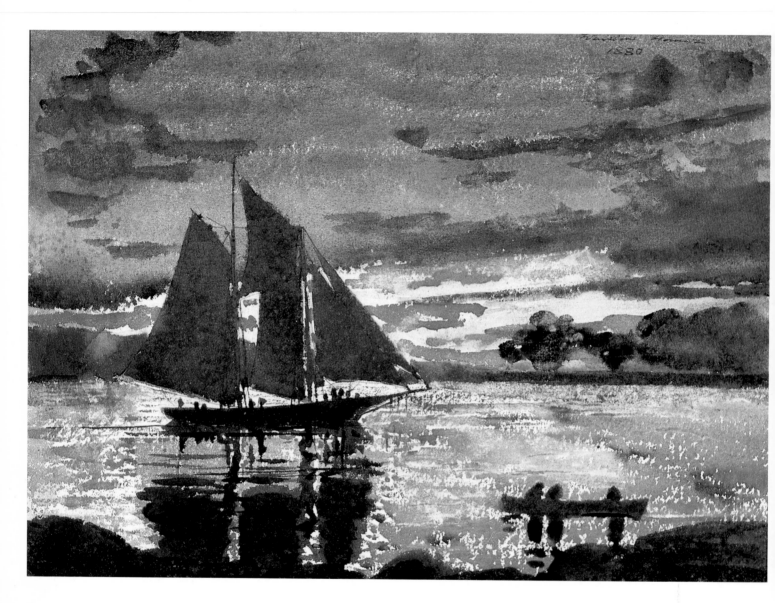

Sunset Fires

1880. Watercolor, 9¾ x 13⅝″
Westmoreland County Museum of Art,
Greensburg, Pennsylvania.
William A. Coulter Fund

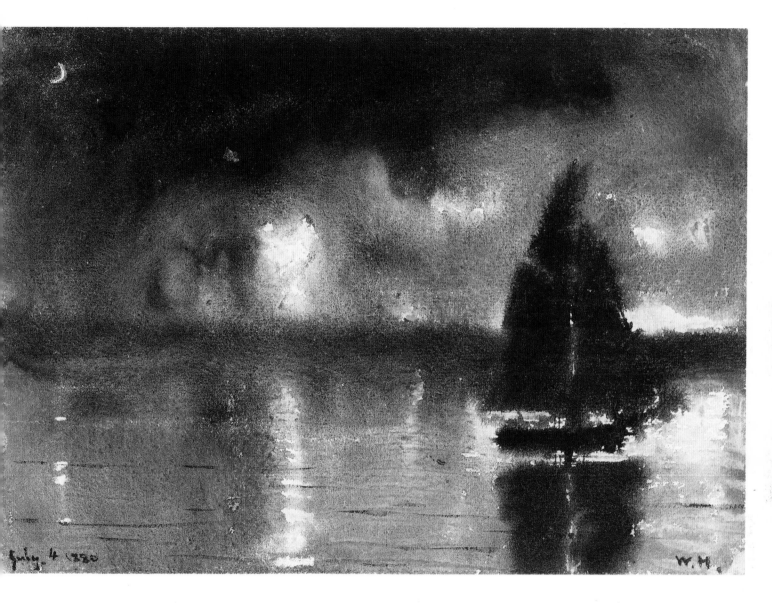

Schooner at Sunset

1880. Watercolor, 9¾ x 13¹¹⁄₁₆″
Fogg Art Museum, Cambridge, Massachusetts,
Bequest of Grenville L. Winthrop

The intensely colored, vigorously painted watercolors that Homer made during the summer of 1880 at Gloucester startled those who saw them in Boston that December. "How queer they are and how unexpected," Edward D. Hale wrote. "Some of them seem to lack common sense." Sensing that they expressed a state of mind more than a condition of nature, the critic for the Boston Advertiser *found them "almost morbid in their intensity."*

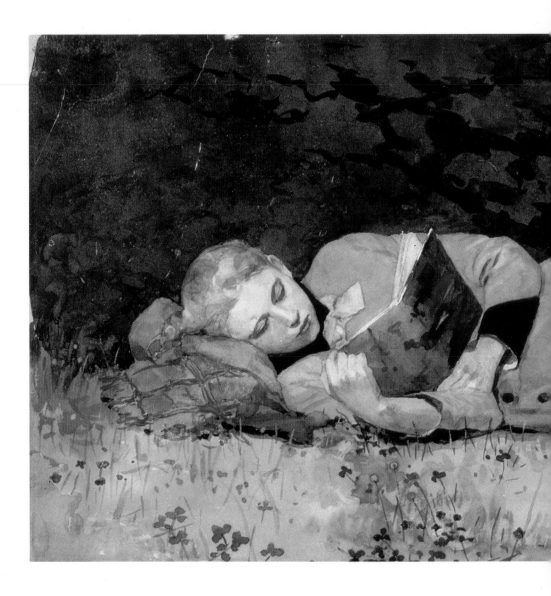

Some were working shepherdesses whom he saw at Houghton Farm, the property of his friend and patron Lawson Valentine, near Mountainville, New York, that Homer visited during the summer of 1878. Others, however, just as obviously were not. *Fresh Air,* for example, is clearly a costume piece that originated not in actual experience or in present time, as everything in Homer's earlier art had done, but in experiences of art and in time past. The shepherdesses he painted on his decorated tiles were traditionally one of the most popular subjects in tile decoration, and it was surely there that Homer found them. From that decorative tradition the subject found its way into Homer's decorative art, and thence into the paintings and watercolors of the late 1870s. The shepherdesses are the first importation of conventional imagery into Homer's art, the first real indisputable instance of his borrowing. This relationship to artistic tradition and convention would henceforth be an essential, and very soon a pervasive, part of his art.

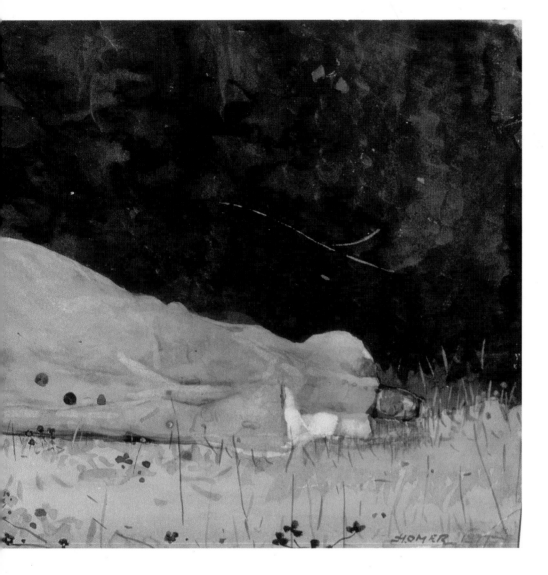

The New Novel

1877. Watercolor, 9½ x 20½"
Museum of Fine Arts, Springfield, Massachusetts.
The Horace P. Wright Collection

Both Blackboard *(overleaf) and* The
New Novel *are monumental watercolors
that depict the same woman. But with
single-word titles (*The New Novel *was
originally called* Book; *another, now
called* Woman Peeling a Lemon, *simply*
Lemon) *that are more labels than descriptions they seem to be formally posed images
of women's social roles and capacities—
professional, literary, domestic—rather
than the informal episodes of a personal
relationship.*

The decade of the 1870s, during which Homer's art and artistic understanding underwent such profound changes, closed with a group of watercolors made at Gloucester during the summer of 1880 that are some of the most astonishing things he ever did. They are his most purely colorful paintings both in the intensity of their hues, and the degree to which they depend in their form and expression almost wholly on free, vigorously uninhibited washes of pigment. Homer may have been influenced by contemporary color theory (he owned a copy of Chevreul's classic text on color, and Ogden N. Rood's important *Modern Chromatics* was published a few months before he went to Gloucester). They may also be attempts, of a kind that it never interested him before to make, to record transient effects. Far and away the most emotionally charged and expressively affecting images that Homer ever painted, their "morbid intensity," as one critic described it, and their "fervid, half-infernal poetry," as another said—the disruptive tension and anxiety that inhabit them and shape their visible appear-

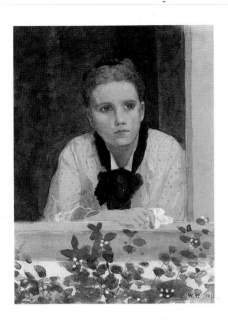

Young Girl at the Window

1875. Watercolor, 6½ x 5"
New Britain Museum of American Art,
New Britain, Connecticut

For about four years in the later 1870s the same unidentified woman recurs in Homer's art. Her disappearance from it, and presumably from Homer's life, in 1878 shortly preceding his trip to England and his subsequent settlement at Prout's Neck, Maine, must have been an emotional crisis that contributed greatly to the compulsive privacy and reclusiveness of his last thirty years. This is possibly the watercolor Homer exhibited in 1876 with the title, Too Thoughtful for Her Years.

Blackboard

1877. Watercolor, 19⁷⁄₁₆ x 12 ³⁄₁₆"
Collection of Jo Ann and Julian Ganz, Jr.

ance—originated largely in Homer's emotional life. What they tell of his condition is confirmed by other signs of inwardness and disturbance. During the 1860s and for most of the 1870s Homer had been actively social, part of a circle of friends and fellow-artists in New York, with whom he often traveled during the summer. During his first visit to Gloucester in 1873, Homer lived in town, staying at the Atlantic House. But in the summer of 1880 he boarded instead at the lighthouse on Ten Pound Island, in the middle of Gloucester harbor. Withdrawal was reflected also in other aspects of his behavior. Two years earlier, when he sent nothing to the annual watercolor exhibition, a writer said he "sulks in his tent." Another reported that he was "under the weather." The next year a critic called him a hermit and a recluse. In 1880, a writer said "he is *posé* in the extreme, and affects eccentricities of manner that border upon gross rudeness. To visit him in his studio is literally bearding a lion in his den..."

This pattern of withdrawal, while it is a reflection of the artistic crisis that Homer underwent in the later 1870s, was very probably the result also of, and acquired a greater urgency from, an emotional crisis—a romantic disappointment the nature of which can only be guessed at but which permanently affected Homer's conduct, causing in particular that extreme mistrustfulness, defensiveness, and reclusiveness that would become salient traits of his personality in later life.

There are stories, for what they are worth, about Homer's attraction to women; in early life, as he himself said, he was thought to have a "weakness" for pretty girls. Surer evidence of that attraction is the concentrated recurrence of several recognizably different women at separate times in his art of the 1870s—the school teacher of the early 1870s, the young woman who appears in a number of paintings and watercolors of the mid-1870s (such as *Young Girl at the Window* of 1875), and the person who appears in various roles in some of the great watercolors of the late 1870s—as a record of serious, intense, and even intimate heterosexuality. But Homer never married, and that has inevitably fueled speculation about his sexual orientation. The obviously unhappy outcome of the relationship of the late 1870s, whatever its cause, was a psychological and sexual affront from which Homer never recovered; thereafter, the only woman to whom he was close, besides his mother, was his brother Charles's wife Mattie. While it is true that women, who had been one of Homer's chief subjects for roughly the first twenty-five years of his career, appeared only sporadically during the last twenty-five; and while it is perhaps possible to see signs of sexual repression in Homer's later work, there is no evidence, in his art or elsewhere, of either active misogyny or homosexuality.

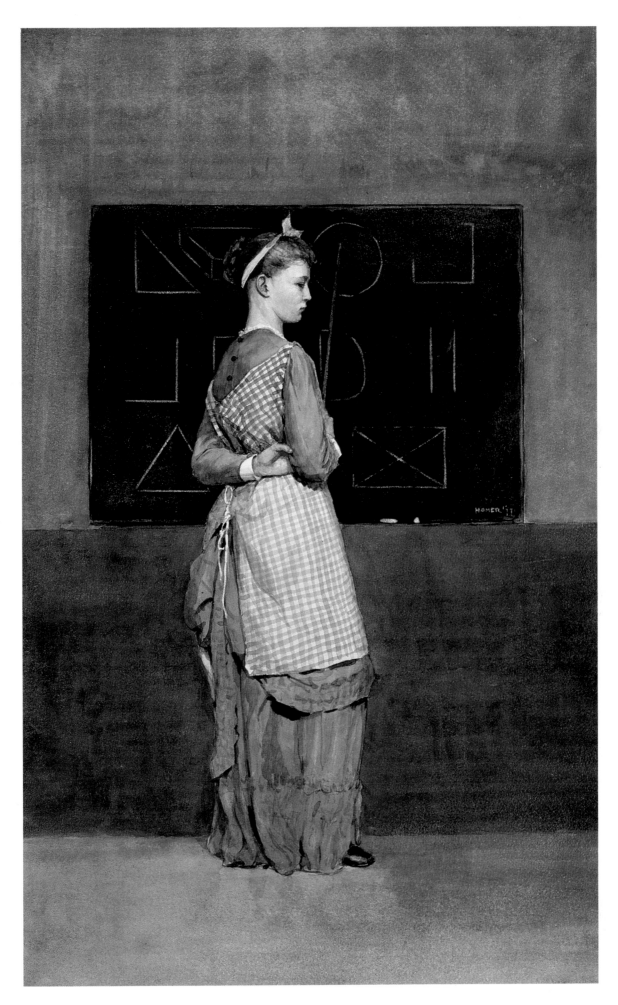

Blackboard

The Houses of Parliament

VI. Cullercoats

Homer lived in the first of the row of houses (now destroyed) facing the ocean, a daily witness of the sea and of the men, and more often the women, whose lives depended upon it.

HOMER'S MOST DECISIVE REACTION TO THE CRISIS (or crises) of the 1870s, his most emphatic and complete act of withdrawal, was to embark on a twenty month trip to England in the spring of 1881 that resulted immediately in a comprehensive, almost point-by-point revision of his art. Homer passed through London remaining only long enough to paint a beautiful watercolor of the Houses of Parliament and to have some intense, profoundly influential experiences of art. But he stayed in the fishing village of Cullercoats, in Yorkshire, near Newcastle-upon-Tyne, where he lived in a house on the coast, observing daily, and making the exclusive subject of his art, the stern lives of the fishermen and their families and their unrelentingly perilous contest with the sea.

We do not, as usual, know why Homer went to England, much less why, of all places, he chose to live in Cullercoats. There was a seasonal art colony there that he may have known about. There is also, in this move to that harsh and distant place the suggestion of renunciation and restoration, a need in Homer for escape, for purification, and even, perhaps, given its rigors, for mortification. Such a retreat from civilization to a state of primitive simplicity motivated the more celebrated journeys of Van Gogh and Gauguin slightly later in the nineteenth century.

It is difficult to think, in the work of another artist, of a change of style and subject quite as complete and as sudden as the one Homer accomplished in his English period. His colors became immediately more restrained, his forms larger, weightier, and more ample; the persons he depicted more mature and their enterprise more serious. And although he worked entirely in watercolor, his sheets became significantly larger in size, his images more ambitiously complex and more dramatic in subject. In his earlier work nothing can be found that is comparable to a large watercolor like *The Wreck of the Iron Crown*, made in October 1881, early in Homer's first year at Cullercoats.

The change in Homer's art was, of course, a reflection of the different things he experienced at Cullercoats—different conditions of weather, for example, or way of life. Yet the change was not as passive, as merely reflective as that; its result was too thoroughly revisionary. Homer's earlier art had been purposefully novel, determined by its consciously nationalist independence to resemble no other. The art of his English period (and after) is, by contrast, purposefully conventional. Like the loss of nerve and consequent retreat from daring innovation into convention that was a recurrent pattern in the development of modernist artists, Homer in middle age aligned himself, not as a reversion but for the first time, with artistic tradition.

The Houses of Parliament

1881. Watercolor, 12½ x 19½"
Hirshhorn Museum and Sculpture Garden,
Smithsonian Institution, Washington

Homer probably made this beautiful watercolor shortly after his arrival in England at the end of March, 1881. He spent most of his time in England in the fishing village of Cullercoats, near Newcastle on the North Sea. This watercolor, and the influence on his English art of classical sculpture that he must have seen in the British Museum, are the most tangible results of his short stay in London.

Four Fishwives

1881. Watercolor, 18 x 28½"
Scripps College, Claremont, California. Gift of
General and Mrs. Edward Clinton Young, 1946

*"They deal with the humble life and vo-
cation of the fisherwomen, a class whose
picturesque costumes and sturdy charac-
teristics afford an alternative theme for
the descriptions of an artist,"* the critic of
the Boston Advertiser *wrote of the Eng-
lish watercolors that Homer exhibited in
Boston in 1882, which included this one.
They belong, as the same critic noticed, to
depictions of labor that were a popular
theme in nineteenth-century European
art: "Their sun-burned faces and sturdy
forms are visible in every scene, but always
in a different phase of labor or repose.
Their costumes are as picturesque as those
of the Normandy peasant women that art-
ists love to paint."*

This cannot have been because he experienced tradition with overwhelm-
ingly irresistible force at the British Museum or the National Gallery; he had
experienced tradition just as forcefully at the Louvre more than a decade earli-
er, but entirely without visible effect. By the early 1880s, however, not only were
the nationalist and modernist convictions that had at one time shielded Homer
from tradition no longer in force but, disillusioned with those convictions and
the art they shaped and guided, he found new meaning, purpose, and comfort
in the authority of tradition. A passage in Henry Adams's novel *Democracy*, pub-
lished in 1880 at about the time of Homer's trip—or, perhaps, his flight—to
England, may explain the state of mind that motivated him and the nature of
the artistic change that it produced. The novel's heroine, Madeline Lee, ex-
pressed her disturbing disenchantment with the venality and immorality of
American democracy in the 1870s this way: "I want to go to Egypt," she said.
"Democracy has shaken my nerves all to pieces. Oh, what a rest it would be to
live in the Great Pyramid and look out forever at the polar star!" A similar
attraction to the restorative stability and consoling authority of tradition, com-
bined with a similar longing for the elemental, may have guided Homer as well,
leading him (as it did Madeline Lee) to flee to the Old World, and giving to his
experiences of artistic tradition in England the effect not of unanticipated dis-
covery but of a purposeful quest for order and orthodoxy.

The presence of tradition, in any event, is fully visible in Homer's English
art. Its greater size, its more ambitiously conceived and more carefully studied
composition, its graver themes and larger, weightier figures—all must come in
significant measure from the desire to give to his own art a weight of meaning
and a dimension of form that he saw in the art of the past in the great public
collections in England.

Homer's English art, moreover, is consistently more complete and more
comprehensive, more realized in execution and resolved in content, than his

Wreck of the Iron Crown

1881. Watercolor, 20¼ x 29⅜″
Collection Mr. and Mrs. Carlton Mitchell

The 1,000-ton Iron Crown *foundered early in the morning of October 21, 1881, at the mouth of the Tyne River, off Cullercoats, where Homer had been living for several months. After twenty of the crew and the captain's wife had been saved one more crewman was discovered on board and was rescued by lifeboat. Homer depicted the rescue of the remaining crewman.*

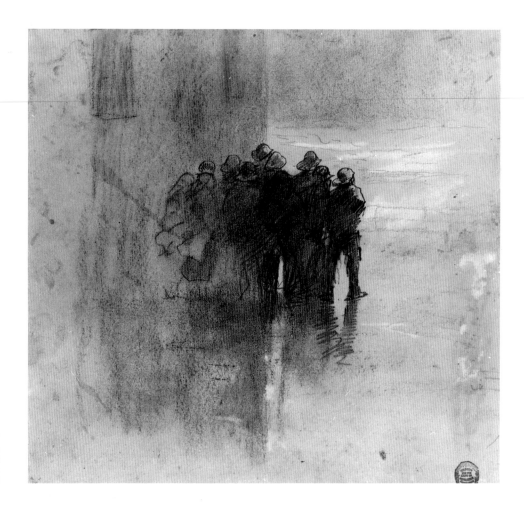

Fishermen in Oilskins, Cullercoats

1881. Charcoal and white chalk, 14¾ x 12¹⁄₁₆″
Cooper-Hewitt Museum,
The Smithsonian Institution's
National Museum of Design.
Gift of Charles Savage Homer

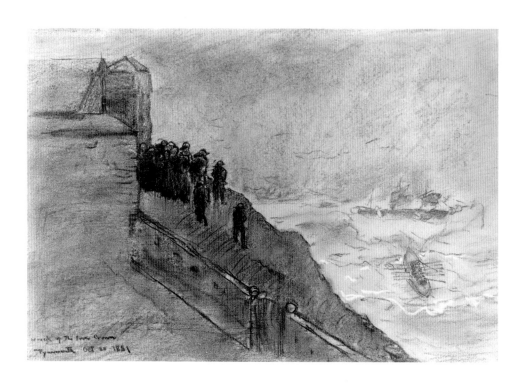

Study for Wreck of the Iron Crown

1881. Charcoal, 8¼ x 12⅜″
Collection Mr. and Mrs. Carleton Mitchell

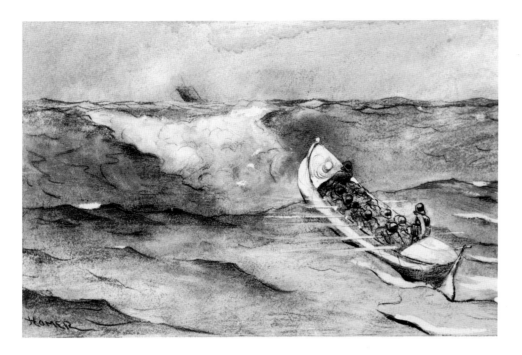

The Life Boat (Wreck of the Iron Crown)

1881. Black chalk, black wash, and white gouache, 13⅞ x 19¹/₁₆″ Cooper-Hewitt Museum, The Smithsonian Institution's National Museum of Design. Gift of Charles Savage Homer

During the wreck of the Iron Crown *a taxi drew up at the shore and "out stepped a dapper medium-sized man with a water-colour sketching block and sat down on the ways." That, according to the memoirs of his neighbor at Cullercoats, the English watercolorist George Horton, was Wins-low Homer. Homer's depiction of the wreck of the* Iron Crown *was not, as this suggests, a firsthand, eyewitness account. He explored the dramatic and compositional structure of the subject in a series of powerful drawings (left and opposite), and seems to have used a photograph as well.*

earlier more fragmentary and allusive art had been: "His pictures are not what they used to be, things of shreds and patches," a critic wrote. One reason for that is a change in Homer's artistic method. He had always been a prolific and incisive draftsman; in that, if in nothing else, his apprenticeship trained him. His early drawings were notations of experience recorded for later use, singly or in varying combinations, in his paintings, watercolors, and prints. But in England he began almost immediately to use drawing in another and rather more traditional way to develop compositional arrangements and explore alternative pictorial thoughts. The deliberateness of this change is suggested by the observation of a critic, on the occasion of an exhibition of Homer's drawings in 1883, that "*he desires it to be understood* that these are in no sense to be regarded as pictures, but as studies, which are of the nature of memoranda, and form *simply one of the steps in the process of making a picture* [emphases added]." It was precisely by that preparatory method of drawing that he considered various formal and dramatic structures for *The Wreck of the Iron Crown.*

Homer's more methodical artistic procedure may have resulted also from a concern to correct what had been the most relentlessly criticized aspect of his earlier art—its lack of finish, of stylistic resolution. He did not, however, suddenly capitulate to conservative taste, for lack of finish had never been a question merely of taste. It had been an important vehicle of meaning. But now, when the contingencies of nationalism and modernity that those equally contingent conditions of style had once addressed lost their force, or were, in such different circumstances, no longer enforceable; when Homer was concerned instead with permanence of form and universalities of meaning, the convincing exposition of those values of form and content required him to produce more complete, considered, and capacious paintings. And that required, at least for a while, more careful pictorial study.

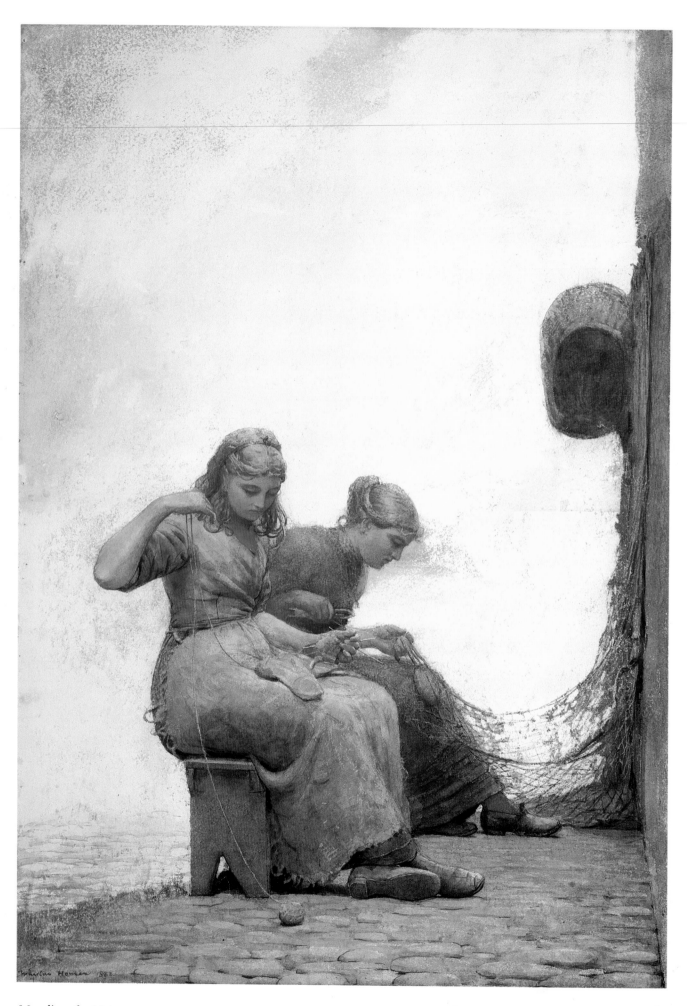

Mending the Nets

VII. Works of High Art

Homer returned to America in November, 1882. When he showed his English watercolors in New York two months later, critics saw at once that he had changed. "He is a very different Homer from the one we knew in days gone by," one said. Before Homer went to England this same critic spoke disparagingly of "the indistinct crudeness" of his work, but now it consisted "no longer [of] sketches or studies," she wrote, "but pictures in the truest sense of the word." "They touch a far higher plane.... They are works of High Art."

That was because they were more complete, more realized, but also because they had "an ideal element." Their ideality was seen in the resemblance his new work bore to the most celebrated of all High Art: His paintings "might be transferred without alteration by a sculptor to a bas-relief," for, as the critic explained, "Mr. Homer has worked in this point a little after the pattern of the Greek sculptor in his so different art." Inspired by the great works of classical antiquity that Homer saw in England (probably at the British Museum), this resemblance was intentionally produced; the features, anatomy, and lithic plasticity of Homer's figural type in nearly all of his English works was patterned upon the example of Greek classical sculpture. This is particularly clear in a large watercolor that Homer sent to New York for exhibition in 1882. Originally called *Far Away from Billingsgate* (the London fish market) it was described when first exhibited as two women "seated in a corner mending some fishnets that hang from an opposite wall." Later, Homer scraped away most of the background, removing indications of specific place in order to achieve the effect of figures against a plain, unlocalized background that is characteristic of Greek relief sculpture. The watercolor is now known as *Mending the Nets*, the title Homer gave it when he showed it again, in its altered, classicizing form, in 1891. Similarly, the carefully plotted echoes and repetitions of shape and line in a watercolor like *Inside the Bar* also correspond to principles of design to be seen in classical Greek relief sculpture, such as, for example, the metopes and friezes of the Parthenon (the Elgin Marbles) in the British Museum.

By ideality, however, the critic meant more than the resemblance of Homer's art to classical sculpture. She was referring also to that condensation and generalization of experience and its compression into heroic form and elevation to universal meaning that ideality in true classical form consisted of.

Homer's most wholly and conspicuously "ideal" paintings were a group of canvases that properly began with *The Life Line* of 1884, a series of large works

Grave Stele of Hegeso

c. 410–400 B.C. Marble, height 59"
National Museum, Athens

The overt conventionality of Mending the Nets *was achieved by scraping away its original background to make it resemble the profile figures against plain backgrounds that are characteristic of classical Greek relief sculpture.*

Mending the Nets

1882. Watercolor and gouache over graphite, 27⅜ x 19¼"
National Gallery of Art, Washington.
Bequest of Julia B. Engel

"One needs to read the signed name before believing that the maker of these British water-colors is the same who used to rouse the wrath or admiration of critics by his quaint conceits, his bald oddities, his lovely transcripts of scenes that only he knew how to depict," wrote The New York Times's *reviewer of the exhibition to which Homer sent the first of his English watercolors. "Mr. Homer's brightness and boldness are strangely lacking to these very conventional water-colors ..."*

Inside the Bar

Inside the Bar

1883. Watercolor, 15⅜ x 28½"
The Metropolitan Museum of Art, New York.
Gift of Louise Ryalls Arkell,
in memory of her husband, Bartlett Arkell, 1954

*Speaking of the controlled, carefully con-
trived rhyming of line and echoing of
shape in the composition of this and other
of Homer's English watercolors, Mari-
ana Griswold van Rensselaer, in* The
American Architect and Building News
*in 1883, wrote of "such an arrangement
of the figure, (where more than one was in
question) that the lines of one should sup-
port and almost duplicate the lines of the
other, producing simplicity without mo-
notony, harmony without rigidity."*

Parthenon metope

c. 438–432 B.C. Marble, over lifesize
The British Museum, London.
Reproduced by Courtesy of the Trustees of the
British Museum

*In his English watercolors, Mrs. van
Rensselaer wrote, "Mr. Homer has
gained the power to compose and draw
figures which . . . might be transferred
without alteration by a sculptor to a bas-
relief." Much of their compositional so-
phistication was learned from classical
relief sculpture, such as this example in the
British Museum.*

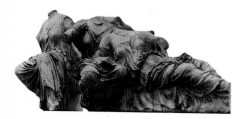

Parthenon pediment sculpture

c. 438–432 B.C. Marble, over lifesize
The British Museum, London.
Reproduced by Courtesy of the Trustees of the
British Museum

Undertow, *the critics saw, had the weight and authority of classical sculpture, "an heroic sculpturesque effect," The Critic said, "which endows [the figures] with the quality of the antique" and of "the frieze-like relief of the chain of bodies." It recalls most of all figure groups of the Parthenon pediment in the British Museum.*

Studies for *Undertow*

1886. Pencil, 5⅝ x 3⁹⁄₁₆″ and 6¾ x 8⅞″
Sterling and Francine Clark Art Institute,
Williamstown, Massachusetts

1886. Pencil, 5¾ x 7¼″
Sterling and Francine Clark Art Institute,
Williamstown, Massachusetts

Homer developed the composition of Undertow *with unprecedented care in a series of drawings, of which two are at right. "Probably no one will ever know the amount of work which has entered into this picture; it is the result of a year's labor," the* Boston Evening Transcript *reported. "Mr. Homer," it added, "is essentially a sculptor who expresses himself by the graphic method."*

that included *The Herring Net, The Fog Warning,* and *Lost in the Grand Banks* of 1885, and *Undertow* and *Eight Bells* of 1886. Conceived more monumentally and larger in actual size than any he had painted earlier, these paintings carried themes Homer first explored in his English watercolors to a new scale, concentration, and wholeness. Homer claimed to have witnessed the event of rescue he depicted in *Undertow* at Atlantic City, New Jersey, in 1883. If so, nothing merely incidental or contingent survives in either its subject or its form. Instead of being

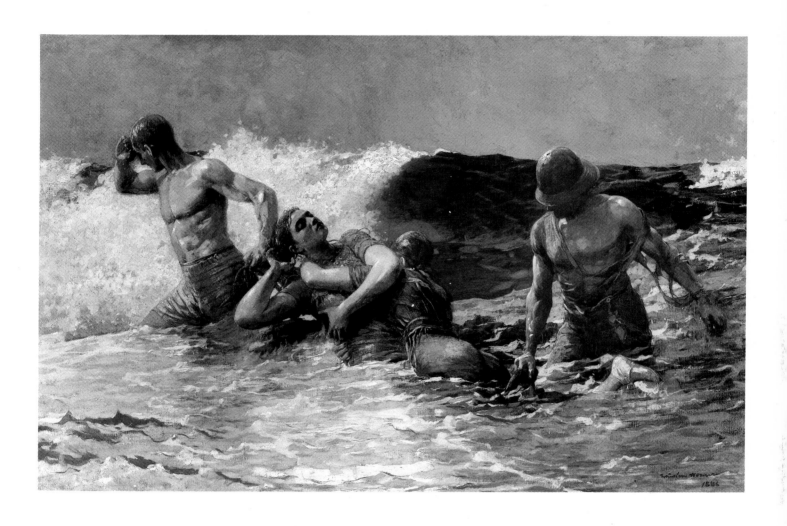

Undertow

1886. Oil on canvas, 29¹³/₁₆ x 45⅝"
Sterling and Francine Clark Art Institute,
Williamstown, Massachusetts

The rescue of two bathers from the under-tow was the pretext for Homer's most am-bitiously complex figure painting since Snap the Whip. *Said to have been in-spired by an incident Homer witnessed at Atlantic City, New Jersey, in 1883, it originated more truly in the pictorial and sculptural art that Homer saw and the events of rescue that he experienced earlier in England.*

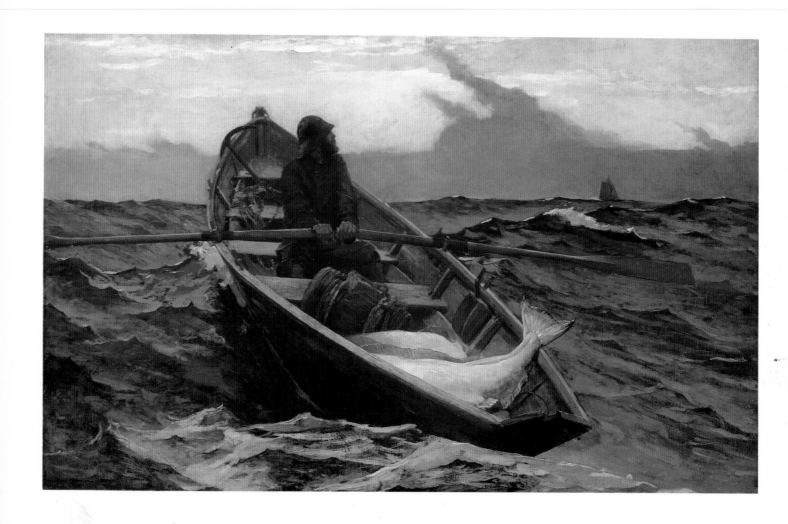

The Fog Warning

1885. Oil on canvas, 30 x 48"
Museum of Fine Arts, Boston

"Full of adventure, hazard and hardship is the fisherman's voyage to the New-foundland Banks, especially in the fresh halibut fishery," an article in Leslie's said in 1884, describing the subject of Homer's painting (which he first called Halibut Fishing). *"Even in Summer, the men who go out in their dories . . . are frequently overtaken by the dense fogs so prevalent on the Banks. Losing the position of their floating headquarters, the schooner, they drift helplessly about, falling prey to hunger and thirst, until, perchance, they may reach land, or, exhausted and emaciated, be picked up by some passing vessel." Even worse, "Too often are these brave fellows . . . overwhelmed by the force of nature's elements, and borne down for ever to a billowy grave, their lonely fate witnessed only by screaming gulls."*

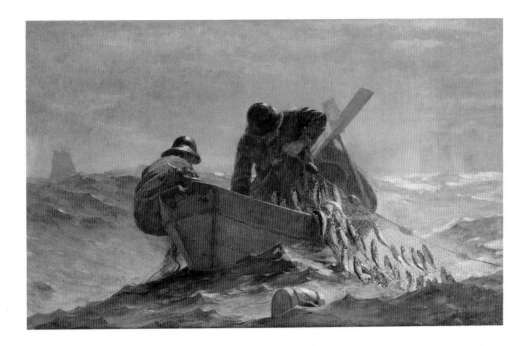

The Herring Net

1885. Oil on canvas, 29½ x 47½"
Art Institute of Chicago

In 1884 an unusually large school of herring attracted an unusually large number of fishermen in the vicinity of Prout's Neck. That event, transmuted into timelessly heroic form, was the subject of this, one of Homer's most monumental paintings.

merely optically or sociologically recorded (as an earlier subject such as *Eagle's Head, Manchester, Massachusetts* of 1870 had been), experience is recast and reconstituted as a solemn, tragic event of timeless and universal meaning. A measure of this difference, perhaps, is that when Homer's earlier *Breezing Up* was shown in 1887, it seemed after a painting like *Undertow* of the year before or others in the series of heroic and ideal pictures that *The Life Line* began, to be, one critic wrote, "a genre, and not a heroic motif," that is, merely a depiction of an incident of everyday life without higher significance.

In the process of reconstituting experience Homer drew upon artistic precedents. The very size of his paintings, their sudden enlargement, was surely inspired by the scale of older paintings that he had seen in England. The pyramidal compositional form of the figure group of *The Herring Net* is a virtually standard formal device of High Renaissance classicism—which is probably what the critic had in mind who wrote that Homer's painting "recalls certain old Italian work, it is the very concentration of strength." The complex, compactly interwoven group of bathers and their rescuers in *Undertow* is a citation of a pediment group from the Parthenon, another of the Elgin Marbles which Homer would have seen in the British Museum.

But it was a profoundly altered understanding of art and artistic meaning, not precedents of form however impressive, that determined the character of Homer's "ideal" paintings. In 1887, at the conclusion of the series that comprised them, Homer was reported to complain, "For fifteen years the press has called me a 'promising young artist,' and I am tired of it." That rankled because Homer was, of course, no longer a young artist. He was fifty years old in 1886, and much of the weightier, deeper, pondered meaning of the paintings he began making at about that time, in his middle age, contained a matured vision

of life, a tragic vision shaped by perceptions of mortality and destiny. It rankled also because Homer was no longer merely promising, with everything that implied of unrealized or imperfect achievement. For what was at stake in these paintings was Homer's determination to paint, as one critic described *The Herring Net* and *The Fog Warning,* "genuine pictures," pictures that were by the authority of their size, style, and substance, and by their definitive finality and formality, wholly and emphatically unprovisional. How much was at stake for Homer is suggested by the evident effort of their making. When *Undertow* was first exhibited early in 1887 it was reported that Homer had been at work on it for a year, and the many preparatory drawings that survive are tangible evidence of that exertion. To some degree the linear and plastic complexity of the figure group of *Undertow,* more complex by far than anything Homer had ever attempted earlier, explains that exertion. But it is also as if manifest complexity and exertion were, for Homer, in themselves tokens of earnest; proofs, by the seriousness and learning of which they were almost ostentatiously the visible evidence, of his artistic maturity. Perhaps it was this that the critic noticed who said *Undertow* testified to Homer's "mastery of his profession."

The Life Line

1884. Oil on canvas, 29 x 45"
Philadelphia Museum of Art

"No subject at the present moment is more replete with vital and romantic interest at home and abroad," said a writer in Harper's Magazine *in 1882, "than that of the American Life-saving Service." The subject's tragic possibilities were clear to the critic of the* New York Herald: *"The world is small above the trough of that tremendous sea" over which the figures in a breeches buoy are suspended by the lifeline that, as another writer pointed out, can "snap and break asunder like packthread." A writer in* The New York Times *in 1884 detected the subject's eroticism: The woman "has nothing on but her shoes, stockings, and dress, while the skirt of the latter has been so torn that her legs are more or less shown above the knees. Then, the drenching she has received makes her dress cling to bust and thighs, outlining her whole form most admirably." But, he added comfortingly, the painting's "sensuousness...is none the less admirable because, true as it is, it will not shock the most decorous." The Life Line was greatly admired and was purchased by the important New York collector Catharine Lorillard Wolfe.*

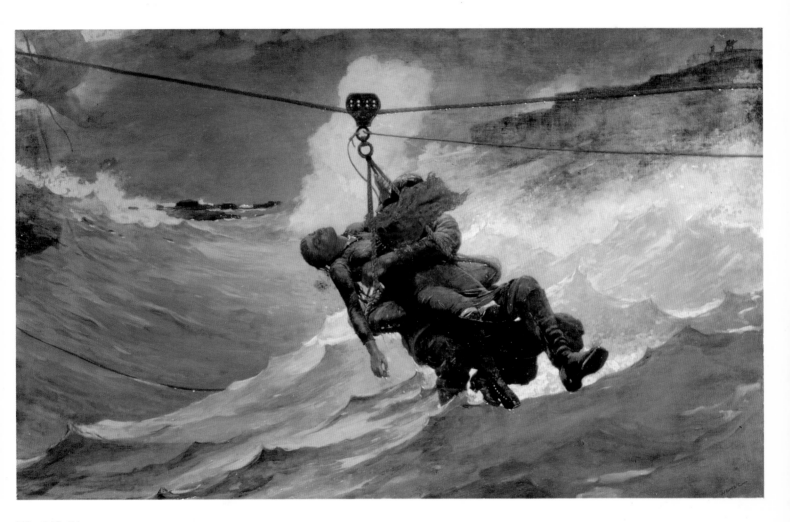

The Life Line

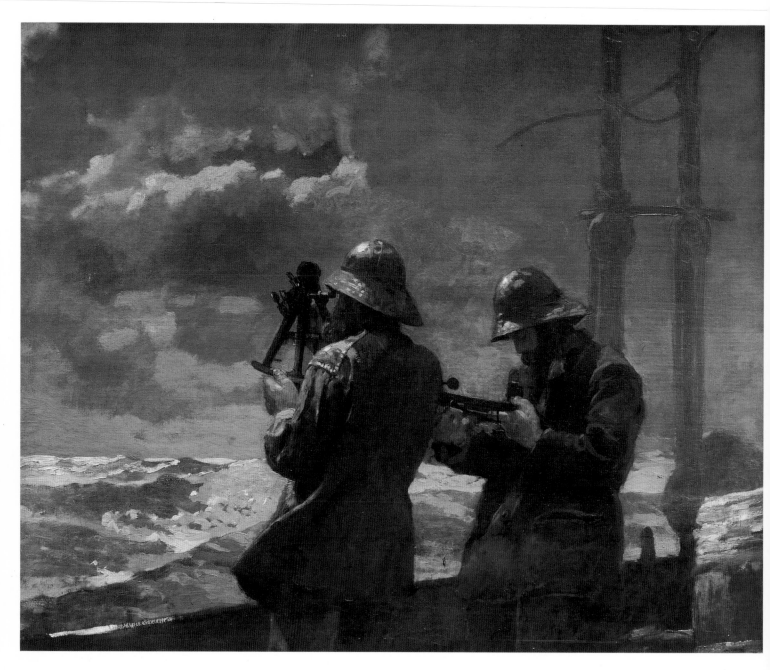

Eight Bells

VIII. Hermit of the Brush

H OMER LIVED IN NEW YORK after returning from England late in 1882. But at the end of May, 1883, several newspapers in Boston and New York reported that he planned to resettle "permanently" at Scarborough, Maine. In early December the *Boston Transcript* said "he has recently built himself a home and studio" on "the coast of Maine," and a few Maine subjects were included in an exhibition of his watercolors held in Boston at that time.

Homer and other members of his family had visited Prout's Neck, about ten miles south of Portland (Scarborough was its railroad station and post office), as early as 1875 and acquired land there. At about the time he decided to live at Prout's Neck his brother Arthur built a cottage there and his brother Charles bought a large house. It was the stable of Charles's house, The Ark, that Winslow made into his home and studio. The *Boston Herald* reported in 1884: "Prout's Neck is a narrow strip of picturesque land a few rods above the beach, and projecting into the sea, and on the narrowest point and boldest bluff of this neck is situated the little red cottage and studio of Winslow Homer. Here...the artist passes summer and winter, in profound and guardedly selected solitude, seeing no company, speaking to any of the natives only on business or necessity, and absolutely tabooing all curious visitors and sightseers. Except a month or six weeks in midsummer, he is not, to be sure, likely to be troubled with the latter; for, although there is a large hotel near Scarboro Beach and a smaller one at Prout's Neck, only the direst heat of the fashionable season lures guests hither, nor unless they have inherited the lungs of Norsemen and feel the tingle of Viking blood in their veins, will they care to remain longer...."

Prout's Neck was an inhospitable place, but Homer did not lead an ascetic or wholly isolated life there. In the summer he was close to his family, and all the year he enjoyed good food and drink with which he supplied himself from Boston and Portland. But the winters were long and severe, his studio was heated only by a single small stove (water froze ten feet from it and one winter he had to wear "rubber boots & two pairs of drawers" indoors to keep warm), and he was four miles from the post office and did not keep a team of horses (as he liked to tell potential visitors to discourage them). Then, his life was rigorous and lonely, and that was how he wanted it. "I like my home more than ever as people thin out," he wrote his brother Charles the second year he was there.

Homer's retirement to Prout's Neck was his most decisive and protracted act of retreat from society. In 1885, a writer in the *Lewiston [Maine] Journal*

Eight Bells

1886. Oil on canvas, 25⁷⁄₁₆ x 30⅛″
Addison Gallery of American Art,
Phillips Academy,
Andover, Massachusetts

"This picture of two seamen on the deck of a coasting vessel, quadrant in hand, taking the noon-day observation, the figures painted in sunlight with a heavy blackish sky of breaking clouds, and the rolling waves green and white-capped, forming the background, is painted in Mr. Homer's usual robust manner," the critic of the New York Evening Post *wrote when it was exhibited in 1888. "Quite the most remarkable picture in the exhibition," it established Homer, he believed, "in a place by himself as the most original and one of the strongest of American painters."*

described Homer's motives in settling at Prout's Neck as a mixture of misogyny, oddity, artistic utility, and misanthropy: "Wealthy and unmarried, [he] likes to be alone, and gratified an eccentric taste by building a studio at Prout's Neck because he found studies there that he liked and could keep out of the way of the world, against which he seems to have a grudge." If the move to Prout's Neck was caused by the same disappointment and disillusionment he experienced in the later 1870s, it seems, at the same time, less urgent and impulsive than his earlier acts of retreat, less a matter of renunciation than of a more positive need for a simpler life and for the almost philosophical consolation of solitude. Just after moving there in 1883 he suggested that one of the reasons he did so was to escape obligations of society that were more than he could deal with—or wished to. "You are extremely polite & how you can find time to be so & yet attend to your business & family is a mystery to me," he wrote an acquaintance. "If I had your gift of doing four things at once all equally well I could live in New York." In Maine, Homer escaped both the distracting and stressful conflicts of modern urban life, and its bothersome social duties (such as politeness). In 1888, he teasingly chided his brother Charles about the benefits of his simplified life: "Do not waste so much on appearances. You do not live well enough." He went on to describe how well he lived, having brought from Boston a leg of mutton, two spring chickens, Bermuda onions, an Edam cheese, six bottles of rum, and six bottles of rare old whiskey. And then he drew the lesson: "You see I can afford to live better than you can—as I cut off servants that mean all these good things—each one means about three legs of mutton—while you go without & eat corned beef & cabbage."

But a couple of years later he told Charles of what was surely the most important benefit of his new life, so far at least as his art was concerned. "I thank the Lord for this opportunity for reflection," he said (adding, with an ironic reference to the rigorousness which was the price he willingly paid for the opportunity, "I am grateful for the advantage I enjoy over Sir John Franklin," the famous arctic explorer who perished trying to find the Northwest passage). At Prout's Neck Homer found new subjects, like the seascapes he added to his repertory beginning in 1890. But the "opportunity for reflection" that his life at Prout's Neck gave him had a more immediate, more profound, and more pervasive consequence for his art. Reflection—compounded of meditation, self-examination, and thought, and manifested simultaneously as almost philosophic seriousness of meaning (what a writer in 1884 called "the painting of ideas"), in certain cases as self-reflection and self-expression, and as methodically contrived configurations of form (what another writer referred to as "artistic reasoning")—was the chief ingredient of all of his major art after his settlement at Prout's Neck.

These were the conditions that created and comprised the "ideal element" in Homer's art of the 1880s—that "ideal tinge," as a critic put it, "which lifts [his paintings] above the cleverest transcripts of mere prosaic fact." There was much talk about ideality in the later nineteenth century, and a great deal of art that

strove for the kind of elevated purity that was generally thought to constitute it. The ideality that Homer achieved was a very different thing. It lay essentially in the distillative, transmutative process first conspicuously at work in *The Life Line* of 1884 and, with similar effect, in all of Homer's great oils of mid-1880s. For it was precisely such a reformatory process, lifting experience above mere fact, upon which the achievement of true ideality depended.

If Homer's ideal style coincided with his move to Prout's Neck perhaps it was because, in addition to everything else that caused it, there, purposely removed from the impingement of prosaic reality—the pressures of time and society, the having to do four things at once and obeying the rules and requirements of social conduct—he achieved for himself something very like a condition of actual ideality. In 1895, after more than a decade of living at Prout's Neck, Homer wrote his brother Charles that, "The life that I have chosen gives me my full hours of enjoyment for the balance of my life. The Sun will not rise, or set, without my notice, and thanks"—an expression of contact with the eternal cycles of natural order that recalls Madeline Lee's desire to escape reality to live in the Great Pyramid and contemplate forever the polar star.

After his move to Prout's Neck myths and legends about Homer began to form. From the first he had been recognized as an artist of singular individuality and importance. But in the 1880s his stature began to grow to heroic proportions. References to his hermitic reclusiveness began immediately in 1884 and became a standard, colorful part of his legend. For a younger generation who knew him only through his paintings and by reputation his withdrawal contributed to an image that was larger than life. Deducing that image from his art, for example, a writer said in 1888: "A splendid, healthy, manly figure in art as in real life, we find Mr. Winslow Homer. He puts himself in everything he paints—big, strong, clear-eyed, and simple of speech, and of all the men in our art he does the greatest honor to the magnificent aphorism, 'The style is the man.'" Those who, on the basis of what they knew of his way of life and the nature of his subject matter and style, expected him to be large and rough were surprised by his actual appearance. Harrison Morris, director of the Pennsylvania Academy of the Fine Arts, who met Homer in 1896, "looked for a figure that would fit into the stories told of him at his studio near the wild breakers at Prout's Neck," but he "failed to agree with the conception I had formed." Homer, it turned out, had a "slender, smallish figure" and was "the essence of gentlemanly elegance" who "might have been taken, as he walked and talked at my side, for a successful stock broker." The following year the director of the Carnegie Institute, John W. Beatty, went to meet Homer who was coming to Pittsburgh to serve on an exhibition jury. Not seeing him at the station he asked the painter Frank Duveneck, another member of the jury who arrived on the same train that Homer was expected on, if he had seen him. Duveneck said he had not. Beatty then spotted Homer on the platform, whereupon Duveneck said, "Why, that's the little chap I rode with in the smoker all the way over the mountains, and we talked about everything but art."

Winslow Homer, c. 1880

Photograph by Sarony, New York
Bowdoin College Museum of Art,
Brunswick, Maine

In public, Homer dressed with care and in fashion, dashingly when young, more soberly when older (like a stock broker, as someone described him). His passport application in 1866 described him as five feet seven inches tall, his eyes brown, hair (which he lost in middle age) dark brown, and complexion dark.

Whatever his actual physical stature, Homer had achieved by the 1880s an artistic stature of virtually unrivalled importance (his only serious competitor, in the estimation of many of his contemporaries, was the landscape painter George Inness; but Homer had the field to himself after Inness's death in 1894). He was regarded as America's most authentic, most purely national artist; he was universally praised and his paintings were unhesitatingly called masterpieces. "He prefers to live on a rugged American coast, so that the world may see how much beauty and power even the most commonplace in Nature may exert upon our minds when glorified by the genius of a master," the artist and illustrator F. Hopkinson Smith wrote in 1894. In the same year the critics William Howe Downes (who, after Homer's death, wrote the first full-length biography of him) and Frank Torrey Robinson spoke with the same, and what rapidly became the characteristic, rhetoric of admiration: "Homer is a Yankee Robinson Crusoe, cloistered on his art island; he does not know what is going on in London, Paris and New York; why should he wish to? He is occupied with great things. When future generations come to look at what we have done in art they will proclaim him the great American painter of our epoch." Two years later, refining the formula, they stated that Homer is "the most truly and exclusively national painter ever reared in America." "Like Thoreau," they continued in explanation, "Winslow Homer is a recluse, for the reason that art of the sort he lives for is incompatible with the amenities of society.... No artificial refinements, no etiquette of the drawing-room, no afternoon tea chatter, no club gossip, for this hermit of the brush." As a result of this independence, both of society and of artistic influence, they concluded, "in him we may without extravagance lay claim to the possession of one of the few living painters of the world who can be called great artists."

Eight Bells

1887. Etching, 18⅞ x 24"
National Gallery of Art, Washington

In the 1880s, attempting to capitalize on their success and reflecting a widespread revival of interest at the time in the etching medium, Homer made a series of large etched prints after a number of his important pictures. They are not merely reproductive prints. Compositions were altered, and the colors and textures of pigments transposed into the linear and tonal medium of etching. Though Homer was self-taught and inexperienced as an etcher, his etchings have a largeness of effect, intricacy of line, and richness of texture that those by more practiced etchers rarely achieved. Homer thought highly of his etchings—years later he said some of his watercolors "were as good work, with the exception of one or two etchings, as I ever did"—but he made no more of them after the 1880s.

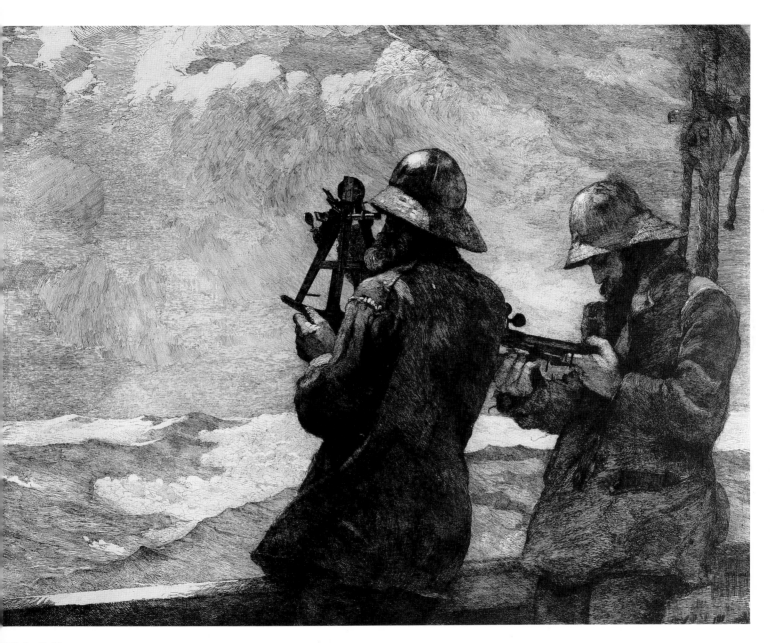

Eight Bells

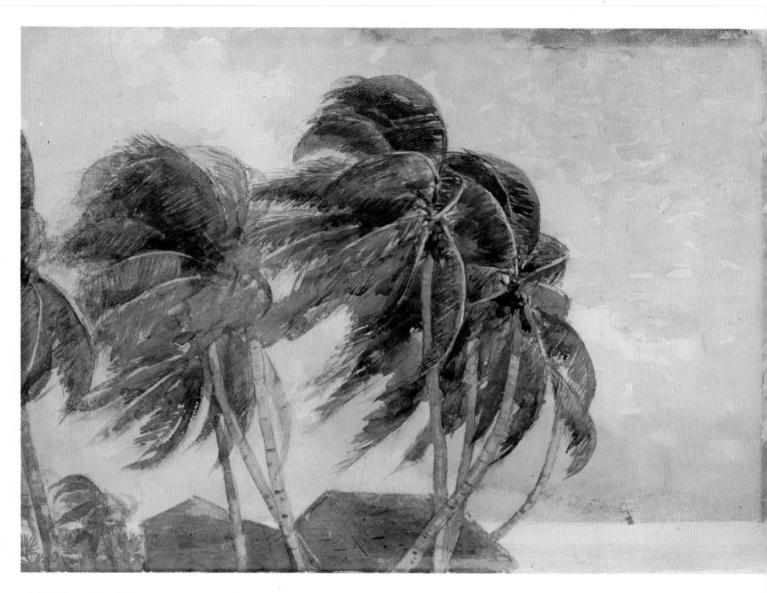

A Norther—Key West

IX. A Ceaseless War

A S HE RESTRUCTURED HIS LIFE by choosing to live at Prout's Neck so Homer also restructured his artistic practice; as he simplified one, so he simplified the other. In the 1860s and 1870s Homer worked in a number of mediums often simultaneously and sometimes interchangeably: He painted in oils and watercolors, made drawings, and designed wood engravings. But by the 1880s he no longer made prints (except for a splendid series of large etchings after some of his important paintings), and, despite the wonderfully powerful drawings he made in England, he drew less and less. By the 1880s Homer had essentially reduced his mediums to two—oils and watercolors—and made the difference between them emphatic, doing in each very different things and for the most part treating different subjects. He tended to concentrate his efforts in painting on single large pictures (in contrast to his earlier tendency to work serially and thematically). And whereas earlier oils and watercolors might depict the same subjects and even share similar techniques (watercolors made with the opacity of oil pigments, oils with the fluidity and transparency of watercolor), now the two mediums diverged drastically in their responsibilities of subject, technique, and purpose.

The watercolors were made chiefly on a succession of campaigns. As a respite from the rigors and loneliness of Prout's Neck winters, and also to fish, Homer made trips to the Caribbean, Bermuda, and Florida. An avid fisherman, he also made summer trips to the Adirondacks and Canada. While he fished, he also worked seriously. "I commence work & play tomorrow—& expect to show you something when I return," he wrote the collector and dealer Thomas B. Clarke from Florida in 1890. He painted watercolors for his own pleasure, of course, but also because he realized that his watercolors, particularly of fishing subjects, were popular and saleable. "As I shall go up [to Canada] for the Spring fishing," he wrote his dealer Knoedler in 1903, "I will take my sketch block & will give you a full line of goods for next Season." He apparently even made some specially for the market; for an exhibition in 1904 he painted what he called, in another letter to Knoedler, "a 'fake' lot of stuff...as a special opening of the fishing season."

But he also painted watercolors because they represented something that he had expelled from his oil paintings. As his oils increasingly became paintings of ideas, his watercolors became in inverse proportion Homer's contact with visual experience and his means of recording visual sensation. As his oils be-

A Norther—Key West

1886. Watercolor, 13⅛ x 19½"
The Fine Arts Museum of San Francisco,
Achenbach Foundation for Graphic Arts.
Gift of Mr. and Mrs. John D. Rockefeller 3rd

A writer for the New York Sun *spoke of "its wind-lashed palm trees, its lurid grey sky, and its glimpses of livid pale green sea—as intensely dramatic a bit of work as a landscape painter could well produce." On the first of several trips to Florida, Homer captured the fury of a tropical storm with an almost oriental compositional refinement and symbolic rather than imitative descriptiveness.*

97

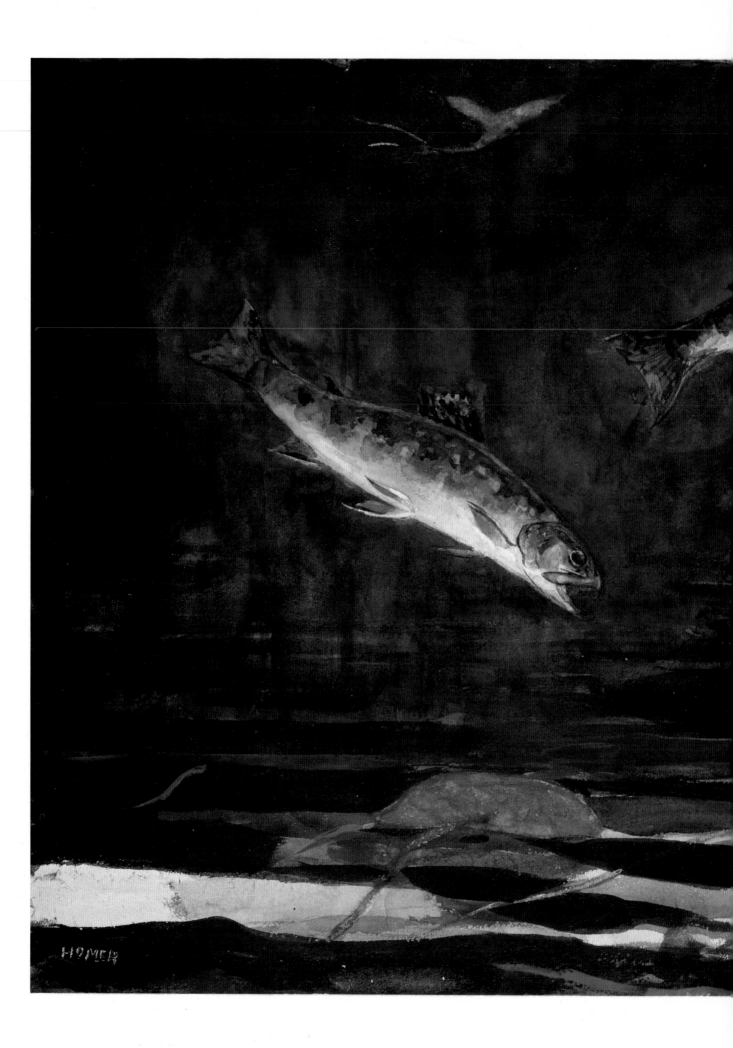

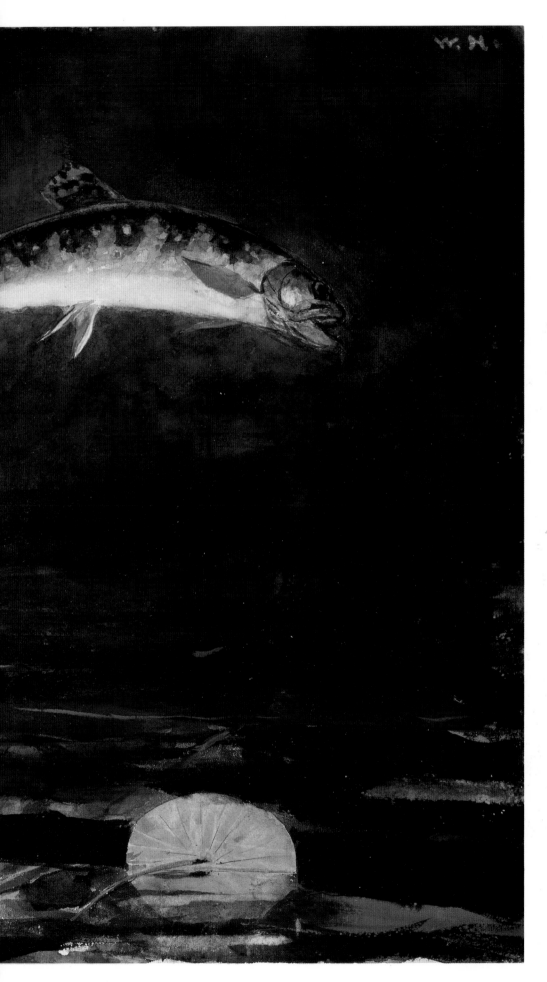

Leaping Trout

1892. Watercolor, 13⅞ x 19⅞″
Museum of Fine Arts, Boston.
William Wilkins Warren Fund

"It is the trout fishing pictures," a critic at
The New York Times *wrote of the Adir-
ondack watercolors, "that are the richest
in color and done with the greatest pleas-
ure. Two trout leaping together from the
flat disks of the lily at the same dra-
gonfly—and missing it—form a picture
that sportsmen will delight in. They be-
long to the most brilliant variety of that
game fish, and sweep through the air like
tropical birds, with their brilliant spots
and ruddy fins fully displayed. The sur-
face of the lake is wrought with a rare
sense of color. Lily leaves overturned by
the wind show their pink and violet under-
sides, and one feels, rather than distinctly
sees, the background of sombre forest."*

came more mindful of tradition, more gravely serious, more universal, and more distant from direct observation (by 1897, to an artist like A. T. Bricher whose practice it was to paint directly from nature, Homer was regarded as "a studio painter"), his watercolors became more daring in form and color and brilliant in technique, and more specific in subject and effect. As his oils became more carefully pondered and plotted, his watercolors became ever fresher and more immediate.

Homer made his first trip to the Caribbean in 1885, visiting Nassau and Cuba. He went to Florida for the first time in 1886, and Bermuda first in 1899. He revisited Nassau in 1898, Florida four more times between 1890 and 1908, and Bermuda again in 1901. With each trip, it seems, his watercolor style became increasingly decisive and assured, and increasingly pure. Its flowing washes of pigment and their interplay with the white of the paper became more and more independent from anything possible in oils, and more and more independent from the armature and structure that drawing could provide.

What is also remarkable about these watercolors is their capacity for capturing, with little apparent tentativeness, the intense colors, moisture-laden atmosphere, and lush vegetation of the tropics, for which nothing in the available precedents of landscape art or Homer's own experiences—especially not his most recent, utterly different experiences of Cullercoats and Prout's Neck—could have adequately prepared him. His instinctive responsiveness to the tropics beginning in the later 1880s—"it is certainly the richest field for an artist that I have seen," he wrote from Cuba in 1885 on his first Caribbean trip, and twenty years later said "I think the Bahamas the best place I have ever found"—is comparable, of course, to Paul Gauguin's attraction to Martinique and Tahiti at about the same time.

Some of Homer's greatest and most powerful watercolors, however, were made in a very different place—the Adirondacks of upper New York State. Homer's Adirondack watercolors are some of his most sheerly beautiful works. But as a group they also contain some of the most poignantly moving, compassionate, and even indignant paintings that he ever made.

Homer went to the Adirondacks to fish (he was a member of the North Woods Club, near Minerva), and fishing subjects are a large part of his Adirondack watercolors. Fishermen cast flies in the glassy stillness of early morning or evening calm. Fish leap for insects or for the fishermen's bait. Homer captures the most momentary effects: whipped arcs of fishing lines (sometimes incised through the pigment into the white paper by the point of a pen knife that in the speed and deftness of its gesture mimics the action it depicts); the dark surface of the water broken by casts, leaping fish, or landing insects (scraped through the surface of the pigment as the water itself is broken); rising fish suspended in mid-air.

Homer painted a whole series of leaping fish. By their opulent color and texture and their exquisite design they transform the most conventional, indeed the canonic, fishing subject into some of Homer's freshest and loveliest water-

colors. It was particularly his ability "skillfully to suggest motion," a critic believed, that enabled Homer "to avoid that curiously base quality which nearly always characterizes 'sporting' pictures of all kinds." Homer could not have captured the leaping fish from life; he painted these convincingly momentary events from dead fish suitably posed. In this sense, these watercolors are the closest Homer came to painting still lifes. They are so vividly alive and instantaneous that they do not register as contrived and immobile still life arrangements, and Homer probably never thought of them as still lifes. But it is interesting nevertheless that they were painted in the great age of American still life, the time when so many other American artists were attracted to still life or specialized in it.

The late nineteenth century was the heyday of sport fishing and outdoor recreation in America. Homer's interest in fishing, therefore, was one he shared with many others—while at the same time contributing his share to the thriving market for paintings of "a fishing & sporting character," as Homer described some of his Canadian sketches, that the popularity of the sport generated; "fishermen will like them," he said. But in the Adirondacks there were not only those who fished and hunted for sport. Deer were killed for meat or for trophies by commercial hunters, and many of Homer's most powerfully moving paintings, in watercolor and oil, depict almost step by step the savage method of "hounding" deer to death by using dogs to drive them into water where they could easily be drowned or shot by hunters who awaited them in boats. Following the Civil War, Adirondack forests were wantonly destroyed by commercial logging, and a number of Homer's paintings depict that process and its legacy of devastation. Homer depicted the human denizens of the Adirondacks—guides, hunters, trappers, and woodsmen (who were often all of these things interchangeably)—with heroic strength and dignity, and in solemn moments of sympathetic communion with the land in and from which they lived. But he also depicted their inhumane cruelty to life and nature, doing so, what is more, with an intensity of feeling that charged many of his Adirondack paintings with compassion and indignation. An aroused conscience dislodged him from his usual posture of ironic detachment and impelled him to make the most touching, angry, overtly critical paintings of his life.

This conscience is felt in the dead and dying animals and the remnants of devastated forests that Homer depicted with unvarnished directness—in certain cases, such as the watercolor *A Good Shot* of 1892, as a compellingly momentary and immediately observed experience. But he also expressed himself differently. For in addition to such touching solicitations of feeling as *A Good Shot* or other detailed, serial reports on the depredations of nature, in *Huntsman and Dogs* (1891) and *Hound and Hunter* (1892) Homer addressed that issue on another level and in the medium—oils—that he reserved in his late works for his most summary, measured, and thoughtful pictorial statements.

The figure in *Huntsman and Dogs* and *Hound and Hunter* and also *The Blue Boat* and possibly *The Woodcutter* (like the older man who appears in *Adirondack*

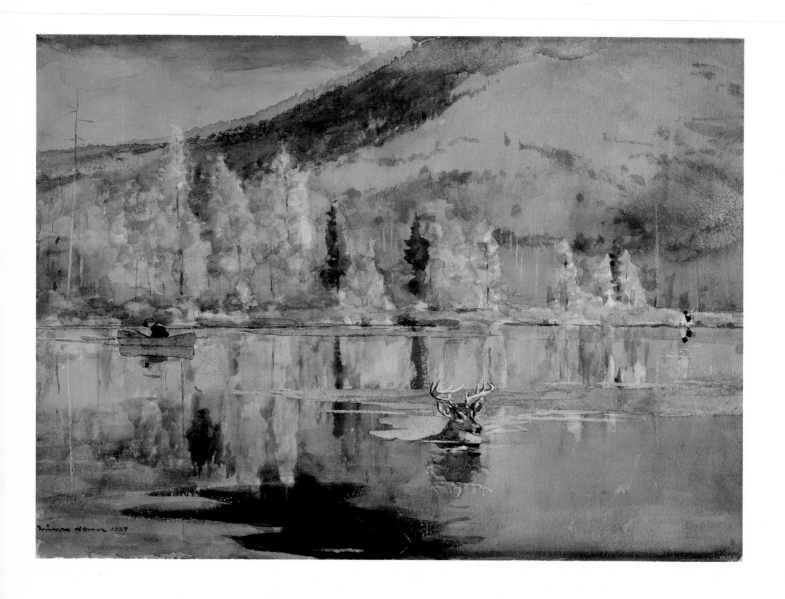

An October Day

1889. Watercolor, 13⅞ x 19¾″
Sterling and Francine Clark Art Institute,
Williamstown, Massachusetts

"One of the more 'important' hunting scenes" that, with fishing subjects, comprised Homer's first Adirondack watercolors, "is an autumn scene, a lake wherein a deer swims hard and fast before a boat," the New York Tribune *reported in 1890. "The shores and mountains are splendidly dressed in the red and yellow robes of autumn, and there are vivid blue tones in the water of the lake. The coloring is intense, but it is neither unreal nor unpictorial." In this lovely setting a brutal event transpires: A deer, "hounded" from the woods by the dog on the shore and helpless in the water, will be shot or drowned by the hunter following in the boat.*

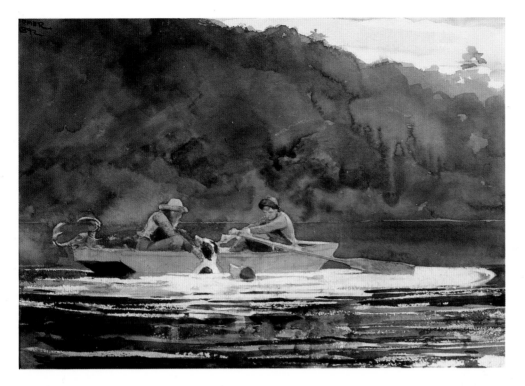

The End of the Hunt

1892, Watercolor 15⅛ x 21⅜".
Bowdoin College Museum of Art,
Brunswick, Maine.
Gift of Misses Harriet and Sophia Walker

Although painted at different times, a number of Homer's watercolors describe the processes of fishing and hunting in the Adirondacks in an almost sequential way. Here, the deer driven into the lake has been killed—drowned, clubbed, or shot—and the dogs that pursued it are being pulled into the boat.

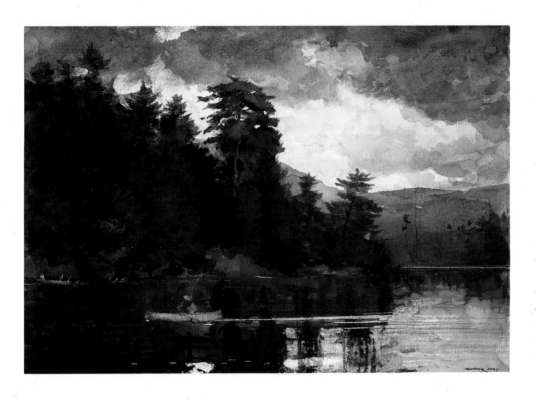

Adirondack Lake

1889. Watercolor, 14 x 20"
Museum of Fine Arts, Boston.
William Wilkins Warren Fund

"The Winslow Homer water-colors were all of fish, fishing, and hunting in the Adirondacks," a writer in The Art Amateur *said of the first exhibition of the Adirondack watercolors at the Reichard gallery in 1890, "and were marked by those bold effects of color, extreme breadth and facility of treatment, and that science of abstraction on which this artist has based his powerful style."*

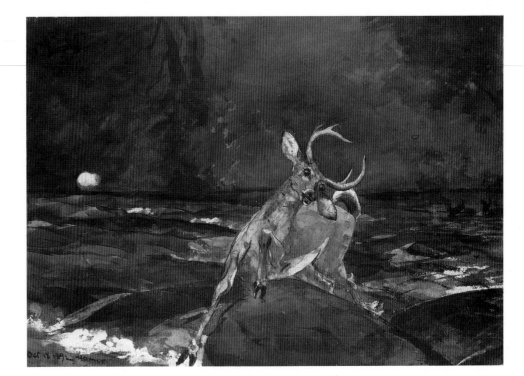

A Good Shot

1892. Watercolor, 15¹⁄₁₆ x 21¹¹⁄₁₆"
National Gallery of Art, Washington.
Gift of Ruth K. Henschel, in memory of her
husband, Charles R. Henschel, 1975

*Cast in the convention of sporting images
that celebrate feats of hunting, like this
"good shot," Homer's moving depiction of
a deer at the instant of its death is more
profoundly an almost epiphanic experi-
ence of mortality.*

Guide and a number of other Adirondack watercolors) is a portrait of an actual
person. It is not his individuality that matters—except to the extent that it adds
authenticity to the Adirondack type that the figure represents. He represents
something larger than locality, and something deeper; something that connects
Homer's images to an idea that touched virtually every aspect of the intellectual,
cultural, and political life of the late nineteenth century. The bloody trophies
that the huntsman carries (in a related watercolor *Guide Carrying Deer* [1891;
Charles Shipman Payson Collection] he carries the entire carcass of a deer) or
the deer he drowns (or has already drowned or shot); the whitened stumps of
cut trees; the wildly baying dogs; and the hunter's coarse and brutal features, all
express a state of almost animal savagery and elemental barbarism.

Homer's late works can in certain general ways be associated with the evolu-
tionary theories of Charles Darwin—the great oils of the 1880s, for instance, in
which anonymous figures are engaged with a kind of instinctual intensity in a
struggle the outcome of which is never certain or predetermined, seem to exem-
plify the random, blind, uncaring processes of Darwinian evolution. But *Hunts-
man and Dogs* and *Hound and Hunter* are more truly Darwinian. More directly,
less metaphorically, they address the most deeply disturbing yet most compel-
ling of Darwin's ideas, the evolutionary descent of man (Darwin published *The
Descent of Man* in 1871) from lower forms of animal life. Both paintings reflect
the widespread fascination, nurtured by Darwin's theories of human develop-
ment, with humanity's earlier savage stages and the supposed survivors of those
stages—Hottentots, Indians, aborigines—that could be the link between civil-
ized man and his animal ancestors. *Huntsman and Dogs* (the hunter, a critic said,

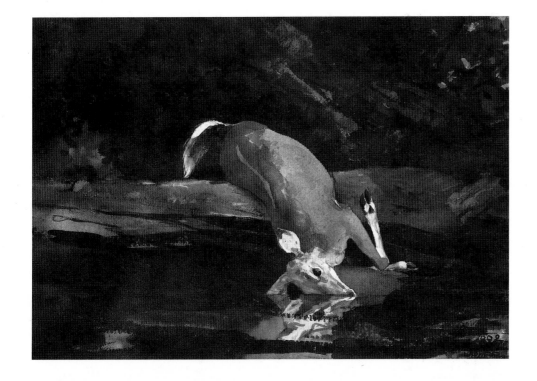

Fallen Deer

1892. Watercolor, 13¾ x 19¾"
Museum of Fine Arts, Boston.
Charles Henry Haydon Fund

Although he often worked in series Homer seldom used the narrative device of pendant images as he did in these watercolors to express with the greatest possible explicitness his outrage at the brutal killing of deer in the Adirondacks by professional hunters. On the rear of Fallen Deer *he wrote, "A miserable [illegible] Pot hunter."*

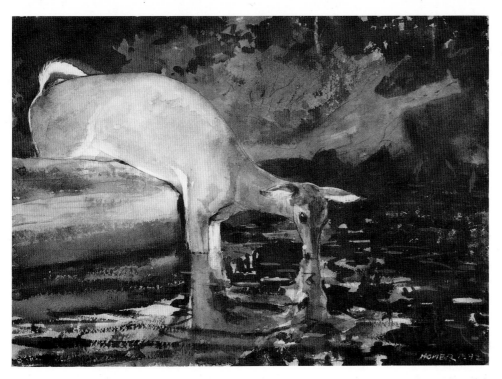

Deer Drinking

1892. Watercolor, 14¹⁄₁₆ x 20¹⁄₁₆"
Yale University Art Gallery,
New Haven, Connecticut.
The Robert W. Carle, B.A. 1897 Fund

"low and brutal in the extreme") and *Hound and Hunter* do not simply describe morally reprehensible ways of hunting deer in the Adirondacks or portray an Adirondack type. Suggesting by his savagery and somewhat simian appearance that the hunter is linked atavistically to a stage of human development below that of civilized man—by situating him, that is, on an evolutionary scale—

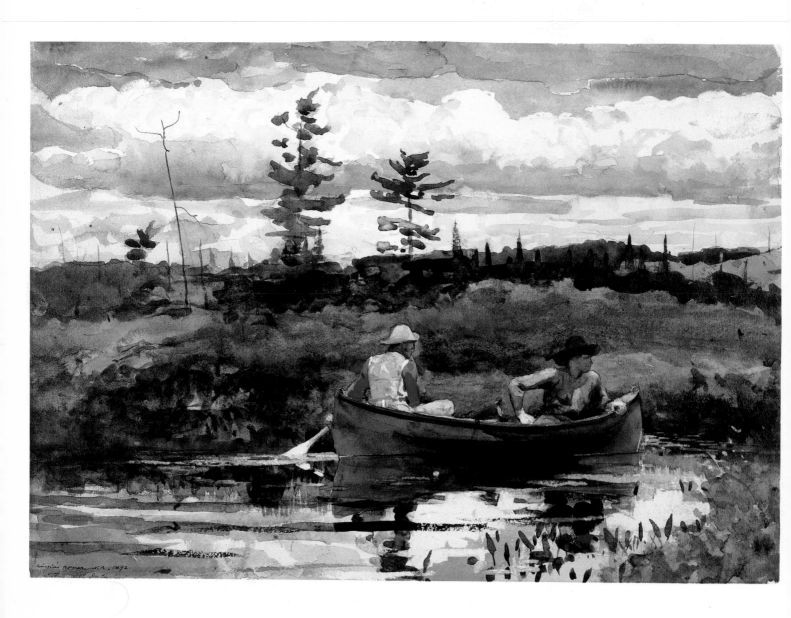

The Blue Boat

1892. Watercolor, 15⅛ x 21½″
Museum of Fine Arts, Boston.
Bequest of William Sturgis Bigelow, 1926

"We have looked over a portfolio of his watercolor sketches of the Adirondacks, where he has lately been hunting, armed with a box of watercolors and those big brushes which he wields with such bewildering skill," wrote a correspondent of the Boston Transcript. *"He gives a wonderfully vivid idea of the immense scale of things, the wildness, the grandeur, the rudeness, and almost oppressive solitude of the great Northern forest. Against this strange and stupendous background, as is his wont, he projects the virile and sinewy figures of the hardy out-door type of fearless men—the hunters, guides, and fishermen of the wilderness."*

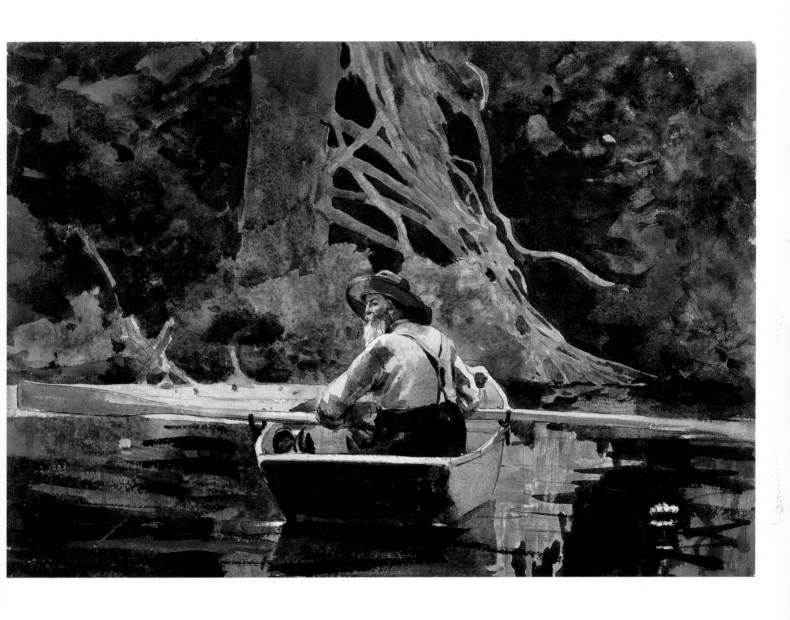

The Adirondack Guide

1894. Watercolor over graphite, 15⅛ x 21½″
Museum of Fine Arts, Boston.
Bequest of Alma H. Wadleigh

The figure of an older guide, often in moments of meditative absorption, recurs in Adirondack watercolors of the early 1890s. Charles Dudley Warner wrote of the Adirondack guide, Orson "Mountain" Phelps, "in all that country, he alone had noticed the sunsets, and observed the delightful processes of the seasons, taken pleasure in the woods for themselves, and climbed mountains solely for the sake of the prospect." The unusually beautiful and almost arbitrarily intense color suggests in artistic terms the source and the degree of the guide's rapt contemplation.

Hound and Hunter

1892. Oil on canvas, 28¼ x 48⅛″
National Gallery of Art, Washington.
Gift of Stephen C. Clark

To soften somewhat the apparent brutality of his subject, which he described simply as "A man deer and dog on the water," Homer insisted that the hunter was not drowning the deer, as he seems to be doing, but tying an already dead deer to the boat. "The critics may think that that deer is alive but he is not—otherwise the boat & man would be knocked high & dry," he explained to the collector Thomas B. Clarke. "I can shut the deers eyes, & put pennies on them if that will make it better understood."

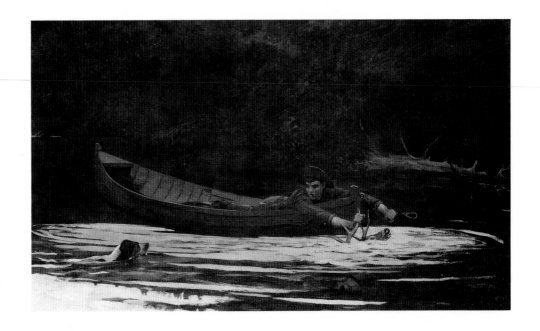

Homer casts upon these images the light of the greatest scientific and intellectual issue of his time. (Homer was not alone in perceiving that issue and giving it the form he did; DeWitt Lockwood exhibited a painting entitled *Prehistoric Hunter* in the annual exhibition of the National Academy of Design in New York in 1891, the same year that Homer painted *Huntsman and Dogs*; it is also reflected, somewhat differently, in George de Forest Brush's *Celtic Huntress* of 1890 [Fine Arts Museums of San Francisco].)

The Darwinian biological principle of natural selection, when translated into the concept of "the survival of the fittest" (coined by the English philosopher and sociologist Herbert Spencer) and applied in what is commonly called Social Darwinism to the description of human society, was the most widespread and popular application of evolutionary thought, particularly in late nineteenth-century America. In the epoch of high industrial capitalism it justified unregulated competition, social inequality, and economic hardship as results of the impartially selective processes of natural law. As images of the struggle for survival, *Huntsman and Dogs* and *Hound and Hunter* were emblems of the age. They are, however, deeply equivocal images—reminders of the depravity and brutal savagery of the struggle, but also that fitness did not necessarily convey morality, or survival confer civilization—and in that way, perhaps, they become Homer's mordant commentary on his time. (In this connection, one of the offshoots of Darwinian evolution was the "criminal anthropology" of Cesare Lombroso that became widely influential in the 1890s. Lombroso claimed that criminality was atavistic, a throw-back to a savage state that was recognizable, he believed, by such apish "stigmata" as long arms, large jaws, low and narrow foreheads, and darker skin—traits of appearance that are visible, perhaps, in Homer's hunter and that, if so, brand him according to Lombroso's theory as a criminal type.)

A CEASELESS WAR

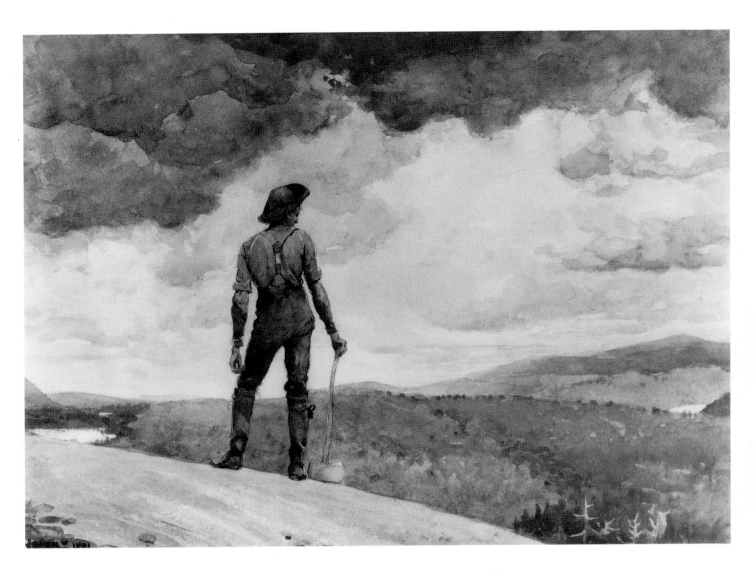

The Woodcutter

1891. Watercolor, 13¾ x 20″
Private collection

"The public mind has been thoroughly aroused to the peril that threatens the Adirondack woods," said a writer in Harper's Weekly *in 1891, and so was Homer, as moved by the wanton destruction of the Adirondack forest as he was by the brutal hunting of deer. This tersely symbolic image of a woodcutter surveying an expanse of woods from a deforested mountain was made one year before the creation of the Adirondack State Park, preserving over three million acres of forest from destruction.*

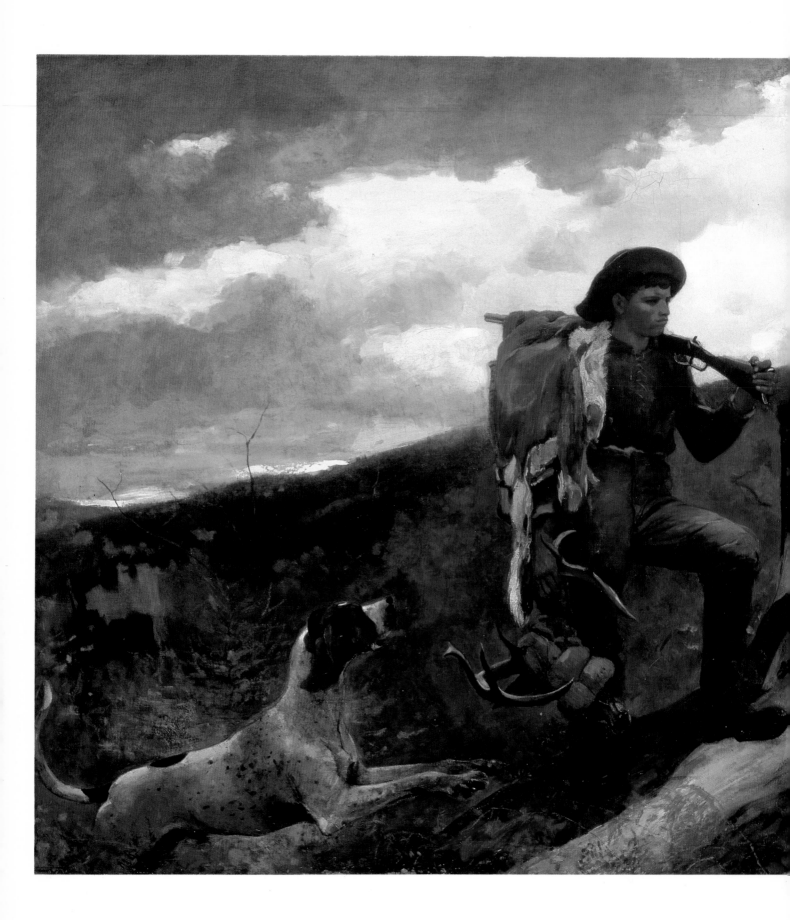

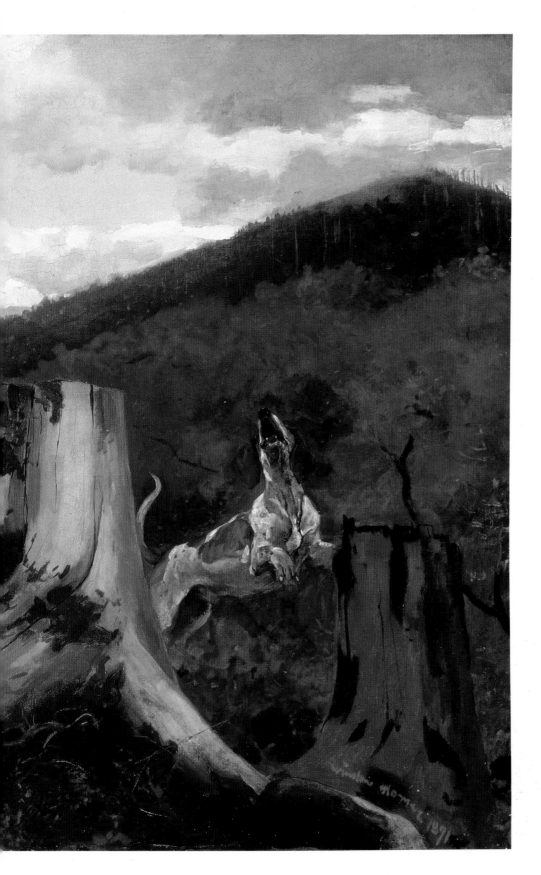

Huntsman and Dogs

1891. Oil on canvas, 28 x 48"
Philadelphia Museum of Art.
The William L. Elkins Collection

One of the most powerful of Homer's Adirondack paintings, Huntsman and Dogs is an image of primordial savagery. "Every tender mercy of nature seems to be frozen out of it, as if it were painted on a bitter cold day, in crystallized metallic colors on a chilled steel panel," Alfred Trumble wrote in The Collector in 1892. "He is just the sort of scoundrel, this fellow, who hounds deer to death up in the Adirondacks for the couple of dollars the hide and horns bring in, and leaves the carcass to feed the carrion birds."

Homer's Adirondack paintings are not his only "Darwinian" ones. *Fox Hunt* is another. It is one of Homer's very greatest works of any period, and his largest. Searching for food—the meager sprig of berries to which it slogs desperately through the deep snow of a hard Maine winter—the fox is suddenly attacked by crows who, in an inversion of the usual natural order, have become predatory from hunger. *Fox Hunt* is an intensely haunting image of the struggle of survival in its most primal form. Yet Homer described it as a "*very beautiful picture.*" Borrowing without dissemblance from the formal strategies of Japanese art, he cast his violent subject in the most delicately subtle pictorial form. What Homer had in mind by this contrast between his subject and its aesthetic dress we do not know. If he intended a kind of allegory of civilization and savagery, that is consistent with the sort of ironic allusions that other aspects of this painting make more clearly: Its title, for example, that invokes the "civilized" sport of fox hunting to describe a primordial Darwinian struggle and thereby suggests their equivalence; or his signature at the lower left, echoing the position of the fox and like it sinking helplessly into the snow, by which Homer cleverly identifies himself with the fox's plight.

Perhaps Homer's grandest Darwinian subject was the one he introduced into his art in 1890. In that year he made the first of the series of seascapes that he painted until his death twenty years later, the paintings that his contemporaries almost universally considered to be the greatest achievement of his career. He painted no other subject for so long. But then no subject was for so long, or so intimately and insistently, part of his experience as was the seacoast at Prout's Neck. On walks, or from the balcony built from the second floor of his studio, he observed and depicted it in every season, mood, and condition of weather. Seascape was a new subject for Homer, and one taken up late in life, yet he made it wholly his own (as he had made tropical landscape his own a few years earlier). He stamped it with the acuteness of his vision, the depth of his emotional and intellectual experience, and the largeness and strength of his character—for to paint the sea as he did required a special strength of character: "The fierce fight intermittently waged between the mighty ocean and beetling shore [at Prout's Neck] would soon drive home the human hummingbird of ordinary seaside existence," an anonymous writer in the *Boston Herald* said. By his artistic power and expressive force Homer revised the painting of the sea so completely beyond anything it had been before in American art that the paintings by such contemporary seascape specialists as A. T. Bricher and William Trost Richards are merely pretty in comparison to his definitive, iconic, images.

If Homer painted the sea with such concentration and understanding it was because at Prout's Neck he had an intense experience of it. He had, however, painted it often beginning about 1870, and at Cullercoats in the early 1880s he had responded to the sea with similar intensity. But if none of those earlier encounters had the same result, it was not so much the experience itself that had changed but Homer's understanding of it—the conceptual framework, the philosophical perspective, that gave that experience meaning. It is suggestive, from this point of view, that Homer's greatest seascapes are invariably in oil, not

A Summer Night

1890. Oil on canvas, 29½ x 39¾"
Musée d'Orsay, Paris

In this, the first of a series of seascapes that would become some of Homer's most celebrated paintings, silhouetted figures on the shore gaze at the moonlit sea while two women, as though under a lunar spell, dance on a porch (the painting was originally titled Buffalo Gals *from the song of the same title with the refrain: "Buffalo Gal won't you come out tonight and dance by the light of the moon?"). Homer had always been alert to double meanings, often using punning titles to suggest them, but his art of the 1890s was often more positively enigmatic and even mysterious. A* Summer Night *was purchased for the Luxembourg Museum from the Universal Exposition of 1900.*

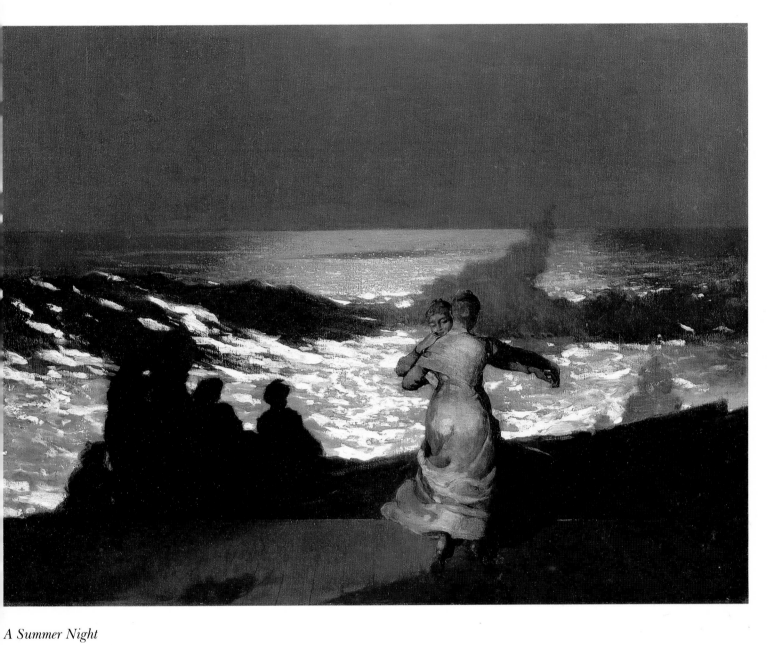

A Summer Night

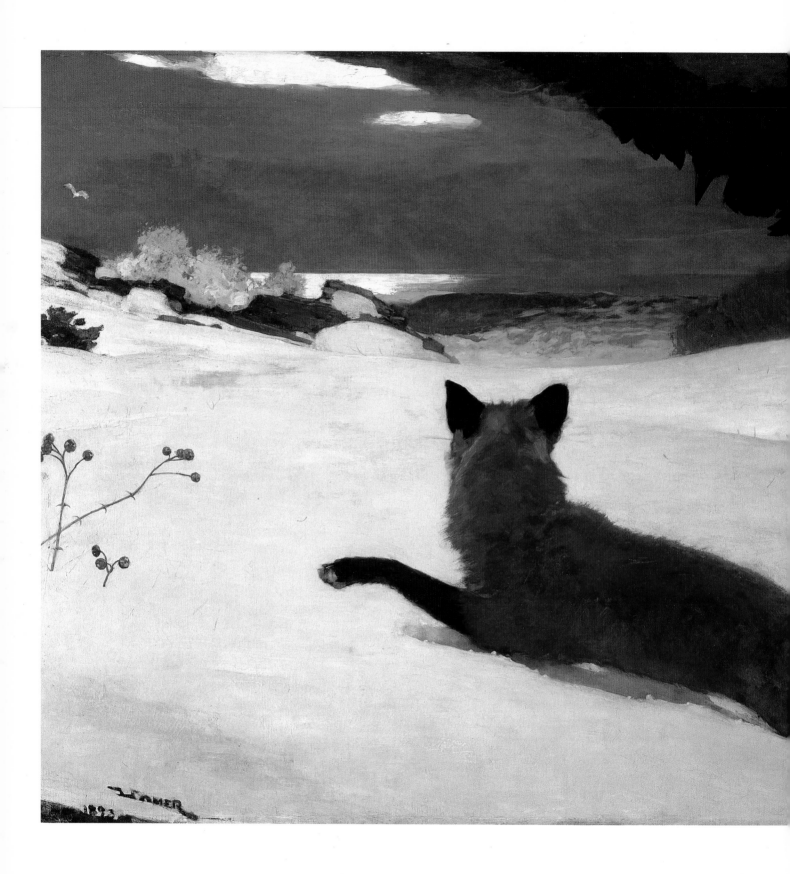

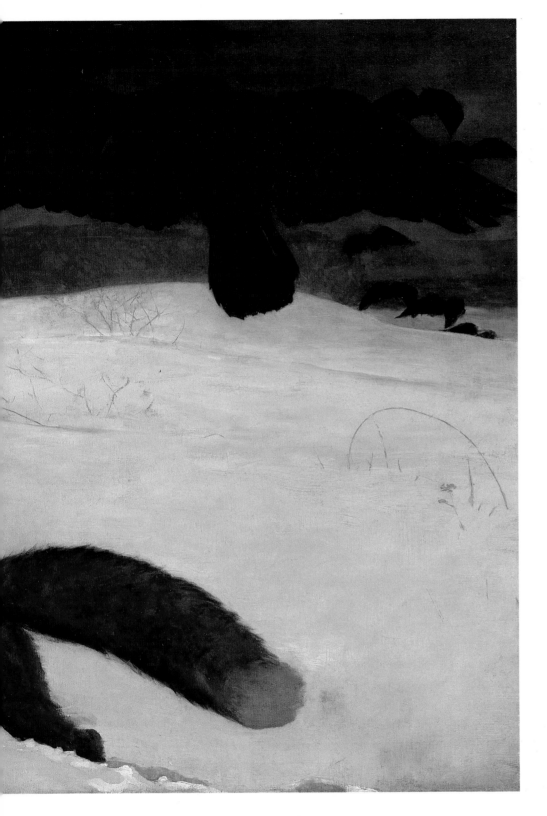

The Fox Hunt

1893. Oil on canvas, 38 x 68"
The Pennsylvania Academy
of the Fine Arts, Philadelphia

"The subject is very novel, and requires a word of explanation as to the fact in natural history of which it is a dramatic illustration," the Boston Transcript *wrote. "In the depths of winter, when the ground is for long intervals covered with snow along the coast of Maine, it is observed that a flock of half-starved crows will have the temerity to attack a fox, relying on the advantage of numbers, the weakened condition of the fox and the deep snow, which makes it the more difficult for the victim to defend himself." "There is something very impressive and very solemn about this stern and frigid landscape,"* the writer *added, "and it is a fit scene for the impending tragedy that threatens the fox." Of this novel, dramatic, and tragic subject Homer painted his largest picture, and the first to enter a public collection when purchased by the Pennsylvania Academy of the Fine Arts in 1894.*

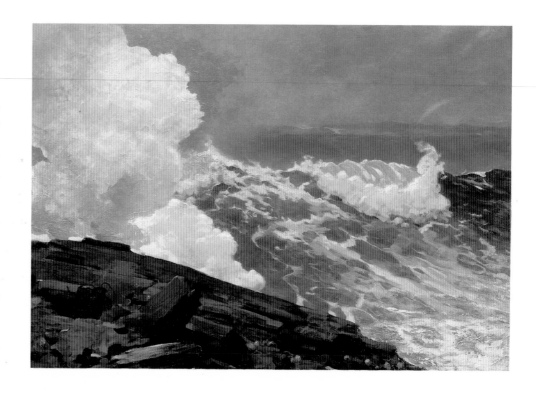

Northeaster

1895. Oil on canvas, 34⅜ x 50¼"
Metropolitan Museum of Art, New York

Many of Homer's contemporaries considered this the greatest of his seascapes. It was awarded two gold medals, once in 1895 and again (after Homer had repainted it) in 1902, when a critic for the New York Evening Post wrote, "The picture is instinct with the grandiose beauty of the storm.... Behind the great wave, which is the hero of this ocean epic, the menace of two others, the actual forms of which are lost between lowering sky and flying mist, is perceptibly felt. One turns away...with a heightened realization of the ocean's ceaseless war with the land...."

in watercolor (although he painted some in watercolor); they are painted in the medium Homer reserved for his most deliberated expressions of emotion and ideas instead of the medium—watercolor—by which he recorded immediate experience. Homer's new and pure interest in the sea was not, in other words, solely a response to a new, or newly intensive experience, however impressive that experience undoubtedly was, but to an idea of which that experience was the most compelling embodiment.

Instead of depicting those commercial, recreational, social, or heroic transactions that were the routine subjects of seascape—sailing, fishing, bathing, lifesaving, shipwrecks, all the things he had himself depicted earlier—Homer, as only very few artists had done before (Turner and Courbet most importantly), concentrated on the physical dynamics of the sea itself. In the sea the nineteenth century read with particular clarity lessons that the revolutionary sciences of geology and biology taught about the vast, unceasing, unfeeling operations of natural processes of change through struggle. As the Harvard geologist Nathaniel S. Shaler wrote in 1892, at about the time Homer began to paint the subject in earnest, "the contest between land and sea is the most ancient, far extended, and unbroken of all the many combats which make up the life of this sphere." This primal process was what Homer's critics felt his seascapes expressed. Of *Northeaster* (1895), one wrote in the *New York Evening Post* in 1902, "One turns away from it with a heightened realization of the ocean's ceaseless war with the land." Another, in the *New York Sun* in 1901, spoke of "the elemental force of rock, ocean, and sky" in *West Point, Prout's Neck* and *Eastern Point, Prout's Neck* (both 1900).

A CEASELESS WAR

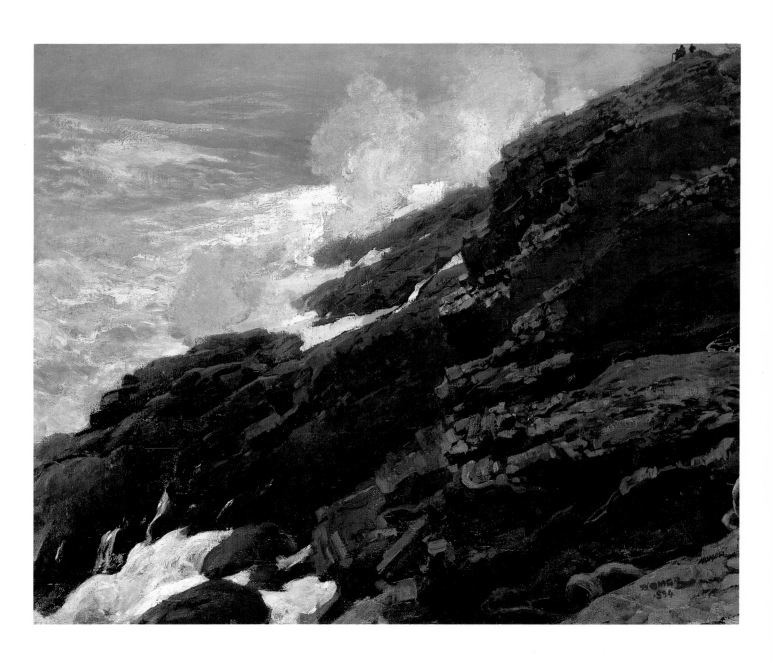

High Cliff, Coast of Maine

1894. Oil on canvas, 30⅛ x 38¼"
National Museum of American Art,
Smithsonian Institution, Washington.
Gift of William T. Evans

Homer's late seascapes no longer depicted what people did on the sea, or at it, but the elemental dynamics of the sea itself. The small figures in the upper right represent the marginal and impotent passivity of humanity in relation to this eternal natural process.

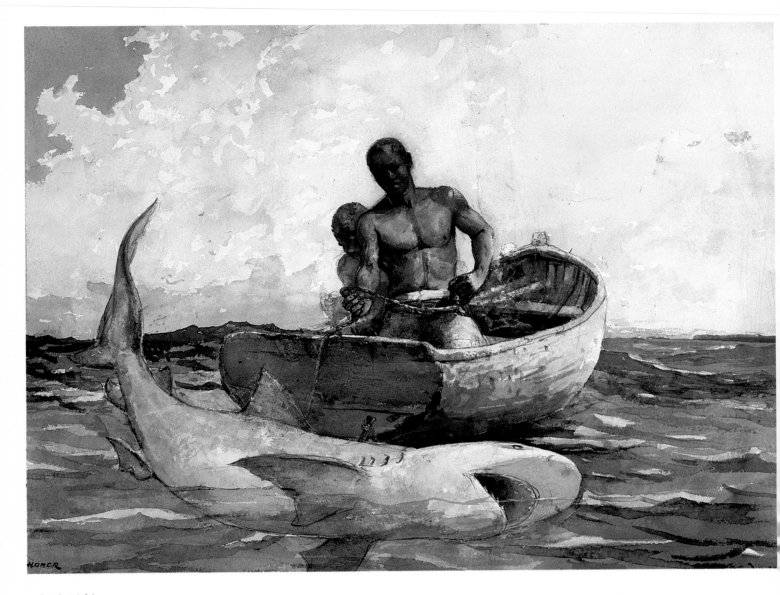

Shark Fishing

X. A Signal of Distress

HOMER'S LATE PAINTINGS SEEM REMOTE from the life of his time, just as he himself chose to live remotely from it. Subjects like fishing and hunting or seascapes, places like the coast of Maine, the tropics, and the Canadian wilderness are in every way—what they depict and where they were made—distant from the great social and political events of his age. And yet, as his paintings of the early 1890s suggest, Homer could be, perhaps because of his very distance from it, a sensitive and intelligent analyst of his time. While in the 1860s and 1870s he had observed his age at closer range and had depicted the texture of its manners and appearance in more detail, in later life he depicted it with greater—with keener and subtler—critical penetration and a more synthetic, connective understanding; a penetration that perceived deep meanings and an understanding that joined experience and ideology to forge, beginning with his great paintings of the 1890s, grand symbolic and even iconic images that were, as his contemporaries sensed, by far the clearest and most forceful figurations of their age.

To that extent they were, in the nature of their meaning and address, paintings engaged in the public life of their time. But at the same moment and in some of the same paintings, by increasingly mirroring his feelings and drawing recollectively on his experiences, Homer's art also became inward and private in ways that it had never been before. In the *Fox Hunt*, for example, by the mimicry of his signature, the literal sign of his identity, Homer introduces himself into his painting and identifies himself with the desperation of the fox. And in paintings of the 1890s like *Fox Hunt*, or, still more insistently, the Adirondack oils and watercolors, death—the immanence (*An October Day*), imminence (*Deer Drinking*), and stark immediacy (*A Good Shot*) of mortality—became an important presence in Homer's art.

If any single painting can be taken to mark this change in Homer's morale it is *The Signal of Distress*. Homer began, completed, and first exhibited *The Signal of Distress* in 1890. But a few years later he extensively reworked it. The principle change, the one that most affected the painting's meaning, was made in the boat in the distance. Originally it was under full sail; after Homer's revisions it became, as we see it now, an unpowered and uncontrollable derelict without sails or masts, bearing the tattered flag of distress but showing no other signs of life. In its first version *The Signal of Distress* recalls an earlier painting like *The Wreck of the Iron Crown*, and like it and such works of the mid-1880s as *The Life Line* and

Shark Fishing

1885. Watercolor, 13⅝ x 20″
Private collection

Homer first visited Nassau, in the Bahamas, in December, 1885. The tropics were new to Homer and unfamiliar to his audience, wholly unlike the places he painted earlier and not yet established in the accepted canons of artistic subject matter. Shark Fishing shares the heroic form and content of Homer's great oils of the late 1880s, but, like all of his Caribbean watercolors, its color is incomparably more high-keyed and intense. As a writer in The Critic *said, these watercolors show "the artist's wonted powers of composition united with his new power of color."*

119

The Gulf Stream

1899. Oil on canvas, 28⅛ x 49⅛"
The Metropolitan Museum of Art, New York.
Wolfe Fund, Catharine Lorillard Wolfe
Collection, 1906

*In response to a request from his dealer,
Knoedler, for an explanation of* The
Gulf Stream, *Homer wrote facetiously (in
August, 1902):* "[I] regret very much that
I have painted a picture that requires any
description—The subject of this picture is
comprised in its title & I will refer these in-
quisitive School ma'ams to Lieut. Maury
[author of The Physical Geography of
the Sea]—I have crossed the Gulf Stream
ten times and I should know something
about it. The boat & sharks are outside
matters; matters of very little conse-
quence—they have been blown out to sea
by a hurricane. *You can tell they ladies
that the unfortunate negro who is now so
dazed & parboiled will be rescued & re-
turned to his friends and home & ever
after live happily—"*

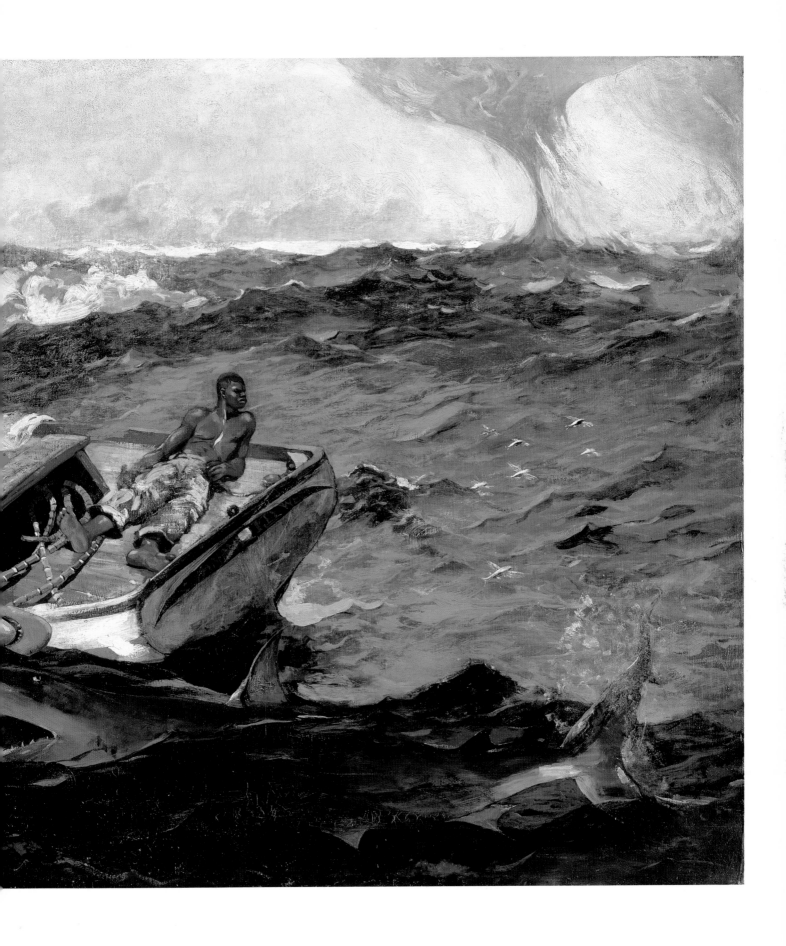

The Undertow, The Signal of Distress originally depicted an event of heroic rescue. In its altered state it did not. The mortal fate of the boat has been decided beyond the power of human agency, however heroic, to influence it.

Homer frequently rethought and revised his paintings after he had finished and first exhibited them. But there is no major painting, no painting of the ambition of *The Signal of Distress*, that he left as visibly unresolved. He did not finish the painting, he simply ended it. His difficulties may have been formal or they may have been technical. But their essence lay in a profound change of spirit and outlook that happened while he was painting *The Signal of Distress*, one that corroded the heroic confidence of the painting's original conception, which it shared with the great heroic or ideal paintings of the mid-1880s (to which group it can be said originally to have belonged), without, despite extensive changes, satisfactorily reshaping its form or subject.

If *The Signal of Distress* was originally similar in conception to the 1881 watercolor, *The Wreck of the Iron Crown*, two of its other components originated at that time as well. A drawing of a lifeboat on its davits, made either on Homer's voyage to England or on his return, provided the main motif for the painting, and the figures rushing to answer the distress signal derive from a number of English drawings in which he explored the theme of rescue. When he painted *The Signal of Distress* in 1890, therefore, Homer reached back more than a decade for its major parts. It is Homer's first distinctly retrospective painting. He had often reused earlier sketches before, of course, but never had the distance between the painting and the experiences upon which it drew been as great, and never had those experiences been so largely past ones.

In *The Signal of Distress*, then, there are two things new to Homer's art, two things that entered it for the first time in the early 1890s: a sense of fatalism and futility, of human powerlessness and uncontrollable destiny; and an attitude of retrospection, of looking backward into his own life and, necessarily inseparable from that, of introspection, looking inward into himself. Homer was in his fifties when this happened, when he painted and then revised *The Signal of Distress*, and in his fifties when he made the Adirondack paintings and the *Fox Hunt* that are so haunted by mortality. If some are paintings about issues of Homer's age, his times, they are all in another sense about his own age, his time of life—about the encroaching anxiety, memory, and mortality of middle age. On the eve of his fifty-ninth birthday in 1895 Homer entertained just such thoughts; to his brother Charles he wrote, "I suppose I may have 14 more (that was mother's age 73 years [their mother died ten years earlier]) and what is 14 years when you look back." (Homer's estimate was uncannily accurate; he died in 1910).

In that time of life and in that state of mind, a few years later, Homer painted *The Gulf Stream* (1899). A visit to Nassau and Florida from December, 1898, into February, 1899, and the passage through the Gulf Stream that such a trip required (Homer said he crossed the Gulf Stream—the great and, where Homer sailed through it to and from the Caribbean, turbulent ocean current— ten times in his life) was the immediate source for the painting, which he probably began soon after his return. But its true source lay deeper in Homer's past,

The Signal of Distress

1890/1892-6. Oil on canvas, 24 x 38"
Thyssen-Bornemisza Collection,
Lugano, Switzerland

"It is a gray morning after a storm in mid-ocean, with gleams of fitful sunshine upon a troubled sea," a writer in the New York World *described this painting. "On the deck of a steamer, evidently a large Atlantic liner which has stopped, an officer and sailors are rushing towards a boat into which two sailors have already tumbled and are preparing to let fall from the davits, evidently to go to the rescue of a far off ship under full sail which is standing towards them." Several critics noticed the resemblance of* The Signal of Distress *to* Eight Bells *when it was shown in 1890. Later, Homer reworked the painting (without ever finishing it), changing the ship originally under full sail into a dismasted derelict and the meaning of the painting thereby from heroism to futility.*

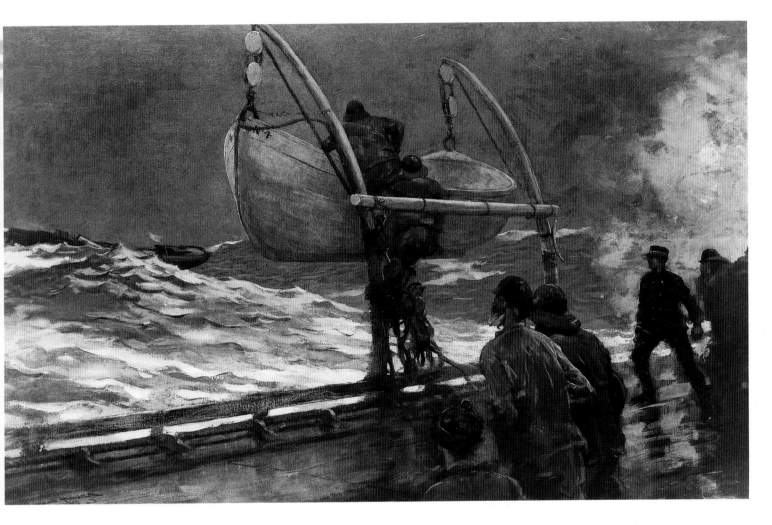

The Signal of Distress

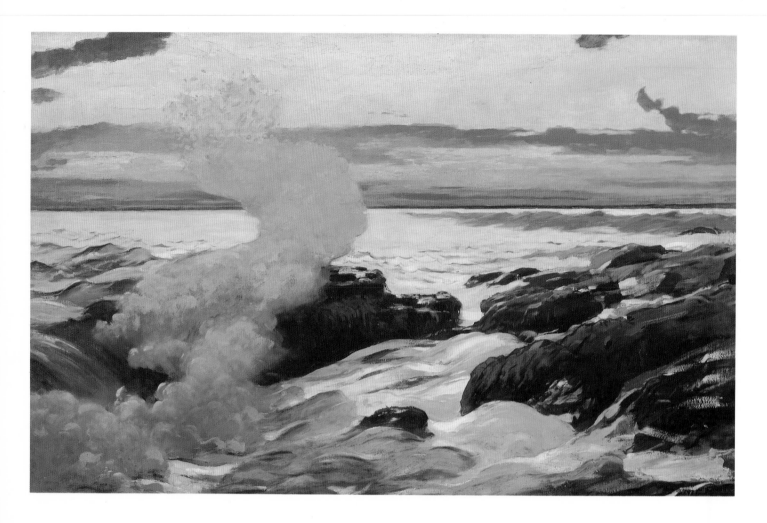

West Point, Prout's Neck

1900. Oil on canvas, 30¹/₁₆ x 48⅛″
Sterling and Francine Clark Art Institute,
Williamstown, Massachusetts

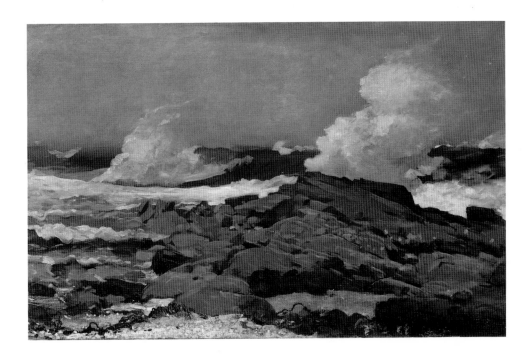

and deeper within himself, than in anything he may have experienced on that trip.

In December, 1884, as relief from the winter at Prout's Neck, Homer made his first trip to the Bahamas, Cuba, and Florida, and the motif he would use many years later for *The Gulf Stream* occurs in an 1885 watercolor of a derelict boat and sharks (there were more derelicts in the Gulf Stream than any other place in the North Atlantic and Homer probably observed this one on this trip to or from the Caribbean). Then, over the next fifteen years or so, Homer revised and refined the initial experience in a series of watercolors and drawings. No other painting underwent the same development; no other single motif preoccupied him for so long a time, and to no other did he return as often.

The Gulf Stream was painted in the year following the death of Homer's father, with whom he had a close though ambivalent relationship (he wrote his sister-in-law in 1895, "I find that living with Father for three days I grow to be so much like him I am frightened. We get as much alike as two peas in age & manners.") The first study for what would become *The Gulf Stream* was made several months after the death of Homer's mother, to whom he was particularly close (and to whom he felt a closeness, more mystical than sentimental, after her death: about a week later he wrote his sister-in-law, "I went into the house at Prouts today. Found it in good order. Thought of mother with a certain amount of pleasure, thank the Lord. I know that if possible she was with me.") Homer painted *The Gulf Stream*, therefore, when he was touched, directly or recollectively, by the deaths of his parents; that is, at a time of life, at whatever age it occurs, of singular finality and aloneness. Perhaps that is why an abandoned and beleaguered boat—especially as an image that entered his consciousness soon after his mother's death and for which he seemed to have an almost obses-

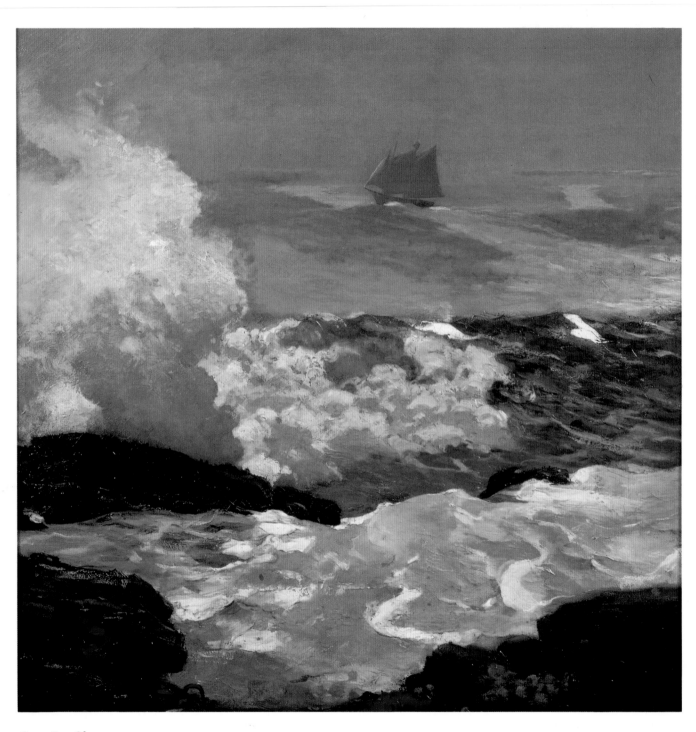

On a Lee Shore

On a Lee Shore (detail)

On a Lee Shore

1900. Oil on canvas, 39 x 39″
Museum of Art, Rhode Island School of Design,
Providence.
Jesse Metcalf Fund

As their subjects and similar sizes indicate, West Point, Prout's Neck *and* Eastern Point, Prout's Neck *(see preceeding pages) were conceived as paired or pendant paintings. For exhibition Homer thought of adding to them a third painting—first* Cannon Rock *(1895; Metropolitan Museum of Art, New York), then* Northeaster *(page 116)—to form a three-part group. When they were actually shown together in 1901 the third painting was* On a Lee Shore. *As a critic for* The New York Times *implied, they formed a narrative cycle.* Eastern Point *"is a stern, uncompromising piece of realism describing the effect of pounding waves on a day of dull skies,"* West Point *"has more incident by reason of the blood-red glow in the sky beyond the racing tide," while* On a Lee Shore *"concedes the presence of a wrecked brig as an additional note in carrying out the action of the elements." Similarly, the writer in the* New York Sun *said* Eastern Point *represented "elemental force" and "fundamental enduring truth" and* West Point *"an occasional phenomenon."*

In Homer's late seascapes pigment is not only a medium of description. It embodies the solidity of rock, enacts the fluidity and weight of water, and is a tangibly expressed record of feelings, as in the detail of the breakers from On a Lee Shore.

sive attraction thereafter—would have special meaning for Homer and become (in a pun he might admire) a vessel for his feelings of abandonment and lonely uncertainty. If so, *The Gulf Stream*, no matter how transposed in subject, is to date Homer's most powerful yet poignantly self-expressive painting. Perhaps it was the intensely private meaning it held for him that caused Homer to write the director of the Pennsylvania Academy of the Fine Arts when he sent *The Gulf Stream* there for exhibition in 1900, "Don't let the public poke its nose into my picture."

The Gulf Stream is also, with self-reflective intensity, a grand meditation on death. On its inevitability—the patiently preying sharks, the frightful, hellish turbulence, and the sail and open hatch in the bow of the boat that resemble an awaiting shroud and tomb—but—in the figure of heroic (in fact, outsized) largeness, immortally untouched by thirst or famine—perhaps on its transcendence as well.

The painting achieves its unusual expressiveness by the force of its subject. But it achieves it also by conditions of style. If one compares *The Gulf Stream* to a watercolor like *Shark Fishing* of 1885—made at the time of the first study for *The Gulf Stream*, and upon which Homer also drew for the painting, appropriating a shark for it—the nature of that stylistic condition is easily apparent. *Shark Fishing*, like other works of the mid-1880s, has a monumental, centripedal density of form, one comprised of large and almost lithic figures in single, solid, centrally

placed compositional geometries of pyramids, cubes, and spheres that command the picture space. *The Gulf Stream* is very different. As befits the uncertainty of its subject, it lacks that singleness and clarity of form. The parts of *The Gulf Stream* are distributed about the painting, or, more exactly, upon its surface. Instead of concentrating in a dense plastic core assertively occupying the picture space (although it does have a clear center), *The Gulf Stream* is organized by means of horizontal planes or bands that, while not absolutely and irrevocably flat, tend to overall flatness.

This tendency to flatness is not a stylistic peculiarity of *The Gulf Stream*. On the contrary, it is visible in a number of Homer's late paintings—in *Cannon Rock* (Metropolitan Museum of Art) of 1895 and in *West Point, Prout's Neck* of 1900 ("the horizon [is] streaked with crimson," a writer in the *New York Sun* observed in 1901, "crowding the horizon forward and lessening the sense of space"); in *Kissing the Moon* of 1904 and *Cape Trinity, Saguenay River* of 1904–1909; and in a particularly emphatic way in Homer's last great work, *Right and Left* of 1909. Flatness, clearly, is an essential formal attitude of Homer's late style.

The parts of *The Gulf Stream* and other of his late paintings lie upon or tend toward their surfaces not for aesthetic reasons, from calculations of design, but from some internal pressure, as though to press out—in that quite literal way to express—what they contain and to bring it before the beholder with as little mediation as possible (such as the distancing implicit in successful spatial and plastic illusion). Flatness, in other words, enabled Homer's art to register feeling with special immediacy. At times the late paintings transgress the conventional boundary of the picture plane in order to place—almost to empty—their meaning, what they actually contain, before the beholder, as in *On a Lee Shore* of 1900. Or they make the beholder the object of their pictorial address in a confrontationally direct and unsettling way, as in such a watercolor as *Diamond Shoal* of 1905, or, with the most expressive power, in *Right and Left* of 1909.

The expressiveness of Homer's late paintings is registered in another and perhaps more direct—because more physical—way: by thickly and vigorously applied paint. Beginning in the seascapes of the 1890s particularly, such as *On a Lee Shore*, not only do forms seem pressed from the painting's interior to its surface but the surface of the canvas itself is activated and energized by paint. The act of painting, largely descriptive and expressively neutral in Homer's earlier work, has become by its tactility and by the movement—the pace, rhythm, and direction—of the brush that it preserves, the palpable record of an experience of feeling.

Diamond Shoal

1905. Watercolor, 13⅞ x 21¾"
IBM Corporation, Armonk, New York

Homer painted less and less in his last years not because his technical and inventive abilities declined—this depiction of a schooner passing the Cape Hatteras lightship, his last dated watercolor, shows very clearly that they had not—but because he less frequently found inspiring subjects. The urgent contact between image and viewer established by outwardly directed narrative and pictorial movement is a recurrent expressive device in Homer's late art.

Diamond Shoal

A Wall, Nassau

XI. Why Should I Paint?

IF CERTAIN OF HOMER'S LATE WORKS share a common condition of style, it is nevertheless impossible to speak of them, and particularly of his late oils, collectively. His seascapes can range greatly in mood from the ferocity of *High Cliff, Coast of Maine* (1894) or *Northeaster* (1895) to the relative calm of *West Point, Prout's Neck* (1900), or in format from the square shape of *On a Lee Shore* (about 1900) to the oblong rectangle of *West Point, Prout's Neck* and *Eastern Point, Prout's Neck* (both 1900). But he painted them with a fairly consistent regularity from 1890 until his death (in doing so, perhaps, following the advice he gave the young artist Leon Kroll, who worked at Prout's Neck in the summer of 1907: "Leave rocks for your old age—they're easy.") And on his trips to Canada, the Bahamas, Bermuda, and Florida he produced suites of watercolors with even greater regularity. Until he made the last of them in 1905 (*Diamond Shoal* is the last one he dated), Homer painted watercolors with unabated skill and unflagging delight. Sheets like *A Wall, Nassau* (1898), *The Coming Storm* (1901), and *Key West, Hauling Anchor* (1903) are some of the most brilliant watercolors that he, or anyone else, ever made—optically bright, chromatically intense, and technically definitive. Homer's use of the medium to its full potential of fluidity, transparency, and spontaneity captures the purity of unmediated sensation, of the power and pleasure of seeing for its own sake.

In the summer of 1900 Homer described his output to an old friend: "My work for the past two or three years has been mostly in water colors, Canadian sporting scenes and Rapids, Indians, etc. I have . . . paid expenses in that way, while I have at times painted an oil picture." Apart from his watercolors, Homer painted infrequently and sporadically—"at times"—in his last years. As he put it to another old friend, the lithographer Louis Prang, in 1905, "I retire from business every now & then, & then take it up again." His wording is characteristic. He liked in later life to affect the language of commerce, speaking of his profession as a "business" and his paintings as "goods": "If I have anything in the picture line again I will remember you," he wrote the Chicago dealers O'Brien and Son. To be sure, he expended a good deal of energy advising his dealers about how to sell and exhibit his pictures. But such language was also a screen that by its matter-of-fact, mercantile diction hid a morbidly acute sensitivity to criticism and insufficient appreciation and, beneath that, a lurking insecurity. In fact, however, Homer's late work was universally and unstintingly praised and he was much honored by prizes and awards. He constantly complained

A Wall, Nassau

1898. Watercolor and graphite, 14¾ x 21½"
The Metropolitan Museum of Art, New York.
Amelia B. Lazarus Fund, 1910

In their immediacy, spontaneity, and almost indulgently sensuous light and color, the watercolors Homer made in the tropics (the Bahamas and Florida) and Bermuda at the end of his life are very different from the serious and often solemn, sometimes sensuously stringent, carefully considered and often labored oils of the same period. In the watercolors he described what lay outside himself, in the oils he expressed what lay within; in the watercolors he painted sensations, in the oils, ideas.

131

The Coming Storm

1901. Watercolor, 14⁹⁄₁₆ x 21⅛″
National Gallery of Art, Washington.
Gift of Ruth K. Henschel, in memory of her
husband, Charles R. Henschel, 1975

*Homer conveys an approaching tropical
storm not only by describing it through col-
or and form but by the almost palpable
wetness of the flowing washes of watercol-
or—not by depicting but by reenacting it
in pigment.*

Key West, Hauling Anchor

1903. Watercolor, 15⅞ x 21⅛″
National Gallery of Art, Washington.
Gift of Ruth K. Henschel, in memory of her
husband, Charles R. Henschel, 1975

*Transcripts not of objects but of sensa-
tions, Homer's late watercolors are his
most purely seen works; rapid and unpre-
meditated, with little or no drawing and
broad, freely applied washes of pigment,
they are also his most purely painted.*

about money, in 1897 writing facetiously to his brother Charles, for example, "Other things, Big things, are booming. I have made $100. cash. $120. of it will go for frames & that is my seasons profit." In 1905, after receiving a check from his New York dealer, Knoedler, he wrote, "I receive with pleasure this unexpected sum of money. It's not a bad idea this looking at a little money now & then—who knows but I may paint something some day." But, in fact, he was financially secure from the sale of his paintings and rents on properties at Prout's Neck. In 1902 he wrote O'Brien, "with the duckets that I now have safe I think I will retire at 66 years of age," and wrote him the following year, "I have rents enough to keep me out of the poorhouse;" in 1905 he wrote Prang, "I am comfortably fixed for life in regard to cash." Nevertheless, he repeatedly threatened to stop painting, and sometimes actually did temporarily, when he felt improperly appreciated. As early as 1887, Augustus Stonehouse reported that "there were times and seasons when he announced to his friends with great bitterness and the utmost solemnity that he proposed to abandon art for business." When, in 1903, *Early Morning After a Storm at Sea* (1902; Cleveland Museum of Art)—"the best picture of the sea that I have painted"—was, he felt, abused and misunderstood he "retired from business for good," painting no oils for the rest of the year. In 1907 he wrote bitterly to someone doing an article on him: "Perhaps you think that I am still painting and interested in art. *That is a mistake.* I care nothing for art. I no longer paint."

Despite his renunciations and complaints, of course, Homer cared very much about art—at least his own. When he went to Pittsburgh in 1901 he brought along varnish, a brush, and a sponge in order to "overlook & put in order" his painting, *The Wreck,* that had been purchased by the Carnegie Institute in 1897. In a letter to John W. Beatty, its director, he expressed a general concern for the condition of his paintings and how they should be seen: "I hope it has not been varnished by any outsider as varnish is what will damage any picture. I hope also that *no glass* has been put over it, as that to me, is a red flag to a bull." (In 1900 he wrote Knoedler about exhibiting *West Point, Prout's Neck,* "I *forbid* any *glass* or 'robbery-box' put onto the picture.") He also suggested how his paintings might be grouped together thematically and aesthetically. For an exhibition in the Union League Club in New York in 1900 he wrote Thomas B. Clarke that *West Point, Prout's Neck, Cannon Rock,* and *Eastern Point, Prout's Neck* hang as a group, including in his letter to him a sketch of how "they would look well—if you would care to hang them so—..." That same year he showed *The Gulf Stream* and *Hound and Hunter* together at the Carnegie annual exhibition, and in 1902 said to Knoedler that *The Gulf Stream* and *Searchlight* "would look well together—in some show." If his paintings were "goods" he cared deeply about their quality and display.

It is not clear why Homer painted so sporadically. At times, assuming his commercial posture, he said that he painted only for money: In 1893 he wrote a Chicago dealer, "At present and for some time past I see no reason why I should paint any pictures," but then added, "P.S. I will paint for money at any time. Any subject, any size." In 1906 he wrote Knoedler, "I am ready to paint but *I no longer*

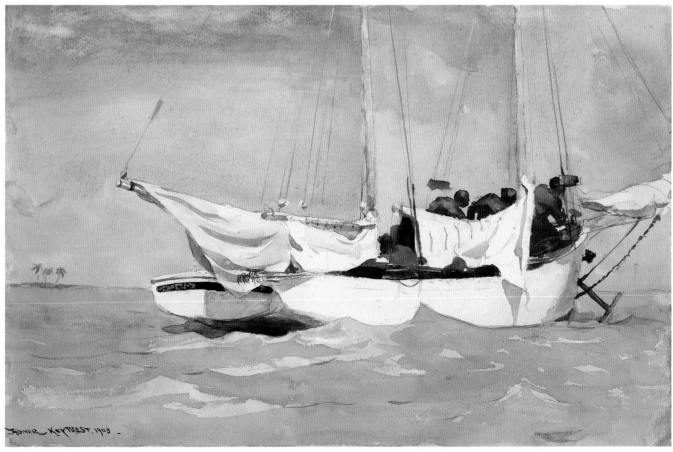

Letter, Winslow Homer to
Thomas B. Clarke,
11 December 1900

Archives of American Art,
Smithsonian Institution, Washington

Homer thought frequently in later life of how his paintings might be exhibited. Here he diagrammed one possible hanging of three seascapes, including West Point, Prout's Neck *and* Eastern Point, Prout's Neck.

paint for nothing." He also indicated a reluctance to paint new pictures while old ones remained unsold. "I wish to know if you are still overloaded with my pictures," he wrote Knoedler in 1901. "I am waiting until some of them get settled for good, before *I paint any more.*" That was based on a businesslike sense of creative thrift: "I find one [painting] a year is enough to fill the market," he wrote Prang in 1905 (he was asking, net to him, about $2,000 for an oil and $200 for a watercolor). But he painted little, too, because he felt his work was not appreciated: "What's the use of my painting any more? The public don't want my pictures," he told the Boston dealer J. Eastman Chase. At other times, he said he painted only when he felt like it or was properly inspired. "Every condition must be favorable or I do not work and will not," he wrote to a friend in 1900. "For the last two months I have not painted—too many people about this place." "I will paint only when I want to, and for my own pleasure," he wrote Beatty in 1903. "You must wait, and wait patiently, until the exceptional, the wonderful effect or aspect comes," Beatty reported Homer to have said (although it does not sound quite like Homer), adding, "sometimes he would spend whole days just looking at the sea, without touching a brush." His brother Charles told how he waited fruitlessly an entire summer for a certain effect. "But he got it the next year." Such waiting delayed the completion of *Early Morning after a Storm at Sea* for years. In March, 1902, he reported to O'Brien (to whom the picture was promised), "It will please you to know that after waiting a full year, looking out every day for it (when I have been here [at Prout's Neck]) on the 24th of Feby, my birthday, I got the light and the sea that I wanted."

Neither pleasure nor patience wholly account for the intermittency of Homer's painting production in his old age. For there can be no doubt that inspiration came to him then more occasionally than consistently—except, of course, from the sea, which was an enduring inspiration. The fact that he reworked old paintings almost as much as he painted new ones suggests flagging powers of invention and the infrequent occurrence of fruitful pictorial ideas or compelling subjects. (In 1900 he wrote to O'Brien, "I do not care to put out any

ideas for pictures. They are too valuable, and can be appropriated by any art student, defrauding me of a possible picture.") But when he did paint new pictures he painted them brilliantly. "Do not think that *I have stopped painting*," he wrote Thomas B. Clarke in 1901. "At any moment I am liable to paint a good picture—..." And he was right; his late works include some of his most powerful, complex, and moving works. Nevertheless, they tended to be somewhat singular and disconnected events. The chief subject pictures of the last decade of his life, *Searchlight* of 1901, *Kissing the Moon* of 1904, *Cape Trinity, Saguenay River* of 1904–1909, *Shooting the Rapids* of 1905, and *Right and Left* finished early in 1909, are very different from one another and unregulated by the thematic seriality that, as recently as the seascapes of the 1890s, usually connected his earlier works.

This is apparent, for instance, in the disjunctive relationship between his last great painting of the 1890s, *The Gulf Stream* of 1899, and the next important painting that followed it, *Searchlight* of 1901. To be sure, they have in common an attitude of retrospection, for *Searchlight* (or, to give it its full title, *Searchlight Harbor, Entrance Harbor, Santiago de Cuba*), like *The Gulf Stream*, reaches into the past—into Homer's own past, deriving directly from a drawing he made at Morro Castle at Santiago, Cuba in 1886 (on the same trip that produced the first drawing for *The Gulf Stream*), as well as into recent history by alluding to the American naval blockade of Santiago harbor during the Spanish-American War of 1898. Otherwise, *The Gulf Stream* and *Searchlight* are very different. *The Gulf Stream*, though it is intensely personal, shared also in a mood of fin-de-siècle retrospection and introspection; *Searchlight*, by contrast, expressed the confidence and historical consciousness of the new century (which began, as many people reckoned it, in 1901, the year Homer began the painting).

Homer said that *Searchlight* was about the "stern facts" of the war and the "stirring sights of June & July 1898"—the blockade and destruction of the Spanish fleet at Santiago—that could be seen from Morro Castle (but which, it should be noted, Homer himself did not see; he knew of the war only through published accounts). *Searchlight*, however, is not simply about an episode of the Spanish-American War, but about another event of greater and more current moment: the advent of the new century. It expressed that momentous historical passage by an emphatic and dramatic contrast of old and new, past and present—of the old castle with obsolete cannon on its ramparts, and the new instrument of naval warfare, the searchlight that pierces the night sky.

The searchlight was shined nightly by American ships into the mouth of Santiago harbor to prevent the Spanish fleet from escaping into open sea under cover of darkness. But in Homer's painting its function is more emblematic than factual. It is a symbol of modern enlightenment, illuminating and dispelling the darkness of the past (Morro Castle, where Cuban political prisoners had been confined, was described as "a cesspool of iniquity [and] the last stronghold of medievalism on American soil"). And by its modern artificial brilliance the searchlight challenges the moon, the natural symbol of romanticism and the sentimentality of the past ("the force of [the searchlight's] actuality contrasted

Searchlight, Harbor Entrance, Santiago de Cuba

1901. Oil on canvas, 30½ x 50½"
The Metropolitan Museum of Art, New York.
Gift of George A. Hearn, 1906

A writer for the New York Sun *said of* Searchlight, *"The painter has dared to face the realistic features of his subject . . . , relying, indeed, upon the force of their actuality as contrasted with the tender mystery of the moonlit sky. This big and serious way of attacking the problem has lifted the realism to the level of very solemn impressiveness, the loneliness and vastness of the scene appealing at once to the imagination. I can quite believe that some visitors [to the exhibition] may not like the picture, but they can hardly fail to be impressed by its virile, resolute originality." The critic of the* New York Tribune *wrote, it "strikes once more the ambiguous note with which, upon occasion, this brilliant artist seems to be content." The* New York Evening Post *thought it, "A curious sort of still life." "This is a small part of* Morro Castle & immediately over the harbor entrance which is only about 400 feet wide," *Homer noted, "& from this point were seen the stirring sights of June and July 1898." As he had done earlier in* Inviting a Shot Before Petersburg, Virginia *and* A Good Shot, *and as he would do again a few years later in* Right and Left, *Homer depicts the event from the victim's point of view.*

The Fountains at Night, World's Columbian Exposition

1893. Oil on canvas, 16⅚₆ x 25¹⁄₁₆″
Bowdoin College Museum of Art,
Brunswick, Maine

Homer sent fifteen important paintings to the art exhibition of the Columbian Exposition of 1893, including Dressing for the Carnival, Eight Bells, Hound and Hunter, Huntsman and Dogs, Fog Warning, *and* The Herring Net. *He visited the exposition, where he painted Frederick MacMonnies's fountain illuminated by electricity. Painted in black and white, it may have been intended (though never used) as an illustration.*

with the tender mystery of the moonlit sky," a writer in the *New York Sun* put it in 1902).

Electricity itself was the clearest sign and (literally) most luminous symbol of the new century. In the international expositions of the turn of the century, by which the modern world boasted of its accomplishments, electricity was the hero. The World's Columbian Exposition in Chicago in 1893 was "all an electrical exhibit," Murat Halstead wrote in *The Cosmopolitan*, at which "magnificent search-lights...sweep the horizon with shafts of flame." In *The Fountains at Night, World's Columbian Exposition*, Homer depicted the "splendors of electricity" that converted the spraying water of the MacMonnies fountain into "leaping rainbows, glowing, fantastical, mystical." A *fête electricité* was a major feature of the 1900 exposition in Paris, at which, too, Camille Saint-Saëns's hymn, "The Heavenly Fire," was performed by a massed orchestra and chorus. And "The City of Light," the Pan-American Exposition in Buffalo in 1901, was, as David Gray wrote in *The Century*, "the first time that human eyes have beheld such floods of artificial light." At the close of the 1900 Paris exposition Henry Adams wrote John Hay, "It's a new century, and...electricity is its God."

Homer lived remote from the modern world and such of its conveniences as electricity, the automobile, and the telephone. At Prout's Neck he was four miles from the railroad and telegraph, living in a house without heat ("Mop frozen stiff in other room," he remarked to Charles in January, 1908). He hated the automobile, and at least affected not to know how to use the telephone. But in *Searchlight* Homer nevertheless painted one of the most perceptive and compelling, as well as one of the earliest, images of the new century. For *Searchlight*

was by a number of years the forerunner in American and even European art of an iconography of modernism that took for its symbols such instruments and achievements of technology as electricity, automobiles, airplanes, ocean liners, and factories. And to some extent, too, it was in the severe reductiveness of its form the forerunner of a modern style as well. When *Searchlight* was shown in 1902 critics sensed its originality. "A departure from all recognized manner, both of theme and handling," said a writer for the *New York Commercial Advertiser.* But they acknowledged it most in their bafflement—the frustrated expectation and incomprehension that sounded as a litany in this century's critical response to advanced art—with the painting's refusal to make the usual ingratiating or explanatory accommodations. "Some visitors may not *like* the picture," the critic of the *New York Sun* admitted, while the critic of the *New York Tribune*, explaining why, noted its ambiguity of meaning, its lack of "pictorial charm," and the "baldness" of its design; altogether, "there is something which repels.... We cannot say that it is beautiful." To this misreading of his purpose Homer's emphatic response was (in a letter to Knoedler), "That Santiago de Cuba picture *is not intended to be 'Beautiful.'* " *"I find it interesting,"* he said, suggesting by that criterion of value sterner and less purely aesthetic motives than his critics, expecting only charm and beauty, were equipped to understand.

In 1904, Homer painted two works each as different in subject from the other as *Searchlight* was from *The Gulf Stream.* One of them, *Kissing the Moon,* harks back, with a retrospectiveness characteristic of Homer's late work, to such paintings of the mid-1880s as *The Herring Net* and *The Fog Warning,* or, more specifically, to a large watercolor of 1883, *The Ship's Boat* (New Britain Museum of American Art), that, although painted at Prout's Neck, harks back in its turn to such earlier English watercolors as *The Wreck of the Iron Crown* of 1881. In *The Ship's Boat* four men, only their heads and hands visible along the crest of a large wave, cling to an overturned boat being swept by a stormy sea toward a rocky shore. What is most distinctive about *The Ship's Boat* is its point of sight. It is as if the beholder is also in the water, sharing and not merely observing the event it depicts. In fact, beneath a small sketch (Cooper-Hewitt Museum) clearly in the lineage of *The Ship's Boat* Homer inscribed, "From the retina of a drowned man," and it is that unusual and inescapably disturbing point of sight that *Kissing the Moon* shares with *The Ship's Boat.*

In depicting a boat liable to being overwhelmed by threatening waters, *Kissing the Moon* is related to a painting that Homer began the following year (but which remained unfinished at his death), *Shooting the Rapids, Saguenay River.* Beginning in 1893 Homer made a number of fishing trips to Canada, on most of which he produced watercolors. One of them, entitled *Shooting the Rapids,* made on his last trip in 1902, was the source for the oil; and in the watercolor, by a device for representing himself in his art that he used earlier in *The Fox Hunt,* Homer placed his signature, curved to echo its shape, in a wave in the right foreground, identifying himself with the point of view adopted in *Kissing the Moon.*

Kissing the Moon

1904. Oil on canvas, 30 x 40″
Addison Gallery of American Art,
Phillips Academy,
Andover, Massachusetts

The compositional order and flattened space of Kissing the Moon *were no doubt influenced by Japanese art, as aspects of other of Homer's paintings had been. But by obscuring and compressing normal physical relationships of gravity and space—man to sea, sea to sky; high and low, near and far—aesthetic design becomes an almost metaphysical condition, one experienced by the painting's occupants with a stilled awareness of a transcendent moment.*

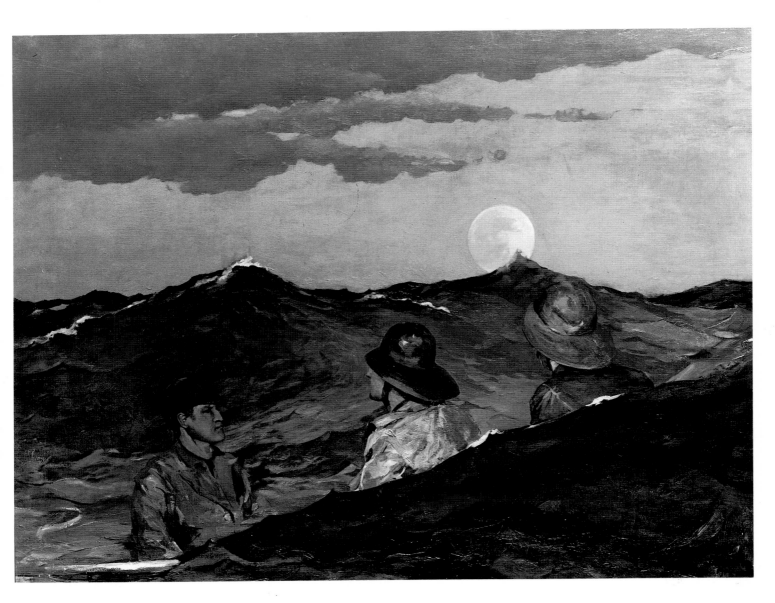

Kissing the Moon

Cape Trinity, Saguenay River, begun in 1904 but not finished until 1909, also originated in one of Homer's trips to Canada. Homer was drawn to Canada by the fishing, and to the Saguenay particularly by the landlocked salmon, the ouananiche, prized by sportsmen for its fight and cleverness. The Saguenay River itself was an attraction—there were steamer trips up river from the St. Lawrence (of which it is a major tributary); William Dean Howells's novel, *A Chance Acquaintance* (1874), opened with one—but the Saguenay was not, however, conventionally scenic. Baedeker's handbook for travelers described it as a "gloomy fjord,...grand but sombre" (and for some "dull and monotonous"); E. T. D. Chambers (in *Harper's Weekly*) wrote of "the deep, dark chasm down which rolls the dismal Saguenay"; Howells called it a "sad, lonely river"; for the travel writer Bayard Taylor it was "the river of death." The "great objects of the Saguenay journey," as Howells described them, the "culmination," the Baedeker writer put it, of "the sublime scenery of the Saguenay," were Cape Eternity and Cape Trinity. Cape Trinity, as Baedeker's handbook described it, "rises perfectly sheer from the black water, a naked wall of granite. Its name is derived," it explained, "from the three steps in which it climbs from the river." (A cross and a statue of the Virgin placed near its top suggest that its name had a larger, more specific meaning).

Cape Trinity, Saguenay River is one of Homer's most unusual and most moving paintings. He described it (to Knoedler), in his typically laconic way, as "a most truthful rendering of this most beautiful & impressive cape." But it is, of course, much more. Virtually monochromatic, charged with the somber images of death and eternity that the gloomy bleakness and dismal blackness of the landscape itself seemed to inspire in all who experienced it, *Cape Trinity, Saguenay River* is not a scenic but an intensely symbolic landscape—indeed, almost a Symbolist one, for in its brooding mood, as well as in its chief characteristics of form, it is strikingly similar to one of the best known and most compelling paintings of the turn of the century, Arnold Boecklin's *Isle of the Dead*, which the Swiss artist painted in six versions, the first in 1880.

Right and Left was completed in January, 1909. Depicting two ducks at the instant they have been shot by the right and left barrels of a single shotgun fired from a boat in the distance, it is very different in subject from the paintings that preceded it (except that, like *Shooting the Rapids*, it too is a sporting subject). Homer, it is said, carefully observed hunters shooting and ducks falling from the air. But it is also said that he made the painting using a pair of ducks he had bought for Thanksgiving. To that extent, the painting belongs to a long tradition of game still lifes with dead birds hung from their feet or wings, with additional debts on one hand to sporting imagery and on the other, perhaps, to Japanese prints (although at this point Homer scarcely needed pictorial sources for guidance or inspiration).

Each of Homer's major late paintings differs one from the other in subject and derivation. But they have in common two things: A principle of form (the flattening that is the recurrent instrument of the increasingly urgent, at times almost expulsive, expressiveness of Homer's late works), and the state of mind

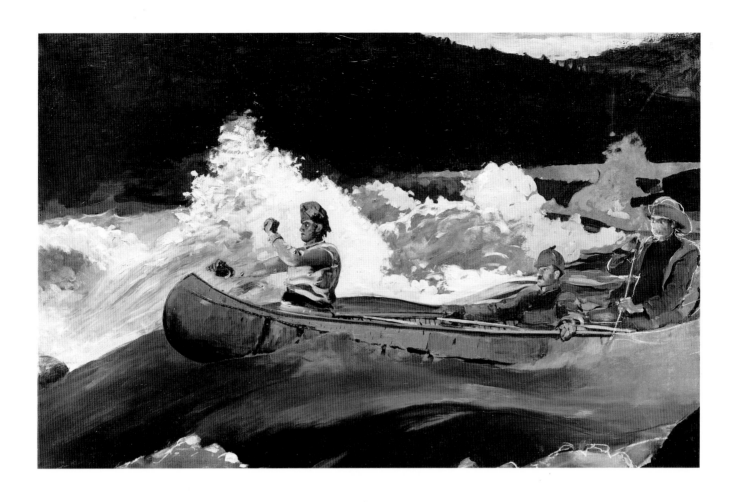

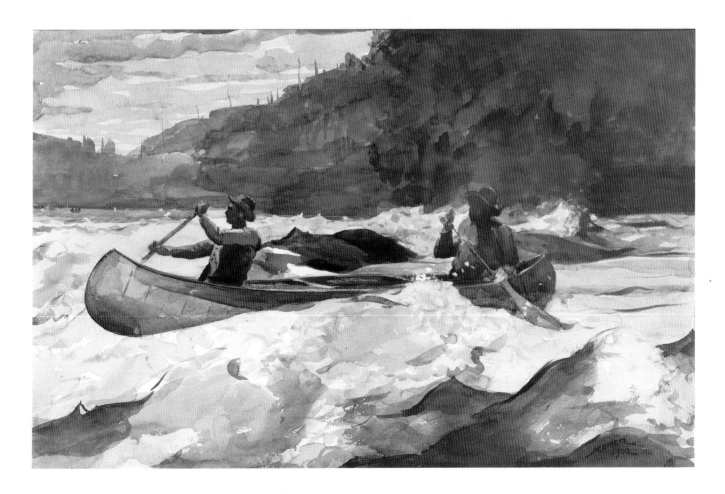

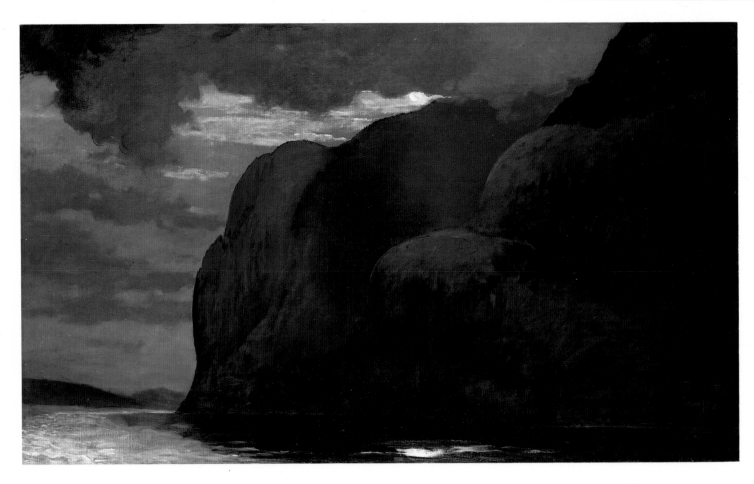

Cape Trinity, Saguenay River

and condition of life that powered that urgency. Intimations of mortality had been present for some time in Homer's art, of course, but he began to feel more than its intimations after about 1900. He continued to be physically active, mentally alert, and self-reliant—living and traveling alone, fishing, working his garden, tending to business and needling his dealers—and he repeatedly assured friends and family of his undiminished health and the certainty of his longevity. To Charles, in 1906, he wrote, "You say 'You are rather well.' That would not do for me. I am A No. 1 in health," while to William Howe Downes he wrote, "I am making arrangements to live as long as my Father & both my grand fathers—all of them over eighty-five." "*I am very well,*" he wrote emphatically, again and again, in his letters. But a good deal of that was whistling in the dark. In 1906, in the summer of his seventieth year, he was seriously ill (it was following this illness that he proclaimed himself "A No. 1 in health.") When he had been sick three years earlier he could joke about it: "The trouble was I thought that for a change I would give up drinking," he wrote Knoedler, "& it was a great mistake & although I reduced the size of my nose & improved my beauty, my stomach suffered—Pardon my particulars but I thought you would be glad to know that you could not catch anything from this letter—..." But after his 1906 illness, although he wrote Charles that he had "entirely recovered my health" he also added. "I am now an ordinary old man." In 1907 he again gave up drinking (a bad sign), and early in the summer of 1908 he suffered a paralytic stroke that for a time affected his sight and coordination, leaving him unable to write, shave, and tie his necktie. He recovered quickly, however. In early June he wrote Charles: "This is the first time I have tried to write & I am quite satisfied with it. Only think of it I shall shave tomorrow morning & if I do I shall call myself well all but tying my neck tie." Two days later he wrote, "I can paint as

Cape Trinity, Saguenay River

1904–1909. Oil on canvas, 28¾ x 48¾"
Regis Corporation, Minneapolis

Despite Homer's description of it as "a most truthful rendering of this most beautiful & impressive cape," his painting, finished the year before he died, is less a view than a vision, saturated by its ominous forms and eery blackness with the immanence and imminence of death. Its meaning is deepened and made more pointed by its apparent similarity to one of the most admired paintings of the late nineteenth century, Boecklin's Isle of the Dead.

Right and Left

well as ever." But his eyesight was still affected: "I think my pictures better for having one eye in the pot & one in the chimney." No impairment of hand or eye is visible in his last paintings, like *Right and Left,* and in 1909, in one of his last surviving letters, he wrote his brother Arthur emphatically "*I am painting.*"

However discontinuous Homer's late paintings seem in certain respects to be there is in each of them a presentiment of death, not as a still distant reality or abstract certainty, as in *The Gulf Stream* of 1899 or other paintings of the 1890s, but as an immanent and imminent event, perceived in old age with almost visionary clarity and mystical immediacy, separating existence from extinction. (Something of Homer's state of mind in his last years may be suggested in a letter to Charles of 1908, in which he wrote, "There is certainly some strange power that has some overlook on me & directing my life.") The spatial ambiguities and visual uncertainties of *Kissing the Moon* are to some extent merely clever and pictorially playful. But the painting's tensions and compressions, edges and angles, convey in formal terms the foreboding that the figures in the boat express in their faces, in the anxious alertness of their glances, and by the implicit danger of their sudden submergence in the swelling sea. The sense of unease is made all the more intense by the quasi-mystical meetings of heaven and earth, night and day, and by the peculiar point of sight—which was, in Homer's first consideration of the subject, that of a drowning man. In *Shooting the Rapids,* the canoe and figures are poised on the edge of destruction, which the figure who grips the gunwales in fear (said to be Homer's brother, Charles) seems to foresee as an instant revelation of destiny. The funereal gloom and a revelatory flash of moonlight of *Cape Trinity, Saguenay River* combine to produce a visionary image of mortal finality. And in *Right and Left* the very moment of extinction is, by the painting's outwardly pressing force, an unmediated, intensely and almost empathetically, shared experience of mortality. Homer died a year and nine months after completing *Right and Left,* on September 29, 1910, in Prout's Neck.

Right and Left

1909. Oil on canvas, 28¼ x 48⅜"
National Gallery of Art, Washington

In December, 1908, Homer wrote his brother Charles from Prout's Neck, "I am painting when it is light enough, on a most surprising picture," Right and Left, *which he finished in early January, 1909. One story has it that he admired the beauty of a pair of wild ducks he had bought for his Thanksgiving dinner but which spoiled by the time he painted them; another, that he was inspired by a brace of ducks that a hunter friend shot and hung on Homer's studio door. Of this still life of two dead ducks converted into a conventional sporting subject (celebrating the feat of killing a bird with each of the two barrels of a shotgun) Homer, in the last months of his life and visited by intimations of his own mortality, made an image of the stark immediacy of death.*

Chronology

1836	Born February 24 in Boston, Massachusetts.
1842	Family moves to Cambridge, Massachusetts.
1855	Apprenticed to Boston commercial lithographer John H. Bufford.
1857	Free-lance illustrator. Begins work for *Harper's Weekly*.
1859	Moves to New York.
1859–60	Works for *Harper's* on a free-lance basis. Evening life-drawing classes at the National Academy of Design.
1861	A few painting lessons from genre and landscape painter Frédéric Rondel. Sent to Washington by *Harper's* for Lincoln's inauguration. After outbreak of Civil War in April detailed by *Harper's* to the Army of the Potomac in and around Washington.
1862	In Virginia on General McClellan's Peninsular campaign. Back in New York by June.
1863	*The Last Goose at Yorktown* and *Home, Sweet Home* in the National Academy's Annual Exhibition mark his debut as a painter and achieve considerable critical success. More life-drawing classes at the Academy.
1864	Elected Associate Academician of the National Academy of Design. Visits the front again at the beginning of Grant's Richmond campaign.
1865	Civil War ends. Assassination of Lincoln. Homer elected full Academician.
1866	December, sails for France. Spends next year in Paris and at the artists' colony in Cernay-la-ville.
1867	Exhibits *Prisoners from the Front* and *The Bright Side* at the Paris Exposition Universelle. Returns to New York in December.
1870	First visits the Adirondack Mountains of upper New York State.
1871	Moves into the Tenth Street Studio Building, a center of artistic activity where Frederic Edwin Church, Sanford Robinson Gifford, John La Farge, and John Ferguson Weir also have studios. Summer trip to Hurley, New York.
1873	Summers in Gloucester, Massachusetts. First serious watercolors.
1874	Exhibits watercolors at the annual exhibition of the American Society of Painters in Watercolor. Summer visits to the Adirondacks, East Hampton, and Walden, New York.
1875	First visits Prout's Neck, Maine, ten miles south of Portland. Submits last drawing to *Harper's*, ending his career as a commercial illustrator.
1876	Spends time at friend Lawson Valentine's Houghton Farm in Mountainsville, New York. Visits Petersburg, Virginia.

1877	Interest in design reflected in creation of sets of decorative tiles and founding membership in the Tile Club.
1878	Summer at Houghton Farm.
1879	Summer in West Townsend and Winchester, Massachusetts.
1880	Summer in Gloucester.
1881	To England, visiting London and settling for twenty months in Cullercoats, near Newcastle.
1882	Returns to New York in November.
1883	Settles at Prout's Neck.
1884	Death of his mother.
1884–87	Paints *The Life Line, The Herring Net, The Fog Warning, Lost in the Grand Banks, Breezing Up, Undertow,* and *Eight Bells,* among his largest and most celebrated works in oil. Wintertime trips to Florida, Cuba, and the Bahamas to fish and paint, continuing until 1909.
1889	Begins regular trips to the Adirondacks.
1890	First seascapes.
1893	Exhibits fifteen paintings at the World's Columbian Exposition in Chicago. Visits Chicago and Quebec.
1895–1900	Trips to Quebec, the Bahamas, Bermuda, and the Adirondacks.
1896	Receives five-thousand-dollar prize from the Carnegie Institute in Pittsburgh.
1898	Two-man show with George Inness (d. 1894) at the Union League Club in New York a huge critical success. Homer's father dies in Prout's Neck.
1899	Thomas B. Clarke sale. High prices for Homer's works.
1900	Gold medal at the Paris Exposition. French government buys *A Summer Night.*
1903	*Northeaster* receives the Temple Gold Medal of the Pennsylvania Academy of the Fine Arts.
1906	The Metropolitan Museum of Art buys *The Gulf Stream.*
1908	Visits Homosassa, Florida, in the winter. Suffers a stroke which temporarily affects his vision and coordination.
1909	Visits Florida.
1910	Spends two weeks of the summer in the Adirondacks. Dies September 29 in his studio in Prout's Neck.

Selected Bibliography

Early Publications

BENJAMIN, SAMUEL GREEN WALTER. *Art in America: A Critical and Historical Sketch.* New York, 1880. Brief but very insightful discussion of Homer at the end of his first period.

COX, KENYON. *Winslow Homer.* New York, 1914. An early postmortem assessment.

DOWNES, WILLIAM HOWE. *The Life and Works of Winslow Homer.* Boston, 1911. The first full-length biography, published the year after Homer's death, and the basis of much subsequent study.

GOODRICH, LLOYD. *Winslow Homer.* New York, 1944. The first modern monograph, and still, on the whole, the best. Includes John W. Beatty's "Recollections of an Intimate Friendship."

Recent Publications

FLEXNER, JAMES THOMAS. *The World of Winslow Homer.* New York, 1966.

GARDNER, ALBERT TEN EYCK. *Winslow Homer, American Artist: His World and His Work.* New York, 1961. Challenges the conventional view (of Downes and Goodrich, among others) that Homer was uninfluenced by other art by proposing English and French sources—ingeniously but not convincingly.

GOODRICH, LLOYD. *Winslow Homer.* New York, 1959. A later, condensed monograph by Homer's chief modern interpreter.

HENDRICKS, GORDON. *The Life and Work of Winslow Homer.* New York, 1979. Opinionated, capricious, often unreliable, but with much valuable information nevertheless, and profusely illustrated.

WILMERDING, JOHN. *Winslow Homer.* New York, 1972. A succinct, well-written, though occasionally fanciful discussion of Homer's art, based mostly on secondary sources.

Topical Studies

BEAM, PHILIP C. *Winslow Homer at Prout's Neck.* Boston and Toronto, 1966. An account of Homer's later years in Maine, drawing on the author's intimate knowledge of the place and the recollections of Homer's descendants and local residents.

————. *Winslow Homer's Magazine Engravings.* New York, 1979. Fully illustrated discussion of Homer's published engravings.

GROSSMAN, JULIAN. *Echo of a Distant Drum: Winslow Homer and the Civil War.* New York, 1974.

Important Early Articles

ALDRICH, THOMAS B. "Among the Studios," *Our Young Folks*, 2 (July 1866), 393–98.

CHASE, J. EASTMAN. "Some Recollections of Winslow Homer," *Harper's Weekly* 54 (22 October 1910), 13. Just that, shortly after Homer's death, by his Boston dealer in the 1880s.

JAMES, HENRY. "On Some Pictures Lately Exhibited," *The Galaxy*, 20 (July 1875), 89–97. The most perceptive early criticism by the famous novelist and essayist.

SHELDON, GEORGE WILLIAM. "American Painters: Winslow Homer and F. A. Bridgman," *The Art Journal*, 4 (August, 1879). The first Homer biography.

SHURTLEFF, ROSWELL. "Correspondence. Shurtleff Recalls Homer," *American Art News*, 9 (29 October 1910), 4. Recollections by an early friend and fellow artist.

VAN RENSSELAER, MARIANA GRISWOLD. "An American Artist in England," *The Century Magazine*, 27 (November 1883), 13–21. Homer's English period and an assessment of his work at mid-career by the most intelligent critic of the period.

Recent Articles and Essays

ADAMS, HENRY. "Winslow Homer: Mortal Themes," *Art in America*, 71 (February 1983), 113–26.

BOIME, ALBERT. "Blacks in Shark-Infested Waters: Visual Encodings of Racism in Copley and Homer," *Smithsonian Studies in American Art*, 3 (Winter 1989), 19–47.

CALO, MARY ANN. "Winslow Homer's Visits to Virginia During Reconstruction," *The American Art Journal*, 12 (Winter 1980), 4–27.

CIKOVSKY, NICOLAI, JR. "Winslow Homer's *Prisoners from the Front*," *Metropolitan Museum Journal*, 12 (1978), 155–72.

———. "Winslow Homer's *School Time:* 'A Picture Thoroughly National,'" *Essays in Honor of Paul Mellon*. Washington, 1986, 46–69.

GERDTS, WILLIAM H. "Winslow Homer in Cullercoats," *Yale University Art Gallery Bulletin*, 36 (Spring 1977), 18–35.

GIESE, LUCRETIA. "Winslow Homer's Civil War Painting *The Initials:* A Little-Known Drawing and Related Works," *The American Art Journal*, 18 (1986), 4–19.

KOBBÉ, GUSTAVE. "John La Farge and Winslow Homer," *New York Herald*, 4 December 1910. La Farge's posthumous recollection of his friend.

PROWN, JULES D. "Winslow Homer in His Art," *Smithsonian Studies in American Art*, 1 (Spring 1987), 31–46.

QUICK, MICHAEL. "Homer in Virginia," *Los Angeles County Museum of Art Bulletin*, 24 (1978), 60–81.

TATHAM, DAVID. *"The Two Guides:* Winslow Homer at Keene Valley, Adirondacks," *The American Art Journal*, 20 (1988), 21–33.

———. "Winslow Homer at the Front in 1862," *The American Art Journal*, 11 (July 1979), 86–87.

———. "Winslow Homer's Library," *The American Art Journal*, 9 (May 1977), 92–98.

———. "Winslow Homer in the Mountains," *Appalachia*, 36 (15 June 1966), 73–90.

WILMERDING, JOHN. "Winslow Homer's Creative Process," *Antiques*, 108 (November 1975), 965–71.

———. "Winslow Homer's English Period," *The American Art Journal*, 7 (November 1975), 60–69.

———. "Winslow Homer's *Right and Left,*" *Studies in the Fine Arts* [National Gallery of Art, Washington], 9 (1980), 59–85.

———. "Winslow Homer's *Dad's Coming,*" *Essays in Honor of Paul Mellon*. Washington, 1986, 389–410.

WILSON, CHRISTOPHER KENT. "Winslow Homer's *The Veteran in a New Field:* A Study of the Harvest Metaphor and Popular Culture," *The American Art Journal*, 17 (Autumn 1985), 2–27.

———. "Winslow Homer's *Thanksgiving Day—Hanging Up the Musket,*" *American Art Journal*, 18 (1986), 76–83.

Exhibition and Collection Catalogues

COOPER, HELEN A. *Winslow Homer Watercolors.* National Gallery of Art, Washington, 1986. A thorough, sensitive study of Homer's work in the medium of which he was an undisputed master.

CURRY, DAVID PARK. *Winslow Homer: The Croquet Game.* Yale University Art Gallery, 1984. An excellent examination of one of Homer's early subjects.

GOODRICH, LLOYD. *Winslow Homer.* Whitney Museum of American Art, New York, 1973.

———. *The Graphic Art of Winslow Homer.* The Museum of Graphic Art, New York, 1968.

Winslow Homer: All the Cullercoats Pictures. The Northern Centre for Contemporary Art, Sunderland, 1988. An "on-site" exhibition of Homer's English work with interesting articles and illustrations.

SIMPSON, MARC, et al. *Winslow Homer's Paintings of the Civil War.* The Fine Arts Museums of San Francisco, 1988. Definitive study of Homer's earliest important paintings and their historical context.

SPASSKY, NATALIE, et al. *American Paintings in the Metropolitan Museum of Art,* 2. The Metropolitan Museum of Art, New York, 1985. Exhaustively complete discussion of the single most important group of Homer's paintings.

WOOD, PETER H. and KAREN C. C. DALTON. *Winslow Homer's Images of Blacks: The Civil War and Reconstruction Years.* The Menil Collection, Houston, 1988.

Photograph Credits

The author and the publisher thank the museums, galleries, libraries, and private collectors who permitted the reproduction of works of art in their possession and provided the necessary photographs. Other sources of photographs are gratefully acknowledged below:

Page 14, *Home, Sweet Home*, Photograph courtesy Hirschl & Adler Galleries, New York; Page 81 (top), *Grave Stele of Hegeso*, Hirmer Fotoarchiv, Munich; Page 113, *A Summer Night*, Photograph © R.M.N., Paris; Page 142, *Cape Trinity, Saguenay River*, Photograph by Gary Mortensen, Minneapolis Institute of Art.

Index